TENNESSEE

POST OFFICE MURALS

DAVID W. GATES JR.

POST OFFICE
FANS

Post Office Fans
PO Box 11
Crystal Lake, IL 60039
Phone: 815-206-8405
Web: www.postofficefans.com • Email: info@postofficefans.com

Publisher's Cataloging-in-Publication Data

Names: Gates, David W., Jr., author.
Title: Tennessee post office murals / David W. Gates Jr.
Description: 1st edition. | Crystal Lake, IL : Post Office Fans, [2021] | Includes bibliographical references and index.
Identifiers: ISBN 9781970088038 (softcover) | ISBN 9781970088045 (ebook) | ISBN 9781970088052 (PDF)
Subjects: LCSH: Mural painting and decoration, American—Tennessee—20th century. | Post office buildings—Decoration—Tennessee—History—20th century. | Public art—Tennessee—History—20th century. | Government aid to the arts—Tennessee—History—20th century.
Classification: LCC ND2635.T4 G38 2021 (print) | LCC ND2635.T4 (ebook) | DDC 751.7309

ISBN (Softcover): 978-1-970088-03-8
ISBN (eBook): 978-1-970088-04-5
ISBN (PDF): 978-1-970088-05-2

Cover and interior designed by John Reinhardt Book Design
Front cover mural: *Electrification*, by David Stone Martin, Lenoir City, Tennessee Post Office, Lenoir City, Tennessee

Printed in the United States of America

DEDICATION

To Mr. Howard Hull, distinguished Tennessean, author, artist, and friend.

ACKNOWLEDGMENTS

I've visited hundreds of post offices and spoken to a lot of people during the creation of this book. I'm inspired by all the interesting people and stories I hear across Tennessee and other states. I can't thank you enough for sharing your time discussing the buildings or art and, most importantly, your stories. I don't always remember your names, and since all my visits seem to blend together, I don't always remember where we met, but rest assured you have had a huge influence in the creation of this book.

Thanks to my mother and father: This book would not be possible without your love and support. I appreciate and cherish the loving grandparents you've become.

Thanks to my wife and son for putting up with me during our family vacations where I just needed one more post office photo. And thanks for putting up with me yet again for the creation of this second post office mural book.

No book of this magnitude is written in a vacuum and brought to fruition without the help of skilled professionals. There are several individuals who have been instrumental in the influence of this book. I wish to celebrate them here.

Howard Hull—author of the original *Tennessee Post Office Murals* book, whose wisdom and knowledge has been a huge influence, inspiration, and source for the present book—is one of the trailblazers for writing and visiting post offices with murals. I've kept all of your books on my desk as a constant reminder of what is possible. I'm delighted to have been in contact with you during the creation of this book and cherish our long-distance friendship. Thank you.

I have learned a great deal from Robert Mis's comments on postofficefans.com. You've also answered an abundant number of questions via email, and for this I can't thank you enough. You know more about post office buildings than anyone I've met, and I've enjoyed our shared interest in these magnificent structures.

Toby McIntosh, author of *Apple Picking, Tobacco Harvesting and General Lee*: Thanks for answering my questions and for your very insightful book. It's been a pleasure connecting with you. You've inspired me to plan a future trip to Arlington, Virginia. I'm still working on those plans, but rest assured, I will make it out East.

Michael Scragg: The amount of history you have housed in your museum is incredible. The personal escort through your world of the post office several years ago left a lasting impression and is something my wife and I will always remember. We look forward to future trips to Marshall, Michigan.

Dr. Jeff Karon, who took this project to a whole new level way above what I would have ever been able to do on my own: Your knowledge and skill are appreciated and valued. What is most impressive to me is our shared vision of getting the story out for others to enjoy these wonderful works of art. You got it right from the start and completely understood the goals and objectives of this project. Not only did you "get it," but your enthusiasm to see it through made it a joy to work with you. Writing a book has its challenges, and when your editor can connect with the material the way you did, the project is a delight. You have my full admiration and respect for working through this project perfectly.

Kathleen Strattan, who edited, proofread, and made numerous suggestions which have improved this work immensely: At first, I had no idea how many seemingly little things were missing. Your attention to the details has improved this book and made it much more valuable than I thought possible. I have also learned a great deal from you, and that means a lot.

John Reinhardt, a fellow Illinoisan and superb book designer: You impress me with your design skills and attention to the details. Thanks for being patient with me. I'm grateful we connected for the Wisconsin project and now for the Tennessee book. Each project has its unique

challenges. What is most impressive is your communication and dedication to creating a superb product.

Thanks to the following individuals who have helped along the way: Angela E., David B., Mike C., Susan I., Benjamin K., Jane F., Amy C., L. Robert Puschendorf, James C., Christine C., Dian B., Keri B., Elizabeth Kendall and Peter Schoenmann of PARMA Conservation Ltd., and the Donohue Group. I'd also like to thank the following USPS staff past and present who also assisted in locating historical pieces of this book: Robert W., Betty L., Mike, Tania, and others whose names I've forgotten to make note of.

Thanks to the staff at Inspection Experts Inc., including Robert F., James F., and James M. Special thanks to the staff of the General Service Administration, including Jennifer C., Brandon B., and Catherine B. If I've missed anyone, it is my own fault and I sincerely apologize.

There were several people early on who helped with various parts of this project, including research, writing, photo editing, designing, and so on. In this modern age of the Internet, I've utilized several platforms for various pieces of this book. I may only know you by your screen name. While I may not have utilized all the work you performed, you have made this book a reality. I've learned a ton working with you, and for that I'm grateful.

Thank you,

David W. Gates Jr.

CONTENTS

Tennessee Post Office Murals

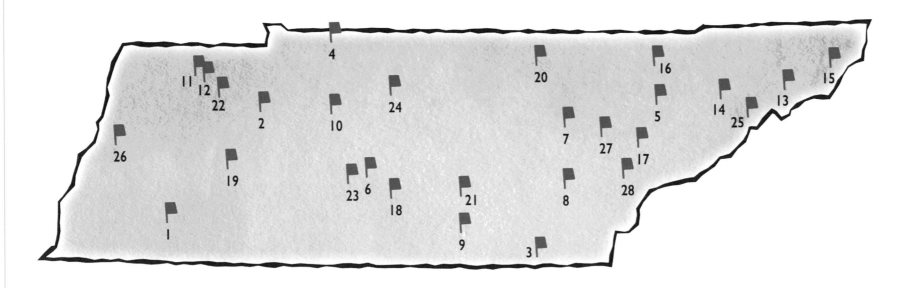

1. Bolivar
2. Camden
3. Chattanooga
4. Clarksville (former)
5. Clinton (former)
6. Columbia (former)
7. Crossville
8. Dayton (former)
9. Decherd
10. Dickson

11. Dresden
12. Gleason
13. Greeneville (former)
14. Jefferson City
15. Johnson City (former)
16. La Follette (former)
17. Lenoir City
18. Lewisburg (former)
19. Lexington (former)
20. Livingston

21. Manchester (former)
22. McKenzie (former)
23. Mount Pleasant
24. Nashville
25. Newport (former)
26. Ripley
27. Rockwood
28. Sweetwater

FOREWORD BY HOWARD HULL

As I look back through the years, I remember a time in 1935 when I went with my father to purchase an automobile. At that time, I was only three years old as I sat in the passenger seat of the shiny 1934 Ford riding up McDowell Street in Welch, West Virginia, looking through the window at the people walking back and forth. Now, as I read various types of literature, I am told that the United States was in a Depression then. Of course, I was too young to know what that meant at the time. I didn't know how it affected people. I only knew about what I could touch and feel and see and hear. I didn't know about Government programs that were put in place to help people survive the tough years of the 1930s. I was just happy to be riding in an almost new car. I didn't know about The New Deal, The Works Progress Administration, The Public Works of Art Project, who President Roosevelt was, or even what a post office was.

As I grew older, lived through World War II, finished high school, served in the military, attended college, and studied art, I would learn about all those things. It would come about because I had found employment at The University of Tennessee and needed a research project as part of my requirements as a professor of Art Education. During a class discussion of art and philosophy, a student asked me if I had seen the post office mural in Newport. When I said that I had not, he described it to me. As I listened to him, I began to wonder if there were any more in Tennessee. After a short visit to the library, I found that there had originally been 30, and that 28 could still be viewed.

So, beginning in 1991, I started researching each mural; I completed the study during the summer of 1994. During that time, I traveled throughout the state of Tennessee and photographed the murals. I also talked to hundreds of people. In addition, I secured information from the National Archives and the Smithsonian Archives of American Art in Washington, D.C., in addition to many available books and newspapers.

And now, 27 years later, David W. Gates Jr. of Crystal Lake, Illinois, has written a beautiful book about those Tennessee Post Office Murals. In it he discusses the many people involved in creating the murals, which stretch from east to west across the entire state of Tennessee.

The murals can be found in post offices in such cities as Bolivar, Chattanooga, Camden, Clinton, and Columbia. They were created by various artists. For some it became a family affair. For instance, William Zorach, who created two wood reliefs, *Man Power* and *Natural Resources* in Greeneville was the husband of Marguerite Zorach, who painted the mural entitled *Autumn* in Ripley. They were the parents of Dahlov Ipcar who painted *On the Shores of the Lake* in La Follette. And then there are the two sisters, Marion and Grace Greenwood, who painted murals in Crossville and Lexington. Also, there is David Stone Martin who did the mural *Electrification* in Lenoir City, and Thelma Martin, his wife, who painted *Wild Boar Hunt* in Sweetwater.

All of these as well as the 23 other murals are beautifully photographed and displayed in David's book *Tennessee Post Office Murals*. Do yourself a favor and pick up an extra copy. It is an excellent read.

INTRODUCTION

In 1933, America was in the grip of the Great Depression, and a quarter of her people were out of work. In response to this financial crisis, President Franklin Delano Roosevelt initiated the New Deal to help a struggling populace. One New Deal program, the Public Works of Art Project (PWAP), dedicated one percent of funding for new federal construction to commission works of art to decorate these public buildings.

Though many Americans didn't know it, the government had a history of supporting the arts long before the Great Depression and Roosevelt's New Deal. While commissioning artists to create murals to hang in post offices wasn't a stretch considering this history, the PWAP was directly related to the Depression. In 1935, the PWAP broke into three separate entities, with the Treasury Department's Section of Painting and Sculpture (later called the Section of Fine Arts) overseeing the post office mural project. The other two programs were the Treasury Relief Art Project (TRAP) and the Federal Art Project (FAP). All three programs continued through 1943.

With the Treasury Department assuming control in 1935, the intention of the program changed. From providing employment to artists, the goal was now improving morale in these Depression-era communities. Artists who won these commissions were expected to consult with prominent members of the community, as well as with regular folk, to create works meaningful to that region.

For example, in the words of Edward B. Rowan, Superintendent of the Section of Painting and Sculpture,

It is suggested that you use subject matter which embodies some idea appropriate to the building or to the particular locale of Camden, Tennessee. What we most want is a simple and vital design.

Artists were encouraged to visit the local post office and consult with the postmaster and locals to discuss appropriate subject matter for the town in question. This is indicated in various letters from Rowan to the artists.

If it is convenient for you to make a visit to this post office, the Section considers it advisable for you to call on the Postmaster and at the same time determine the exact dimensions and most suitable character for the decoration. We shall be very glad to inform the Postmaster of your intended visit.

What began for me as an interest in a photographic subject soon became a deep fascination with the history and presence of a unique moment in American culture and art. Before documenting the murals in this book, I visited hundreds of post offices and spoke to dozens of people across the U.S.—we were united in our enthusiasm for keeping the stories of this art alive and available for the American public.

The present book, which is a tour guide to all 30 of Tennessee's New Deal post office murals, is a contribution to my larger project of visiting and documenting all the murals in each state. I encourage you to visit one of these post offices in Tennessee or seek out one in your own state if you aren't personally traveling through Tennessee. To learn about this special art is to learn about the continuing American journey.

Thank you for traveling with me.

AUTHOR'S NOTE

The Images

The highlight of this book is the art itself, and I—working with my editor and designer—have done my best to present it clearly and evocatively.

In some of the images, the mantel above the postmaster's door has been digitally cut out. In other cases, there may be other architectural features also cut out of the art. I did this simply to create a pleasant reader experience without the distraction of the postmaster mantel intruding into the artwork.

The Buildings

Some friendly readers have suggested removing the images of the buildings and cornerstones. But I decided to keep them in order to provide a reference that included details of the original installation location. In some cases, the artwork has been moved either to a museum or some other private or public location. I want readers to learn about not just the installation but also what the building looks like and how the artwork fits into the time and place.

In cases where I was not able to verify the contractor or dollar amount of the building, I filled in this information with an estimate of the cost when new. Since the mural reservations were approximately 1% of the construction cost, we can estimate the cost of the buildings. If we know the mural commission was $700, then the cost of the building when new must have been around $70,000. This is the number used in place of the actual number. Such cases are identified with an asterisk.

Unfortunately, not all the art remains in the original location. Some buildings have been sold, and the artwork has been moved. This book focuses on the art and the original building where the art was installed. For the current status and location of the artwork, the guidebook series provides this updated, relevant information.

The Artists and Other Information

For some entries, information about the artist or building construction is sparse or missing—this is not an oversight. As I mention in the Bibliography under Archival Sources, the research represents what could be found. I felt that moving forward was more important than any chance encounter which would reveal the missing information. Future editions may help complete these details.

The History of the Murals

The main archival details can be found under the section that details the history of each mural. The correspondence between artists and the Section shows how each affected the eventual mural design, as well as other details such as how several artists worried about payment during a period of economic instability, a situation that has much in common with our contemporary society. The style of the correspondence, I hope, gives the reader a real sense of the time in which these wonderful murals were born.

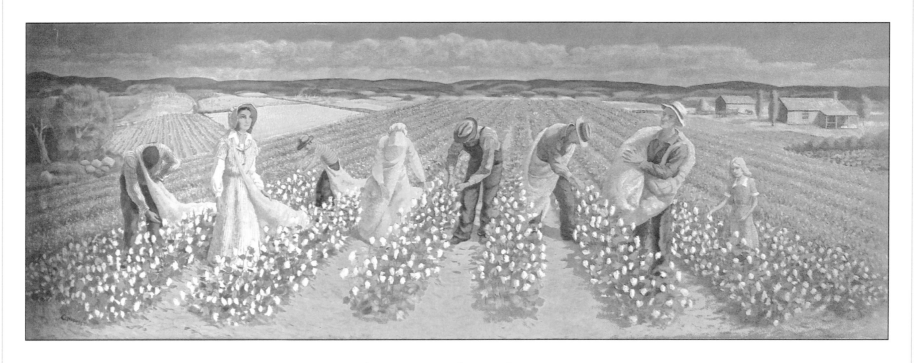

Picking Cotton, by Carl Nyquist

The mural *Picking Cotton* is oil on canvas, measures 13'6" by 5', and was installed in August 1941. The mural depicts men, women, and children picking cotton in a field. The commission was $750.

History of the Mural

Based on designs he submitted for the Wilmington, North Carolina Post Office Mural Competition, Nyquist was commissioned by the Section of Fine Arts to create a mural for the Bolivar, Tennessee Post Office. After a revised design was approved by the Commissioner of Public Buildings, Nyquist was directed to "kindly proceed with the two-inch-scale color sketch and either bring it or submit it to this office for further consideration." His work would be based on measurements from blueprints, though he also was directed to verify those measurements either by visiting the building or corresponding with the postmaster, a suggestion that was made to every one of the mural artists.

In a May 6th letter, Nyquist recounted his visit to the Bolivar Post Office during which he "confirmed the measurements, which were slightly off from the blueprints given him." He also got a better idea of what a cotton plant actually looked like.

After receiving the color sketch, the Section wrote back to Nyquist:

The color sketch is approved at this stage but it is suggested that in the further progress of the work the child being held by the man on the right should be placed on the ground as though he were running up to the workers. I would also appreciate your checking the locale to see if white workers are employed in the cotton fields.

After reviewing the full-size cartoon, the Section approved the painting of the mural following Nyquist's "further study of the locale." Nyquist wrote back, confirming that both white and black people picked cotton, sometimes together, and that most of them were sharecroppers.

On September 8, 1941, the local postmaster confirmed that the mural had been "satisfactorily installed" and the Section agreed based on a photograph of the completed work. Once it was installed, it received "quite a number of compliments on same." The artist added instructions for cleaning: "lukewarm water and Ivory Soap."

ABOUT THE ARTIST

Carl B. Nyquist was born in 1888 in Sweden. He is best known for his paintings and graphic decorations. He studied art at the Corcoran School of Arts & Design in Washington, D.C.

Nyquist immigrated to the U.S. in 1905 and initially settled in Chicago, Illinois. He eventually moved to Washington, D.C., where he was living when he was commissioned for the Bolivar, Tennessee Post Office mural.

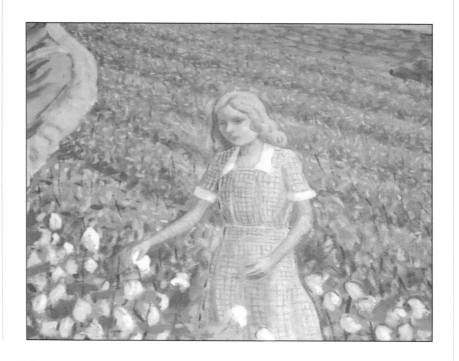

Carl Nyquist, Picking Cotton

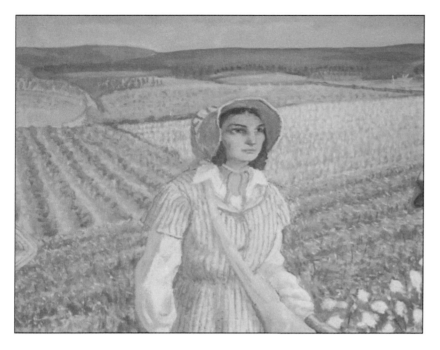

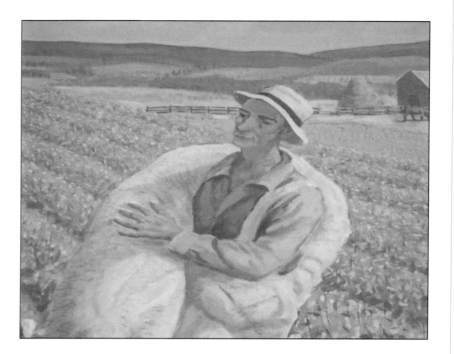

He died in 1959 in Washington, D.C., and is buried in Arlington National Cemetery.

Sources

"Carl Nyquist," Ask Art, https://www.askart.com/artist/Carl_B_
 Nyquist/10039883/Carl_B_Nyquist.aspx

Falk, Peter H. *Who Was Who in American Art 1564–1975: 400
 Years of Artists in America.* Madison, CT: Sound View Press,
 1999.

McMahan, Virgil E. *The Artists of Washington, D.C., 1796–1996.*
 Washington, D.C.: McMahan, 1995.

History of Bolivar

Located in western Tennessee and in Hardeman County, Bolivar is a small town of 5,417 people according to the 2010 census, and was originally named "Hatchie Town" for the river that the Native Americans called "the Big Hatchie." Due to the amount of flooding, the original site of Hatchie Town couldn't be used for the county seat of Hardeman County, so a new site approximately a mile south was chosen and named Bolivar after South American liberator Simón Bolivar, who led several South American countries to independence from the Spanish Empire. Bolivar was officially made the new name of Hatchie and was established on October 18, 1825 and incorporated in November 1847.

From 1862 to 1864 during the Civil War, the town of Bolivar was under martial law and thus saw no armed conflict, though there was

fighting in the surrounding area. But in 1864, the Union leader General Samuel Sturgis came into town with 12,000 soldiers and burned down the business section, the courthouse, and two churches.

The town was plagued with multiple fires from the 1870s to the 1880s, including the explosion in June 1885 inside Moffitt's and Company that destroyed an entire block of buildings east of the courthouse. The post office that was inside Moffitt's was destroyed and then rebuilt in a separate building along with the opera house by August of that year.

SOURCES

"About Us," City of Bolivar, https://www.cityofbolivar.com/about-us

"Bolivar, TN Population," Census Viewer, http://censusviewer.com/city/TN/Bolivar

"History of Bolivar," Historic Bolivar, https://sites.google.com/site/historicbolivartn/history-of-bolivar

The Bolivar Post Office

118 E. Market St., Bolivar, Tennessee 38008

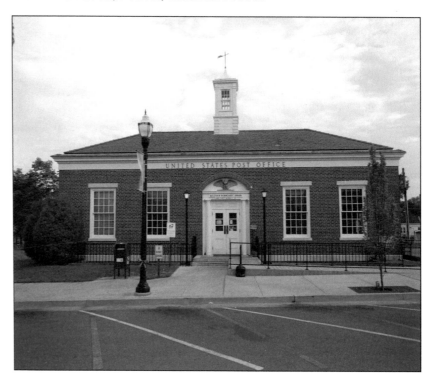

The approximate cost of the building when new was about $75,000.*

The Bolivar Post Office was completed in 1940 as indicated on the cornerstone on the lower right corner of the building, which reads, *James A. Farley, Postmaster General. John M. Carmody, Federal Works Administrator. W. Englebert Reynolds, Commissioner of Public Buildings. Louis A. Simon, Supervising Architect. Neal A. Melick, Supervising Engineer.*

Mail Delivery to Tranquility—The First Post Office in Benton County, by John H. Fyfe

The mural *Mail Delivery to Tranquility—The First Post Office in Benton County* is oil on canvas, measures 12' by 4', and was installed on April 14, 1938. The mural represents mail delivery to the first post office in Benton County. The commission was $510.

History of the Mural

The Section invited Fyfe to submit designs for a mural painting for the Camden, Tennessee Post Office based on a design he submitted for a previous competition. The Section wrote to Fyfe,

> The proposed mural is to be designed for the space in the Public Lobby over the Postmaster's door as indicated on the enclosed blueprints. The proposed panel is to be 12' wide by 4' high. It is agreeable to the Section that you make any slight variations in the dimensions of the proposed panel which you consider would make it more suitable to the particular wall space.
>
> If it is convenient for you to make a visit to this post office, the Section considers it advisable for you to call on the Postmaster. It is suggested that you use subject matter which embodies some idea appropriate to the building or to the particular locale of Camden, Tennessee. What we most want is a simple and vital design.

Fyfe wrote back that he would travel to Camden to meet with the postmaster on August 23 in order to finalize the subject matter. In a later letter, he wrote,

> On each of my trips to Camden, I visited the location of "Tranquility" as nearly as it could be determined [about one mile west of the present post office] and carefully made note of the surrounding terrain so that I might clearly visualize it at the period to be depicted.

He wrote to the Section about the process of selecting a subject for the mural:

> After several conferences with the Postmaster, bankers, doctors, lawyers, planters and other Camden civic leaders, they left the subject matter up to me and I chose these two as most nearly embodying the spirt which they seemed to want in the picture.
>
> I personally, like the sketch dealing with a comparison between the early rural free delivery and the present because Camden and Benton County are almost exclusively rural. In it, I have from sketches and observation, tried to get the character of the county in which the mural will hang. I believe it to be the better picture.

Once they had settled on the subject, Fyfe assured the Section that he would make a cartoon on canvas and then send a photograph.

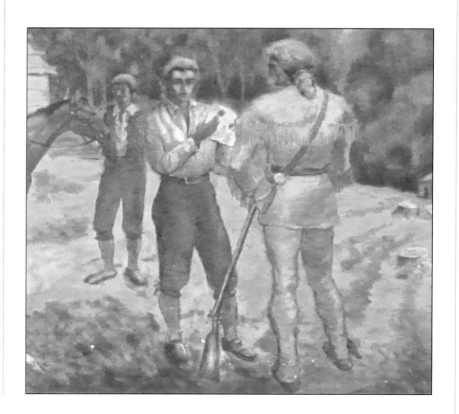

John H. Fyfe, *Mail Delivery to Tranquility—The First Post Office in Benton County*

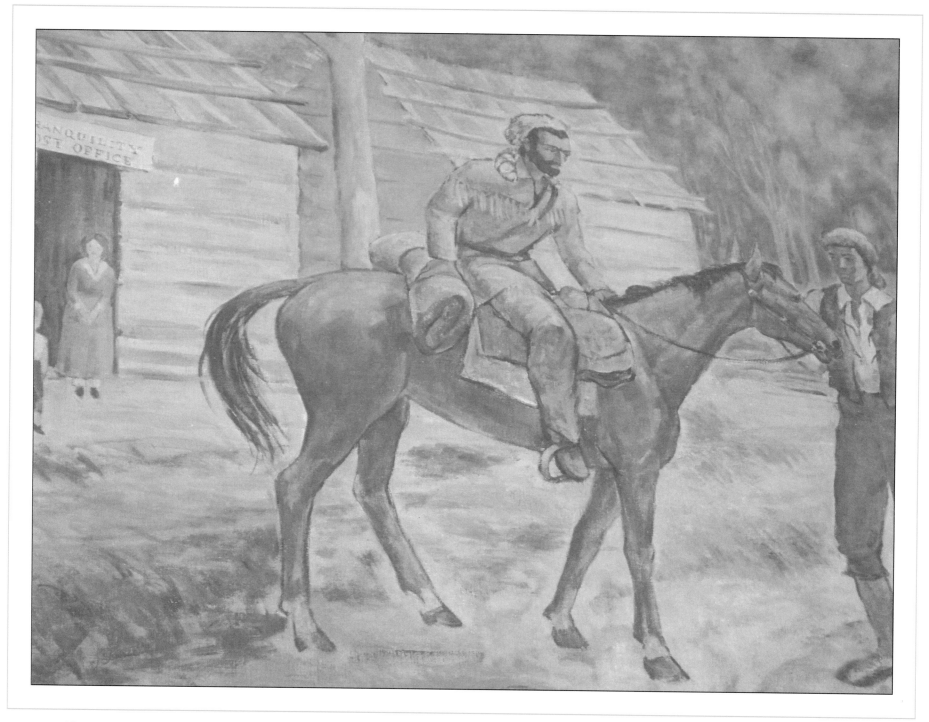

John H. Fyfe, *Mail Delivery to Tranquility—The First Post Office in Benton County*

The Section, along with the Supervising Architect, also made a number of suggestions:

This design in its present state is somewhat interesting in the extreme right portion and it might be possible in developing the work in its larger form to include figures working down in the woods. It is suggested that the two figures on the extreme right be raised slightly more into the composition. This will keep the lower figure from being cut off at the bottom of the panel.

After receiving a photograph that showed the full-size cartoon one-half completed, the Section approved the ongoing work, as well as the second fee installment, though not without further suggestions:

[W]e particularly liked the drawing of the horse and buggy but felt that the automobile occupying so prominent a position would look too much like an advertisement for a particular type of automobile.

In a letter dated October 31, 1937, Fyfe advocated for including an automobile:

Would you rather have used the second sketch had the automobile not been so definitely typed? I could have made one embodying the characteristics of the modern car, without it being any particular make. Also, I could have lessened the importance of the car in the composition had you thought it desirable.

The Section, however, preferred the design—without the automobile—that already had been submitted and approved:

The design is quite attractive but it was felt that you should avail yourself of models in the actual painting of the work. The stance of the large figure in the foreground right does not indicate the strength that is usually associated with pioneers of this caliber and we would like you to strengthen the drawing. The head of the man

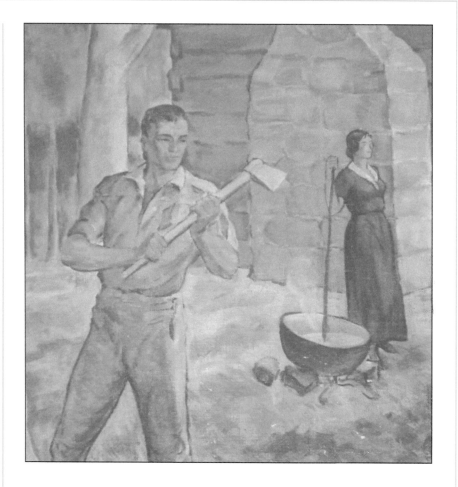

holding the ax on the extreme left seems a little small in relation to the figure and the scale of the figures of the woman and the children at the cabin also seems too small. This is a matter which we would like you to give further study. The general treatment of the design, however, is satisfactory.

Fyfe completed the mural, which was then installed, as verified in an April 14, 1938 report from the postmaster, after which the Section authorized payment of the balance of the fee owed to Fyfe.

John H. Fyfe, *Mail Delivery to Tranquility—The First Post Office in Benton County*

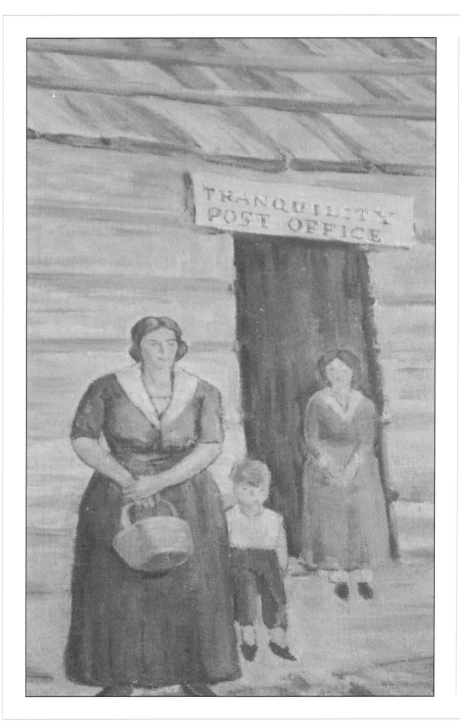

The local postmaster noted that "the picture has been viewed by many of our citizens already and they consider the work of Mr. Fyfe of a high order. He is a real artist." Fyfe expressed his pleasure in working with the Section: "Many thanks for the great freedom and the latitude you gave me while working on it—it has been a pleasure working for you and I hope that I can do other paintings for you in the near future."

ABOUT THE ARTIST

John H. Fyfe was born in 1893 in Gilby, North Dakota. He is best known as a painter, cartoonist, illustrator, and teacher. Fyfe earned his B.F.A. from the Art Institute of Chicago, and also studied at the Society of Illustrators in New York.

Fyfe's work has been exhibited at Mid-South AA, Memphis Palette & Brush, as well as the University of Tennessee, Knoxville. In addition to the Camden Post Office mural, Fyfe also painted the mural for the Magnolia, Mississippi Post Office.

At the time of the mural award, John H. Fyfe was a resident of Knoxville, Tennessee.

SOURCES

"John Hamilton Fyfe," https://www.askart.com/artist/John_Hamilton_Fyfe/10019222/John_Hamilton_Fyfe.aspx#

"Tranquility," https://www.waymarking.com/waymarks/WMAAFE_Tranquility_4A_30_Camden_TN

Falk, Peter H. *Who Was Who in American Art 1564–1975: 400 Years of Artists in America.* Madison, CT: Sound View Press, 1999.

Smith, Johnathan K. T., "Benton County," *Tennessee Encyclopedia*, March 1, 2018, https://tennesseeencyclopedia.net/entries/benton-county/

History of Camden

Camden is the seat of Benton County and was formed in 1835 out of a part of western Humphreys County. According to the 2010 census, the population was 3582. It takes its name from the battle of Camden,

John H. Fyfe, *Mail Delivery to Tranquility—The First Post Office in Benton County*

South Carolina that occurred during the American Revolution, although it was originally known as "Tranquility" after the post office that was established in the home of William H. H. Burton. In 1836, Camden was made the county seat of Benton County and was officially incorporated in 1838.

The Chickasaw Native Americans used the surrounding area as hunting grounds until settlers arrived from Virginia, North Carolina, and South Carolina, as well as other states to the east.

One of the most famous events in recent history that took place in Camden was the death of legendary country music star Patsy Cline, as well as the deaths of musicians Hawkshaw Hawkins, Cowboy Copas, and Randy Hughes, in a plane crash on March 5, 1963. A boulder-shaped memorial with the victims' names was erected in their honor.

Sources

"Camden, Tennessee Genealogy," Family Search Wiki, https://www.familysearch.org/wiki/en/Camden,_Tennessee

"Camden, TN," https://www.cityofcamdentn.com/

"Patsy Cline Crash Site Memorial," *Atlas Obscura*, https://www.atlasobscura.com/places/patsy-cline-crash-site-memorial

The Camden Post Office

81 N. Forrest Ave., Camden, Tennessee 38320

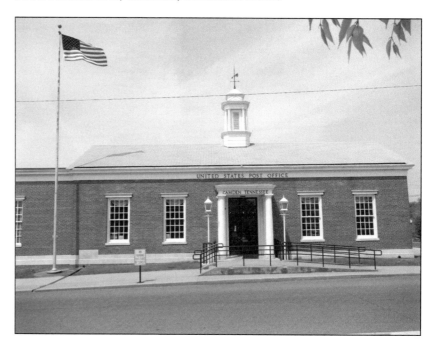

The Camden Post Office was constructed by Charles H. Barnes of Logansport, Indiana. The cost of the building when new was about $46,920.

The Camden Post Office was completed in 1936 as indicated on the cornerstone on the lower left corner of the building, which reads, *Henry Morgenthau Jr., Secretary of the Treasury. James A. Farley, Postmaster General. Louis A. Simon, Supervising Architect. Neal A. Melick, Supervising Engineer.*

HENRY MORGENTHAU JR
SECRETARY OF THE TREASURY

JAMES A FARLEY
POSTMASTER GENERAL

LOUIS A SIMON
SUPERVISING ARCHITECT

NEAL A MELICK
SUPERVISING ENGINEER

1936

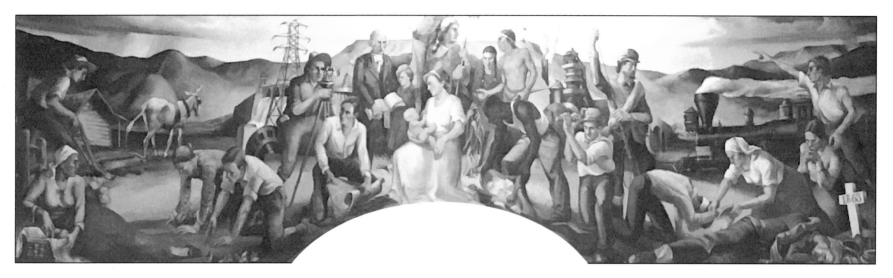

Allegory of Chattanooga, by Hilton Leech

The mural *Allegory of Chattanooga* consists of a large, oblong panel in the curved space behind the judge's seat and measures 8' by 19'9". The commission was $2,900.

History of the Mural

Olin Dows, the Assistant Superintendent of Painting and Sculpture, wrote to the building architect, R. H. Hunt:

There is available the sum of $2,900 for the execution of murals in the Post Office and Court House of Chattanooga, Tennessee, of which you are the architect. $3,000 was the amount set aside, and $100 was set aside for Mrs. Patton as the chairman of the mural competition.

We would like to proceed with the execution of this mural and secure your cooperation in doing so.

In order to carry on the work in the spirit of the general purpose of the new Section we invite you to act as a member of the local committee to handle the work at that end. We are asking Mrs. George Patton of the Art Study Club, to act as Chairman of the committee to supervise this work.

We have asked Mrs. Patton to add such members to the committee as she wishes to select, suggesting, however, that she keep the total number at five. We are writing her at this time and asking her to get in touch with you as per copy enclosed.

From a study of the drawings, I think that the oblong panel directly behind the judge's seat, and broken by the seat, would be the best place to decorate. I make the dimensions of this panel 8' high by 19'9" wide; it is 12' from the floor. I also understand that the wainscoting is oak burl wood, which has a light finish, with a certain amount of ebony inlay. The floor is made up of six color rubber tiles; that the light comes from five clerestory windows on either side; and that the wall behind the judge's seat on which the panel is to be placed is slightly curved.

We would like any information or suggestions which you have as to local subject matter, providing a suitable motif for the proposed murals. In general, we are suggesting local history, past or present, a history of the post in general, or local industries and pursuits, but these subjects can, of course, be modified according to the wishes of the committee.

After a committee was set up—led by Patton and including the architect, R. H. Hunt—and a competition was held, all of the submitted designs were rejected by the Section. But six of the artists "who submitted the most promising sketches" were invited to submit new sketches over the following two months, one of whom was Hilton Leech.

Hilton Leech, *Allegory of Chattanooga*

ABOUT THE ARTIST

Hilton Leech was born in 1906 in Bridgeport, Connecticut. He is best known for his watercolor paintings and teaching. Leech enrolled in the Grand Central Art School and later studied at the Art Students League. He also attended the Ringling Art School in Sarasota, Florida, and was a resident of Sarasota at the time he was commissioned to paint the mural in Chattanooga.

After the war, Leech opened his own school, the Amagansett Art School, also in Sarasota. Leech was a member of many organizations including the American Watercolor Society, the American Federation of Art, and the Salmagundi Club.

In addition to the Chattanooga mural, Leech also painted the mural *Removal of the County Seat from Daphne to Bay Minette* in Bay Minette, Alabama.

He died in 1969 in Virginia City, Montana.

SOURCES

Falk, Peter H. *Who Was Who in American Art 1564–1975: 400 Years of Artists in America*. Madison, CT: Sound View Press, 1999.

"Hilton Leech," Ask Art, https://www.askart.com/artist/Hilton_Leech/117671/Hilton_Leech.aspx

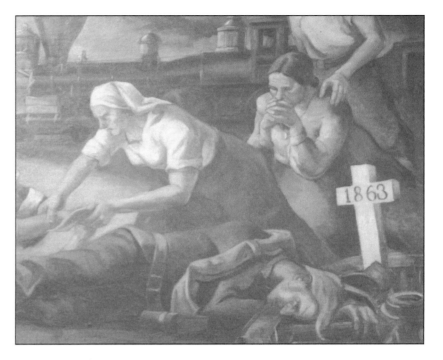

History of Chattanooga

Chattanooga is located in southeastern Tennessee and was originally founded as Ross's Landing trading post in the 1830s along the Tennessee River. It was renamed Chattanooga in 1838, which came from a Greek word for what is known today as Lookout Mountain. Today, it is the fourth-largest city in the state of Tennessee.

Nestled between the Tennessee River and the Appalachian Mountains, the Chattanooga area was first settled as far back as 8,000 years ago by Native Americans. White settlers didn't arrive until the 1830s when the trading post was built. The city was incorporated in 1839, beginning with 53 families, but after the railroad came through in 1850, the town's growth exploded. By 1860, it quickly had become a necessary hub for the transport of goods throughout the region.

The town is famous for the Battles of Chattanooga, which took place from November 23 to November 25, 1863. The battles ended in

Confederate defeat, giving the Union control of the railroad junction of Chattanooga.

Economically, one of the most important additions to the city's prosperity occurred in 1899 when Ben F. Thomas, Joseph B. Whitehead, and John T. Lupton obtained the sole rights to bottle Coca-Cola. It added much income and many jobs to the local economy, and the Coca-Cola Bottling Company remains open in Chattanooga to this day, distributing bottled drinks throughout the region.

In 1933, the Tennessee Valley Authority arrived and became a source of economic relief for Chattanooga, which had suffered through the Great Depression as the rest of the nation had. The construction of the Chickamauga Dam and other TVA projects provided jobs to hundreds of area residents.

Sources

"Battle of Chattanooga," HISTORY, December 11, 2019, https://www.history.com/topics/american-civil-war/battle-of-chattanooga

"Chattanooga," *Britannica*, May 23, 2019, https://www.britannica.com/place/Chattanooga

Ezzell, Timothy P., "Chattanooga," *Tennessee Encyclopedia*, March 1, 2018, https://tennesseeencyclopedia.net/entries/chattanooga/

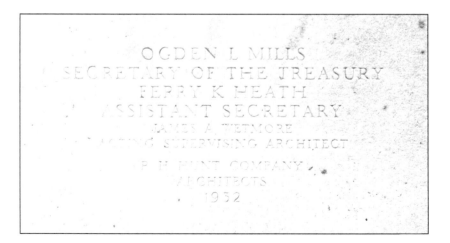

The Chattanooga Post Office and Courthouse

910 Georgia Ave., Chattanooga, Tennessee 37402

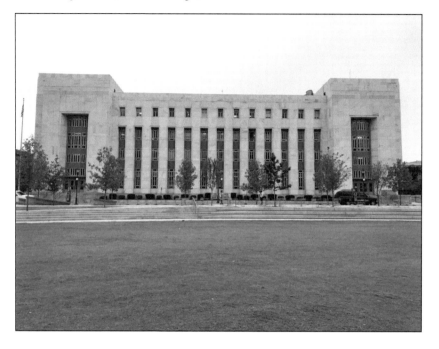

The cost of the building when new was about $1,435,000.*

The Chattanooga Post Office was completed in 1932 as indicated on the cornerstone on the lower left corner of the building, which reads, *Ogden L. Mills, Secretary of the Treasury. Ferry K. Heath, Assistant Secretary. James A. Wetmore, Acting Supervising Architect. R. H. Hunt Company, Architects.*

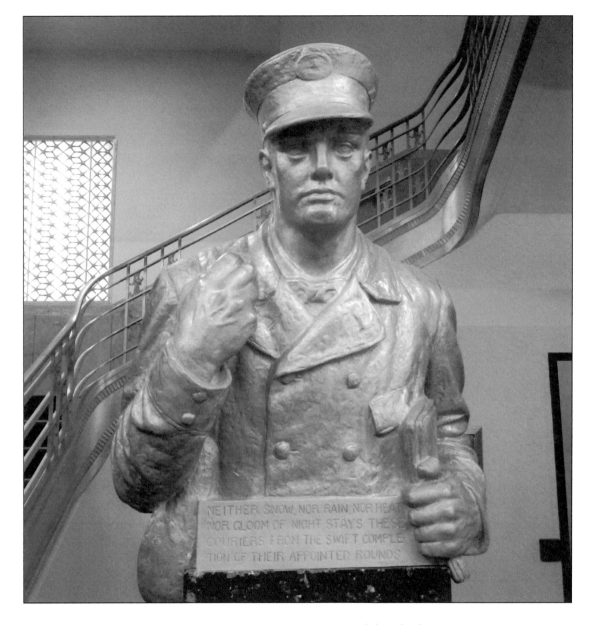

The Mail Carrier, by Leopold Scholz

The bust *The Mail Carrier* is cast aluminum and measures 3' high. The commission was $1,500.

CHATTANOOGA (#2)

History of the Mural

The Section set out the requirements for the eventual sculpture:

This bust is to be a bronze head, ten percent over life size, of Judge Sanford. The sculptor is to discuss the solution of this problem with the local committee and the architect of the building. The local committee can supply data as to the appearance of Judge Sanford.

The sculptor is to prepare a full-size plaster model which will be approved by the local committee and photographs of which will be sent to Washington for final approval by the Director before the bronze is finally cast. The sculptor is to supply the photographs. He may, however, if he prefers, send the plaster bust, itself, instead of sending the photographs.

The sculptor who receives the commission will be required to pay all expenses in connection with the execution and installation of this work.

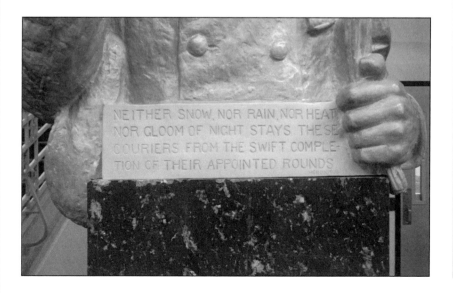

The pedestal, or bracket, for this bust will be supplied by the Procurement division.

Scholz ultimately would win the competition:

I fully agree with you on the quality of Harold Cash's work—I like it immensely.

However, some of the representatives from your state here in Washington consider that Mr. Scholz is a better sculptor and we feel that for fairness sake it would be advisable to have a competition.

We will, of course, join with you in obtaining a decision for quality on the best model submitted.

ABOUT THE ARTIST

Leopold F. Scholz was born in 1877 in Vienna, Austria. He is best known for his outdoor public sculpture.

Scholz married American sculptor Belle Kinney in 1921 and many of their works were combined efforts. The most credited and well-known is the pediment sculpture of Nashville's replica of the Parthenon.

In addition to the Chattanooga sculpture, Scholz also executed the stone relief *A Pioneer Woman's Bravery*, for the Angola, New York Post Office.

Scholz died in 1946.

SOURCES

Ask Art, https://www.askart.com/artist_bio/Leopold_F_Scholz/123484/Leopold_F_Scholz.aspx#

"Leopold Scholz, 69, a Noted Sculptor," *New York Times*, 14 May 1946, p. 21.

Falk, Peter H. *Who Was Who in American Art 1564–1975: 400 Years of Artists in America*. Madison, CT: Sound View Press, 1999.

Leopold Scholz, *The Mail Carrier*

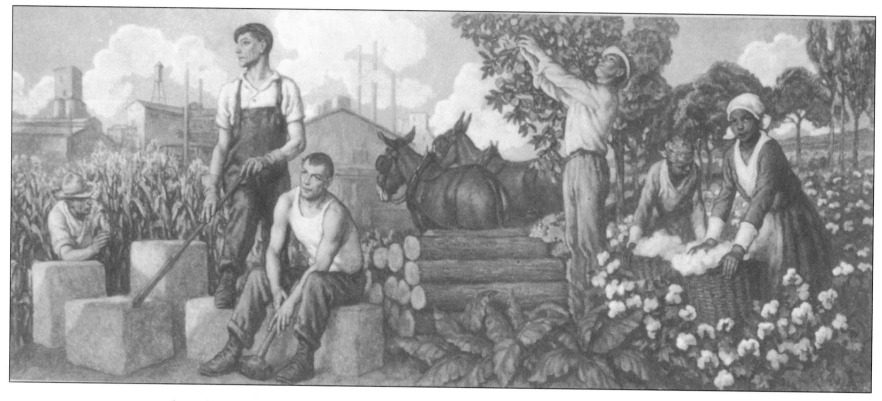

Abundance of Today and _Arrival of Colonel John Donaldson_, by F. Luis Mora

The murals _Abundance of Today_ and _Arrival of Colonel John Donaldson_ are oil on canvas. Each mural measures 12' by 5'. One was installed on the south end of the lobby and the other on the north end of the lobby. The commission was $1,300.

History of the Murals

The Section wrote to the artist that the murals

are to be designed for the spaces at either end of the public lobby as indicated on the enclosed blueprints. Each proposed panel is to be 12' wide by 5' high. It is agreeable to the Section that you make any slight variation in the dimensions of the proposed panels which you consider would make them more suitable to the particular wall space....

It is suggested that you use a subject matter which embodies some idea appropriate to the building or to the particular locale of Clarksville, Tennessee. What we most want is a simple and vital design.

Before he began work on the mural, Mora informed the Section that he would write to the Clarksville postmaster,

asking for whatever they may send of historical value. I am also starting to look things up. I will give you something full of color— The Italians of old enjoyed color on their walls, why shouldn't we?

Mora wrote back to the Section about his selection of color:

I have used the golden tone in the sky to get away from the usual blue. In fact I have thought of giving it the feeling of a gold background. Some years back I painted a number of pieces for a library and used this scheme of the golden tone back of my color.

The effect was truly very rich, and very brilliant. Here again, let me have your reaction, for I am one of those who are aware of the thousand ways that things such as these may be treated. I am very delighted to experiment and try new schemes of color and design.

After receiving Mora's color sketches, the Section wrote back that

No specific criticism was offered in connection with the "Arrival of Colonel John Donaldson" but in the panel "Abundance of Today" it was felt that the composition of figures could be moved to advantage somewhat to the left. This will introduce the cotton picker more into the composition. In the present version the composition seems to be terminated rather abruptly. The suggestion of a simple molding indicated in the sketches also meets with our approval. It looks like a nice architectural arrangement.

The Section approved the final payment to Mora after the local postmaster wrote that "the murals recently painted and installed in the Post Office are satisfactory in every way."

ABOUT THE ARTIST

Francis Luis Mora was born in 1874 in Montevideo, Uruguay. He is best known for his figure and portrait paintings, as well as his illustrations. Mora attended the Boston Museum School of Fine Arts in 1889. In 1893, Mora returned to New York and attended the Art Students League.

Mora became a successful figure painter, portraitist, muralist and illustrator while living in New York and maintaining a studio in Perth Amboy, New Jersey. Mora's work won several awards, and he was a member of several artist associations.

In addition to the Clarksville, Tennessee mural, Mora also painted *Arrival of the Stage* for the Catasauqua, Pennsylvania Post Office.

Mora was a resident of New York at the time he was commissioned for the murals, and worked on them in his studio in that city:

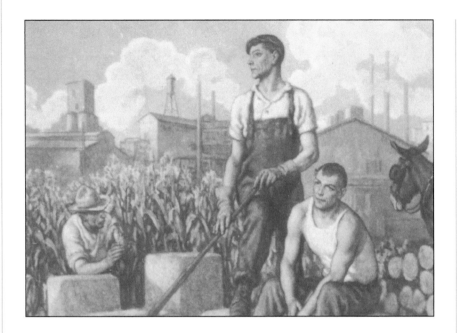

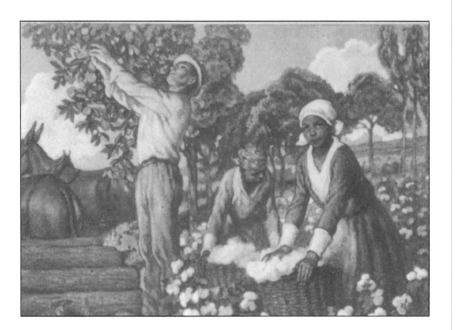

Be assured that I am highly enjoying this work, and will give you my very best efforts.... [But] one awful question: "When do I get that first payment?" This has been a slow month for me. I would appreciate anything that you may do to expedite that check. Very best wishes.

In a similar vein, Mora later wrote,

Whatever you may do to expedite the last payment will be of great help. I have run into one of those devastating cash storms all blown away suddenly. Whatever you may be able to do will be greatly appreciated.

Mora died in New York in 1940.

SOURCES

"Francis Luis Mora," Ask Art, https://www.askart.com/artist_bio/Francis_Luis_Mora/2636/Francis_Luis_Mora.aspx#

Falk, Peter H. *Who Was Who in American Art 1564–1975: 400 Years of Artists in America.* Madison, CT: Sound View Press, 1999.

History of Clarksville

Clarksville is the seat of Montgomery County and is the fifth-largest city in Tennessee. Its population as of the 2010 census was recorded as 132,929. It was established in 1784 by the North Carolina legislature as the seat of Tennessee County, since Tennessee was not founded as a state until June 1, 1796.

Located on the Cumberland River, the city thrived largely on its tobacco trade. By 1789, Clarksville was so central to the trade that lawmakers decided to make Clarksville an inspection point for tobacco on its way to market.

The railroad came to Clarksville in 1859–1860, increasing the area's economy significantly, as well as raising the city's profile during the Civil War. Fort Defiance was established on the Cumberland River by the Confederacy to defend Clarksville's river approach from Union

troops. Clarksville and Fort Defiance were seized by Union troops in February 1862, and the fort was renamed Fort Bruce, after Colonel Sanders D. Bruce who was placed in command.

Much of Clarksville's modern-day prosperity is due to Fort Campbell's establishment just north of the city in 1941. Fort Campbell was made a permanent military base in 1950 and thus has remained the most important factor in the local economy, shaping local culture ever since.

Sources

"Clarksville, TN Population," Census Viewer, http://censusviewer.com/city/TN/Clarksville

"Fort Defiance Civil War Park and Interpretive Center," City of Clarksville, https://www.cityofclarksville.com/461/Fort-Defiance-Civil-War-Park-Interpretiv

"Fort Defiance/Fort Sevier/Fort Bruce," American Battlefield Trust, https://www.battlefields.org/visit/heritage-sites/fort-defiancefort-sevierfort-bruce

Winn, Thomas H. "Clarksville," *Tennessee Encyclopedia*, March 1, 2018, https://tennesseeencyclopedia.net/entries/clarksville/

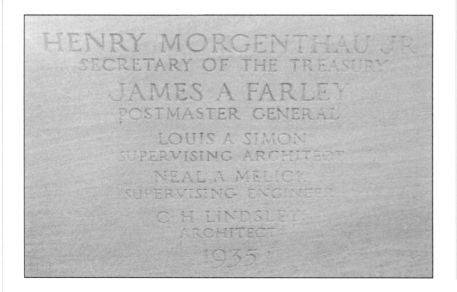

The Former Clarksville Post Office

116 N. 2nd Street, Clarksville, Tennessee 37040

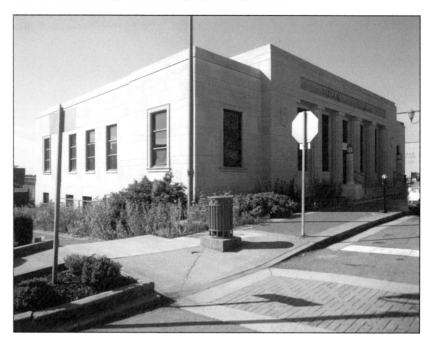

The Clarksville Post Office was constructed by Murch Brothers Construction Company of St. Louis, Missouri. The cost of the building when new was about $78,916.

The Clarksville Post Office was completed in 1935 as indicated on the cornerstone on the lower left corner of the building, which reads, *Henry Morgenthau Jr., Secretary of the Treasury. James A. Farley, Postmaster General. Louis A. Simon, Supervising Architect. Neal A. Melick, Supervising Engineer. C. H. Lindsley, Architect.*

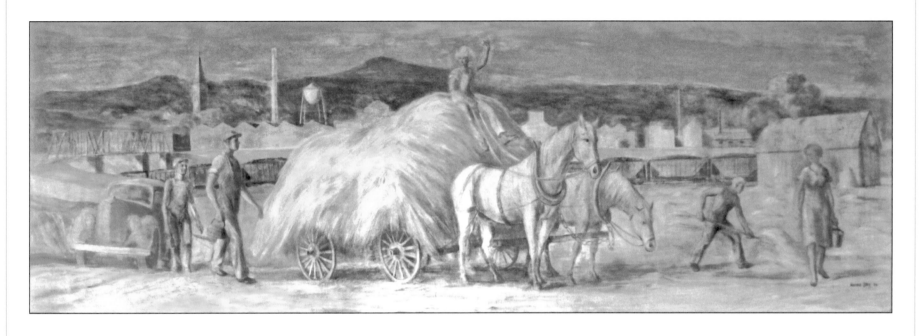

Farm and Factory, by Horace Day

The mural _Farm and Factory_ is tempera on gesso, measures 12' by 4'10", and was installed in June 1940. The mural depicts local farms and factories in early Clinton. The commission was $700.

History of the Mural

Horace Talmage Day was invited to submit a mural design based on those submitted in the Burlington, North Carolina post office mural competition. The mural would fit a 12′ by 4′10″ space over the postmaster's door. The Section laid out the contract terms:

The total to be paid for the mural is $700, which is to cover the complete cost of execution and installation, payment to be made as follows: $200 when the preliminary sketches are approved; $250 when the full size cartoon is approved; $250 when the mural is completed, installed and approved.

The artist described the composition:

The mural attempts to capture the character of this region. The theme is the harmonious relationship between industry and agriculture, with the mountains in the background. The coal mining industry not far away is indicated by the string of coal cars. In the foreground are shown the workers returning from the mill, while others in the family are bringing in the hay.

The tower is that of the Anderson county courthouse. The smokestack is of Magnet Mills, Inc. The bridge is the old one over Clinch River.

After the postmaster, in a letter dated June 12, 1940, stated that the mural had been satisfactorily installed, the artist wrote to the Section:

I have just installed the mural for the Clinton, P.O. under the supervision of Mr. Cross, the carpenter who submitted the plans of installation to you.

I did however make certain changes in the plan which I think are more satisfactory from my point of view.

Dispensed with the aluminum trim which I found was not necessary and would have detracted from the effect I wanted to create of the mural having painted directly on the wall and having only a molding of wood which is painted the color of the wall (cream color) on the bottom side of the panel.

Mr. Cross, the Postmaster, however, cannot approve this revision until it has been approved by Washington, so I am asking you now if this change is satisfactory as you know so he can give the final ok.

If you are not satisfied with this method of installation and want the trim I can have the carpenter put it on, but I am well satisfied with the mural as it is now placed and hope that you will be.

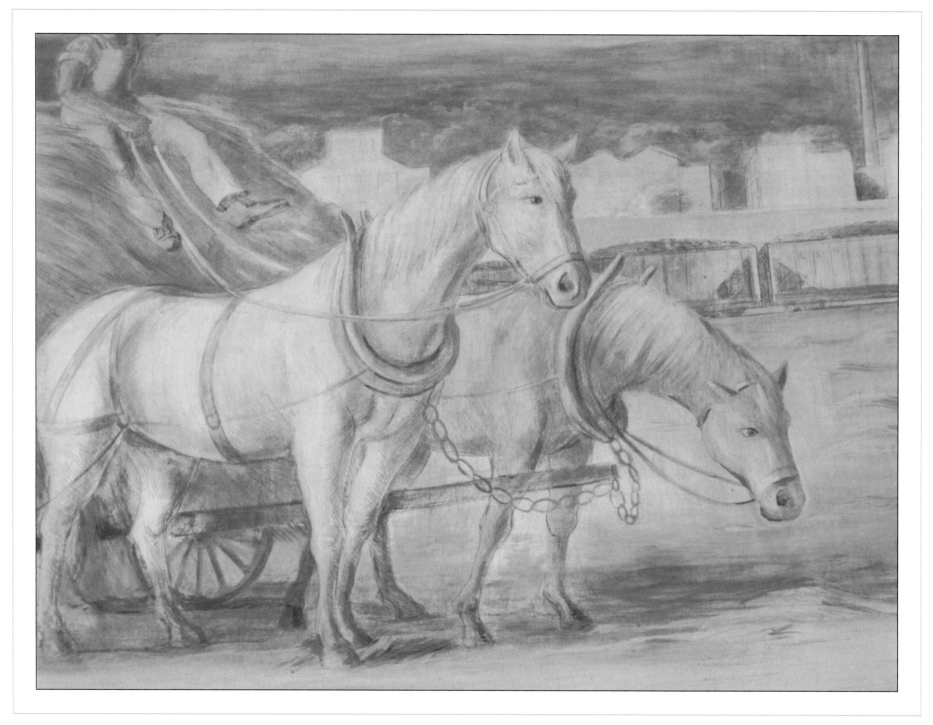

Horace Day, *Farm and Factory*

The Section replied,

The mural was not installed in accordance with the drawing previously furnished by you. The aluminum molding was eliminated, only wood molding used at bottom of mural.

The mural is very nicely fitted and is fastened to the wall with a few finishing nails. No toggle bolts were used.

While it is not installed as per drawing submitted by you, it is [the Section's] judgement that it will remain in position indefinitely without toggle bolts.

After receiving final photographs of the mural, the Section wrote back again:

I am pleased to tell you that the photographs are satisfactory. The Postmaster has been written for a statement relative to the satisfactory installation on receipt of which will be possible to prepare your letter of final settlement.

The postmaster verified that the installation was indeed satisfactory.

The artist recommended cleaning the mural only with a dry cloth and to cover the mural should the surrounding walls need to be painted.

ABOUT THE ARTIST

Horace Talmage Day was born in Amoy, China, in 1909 to missionary parents, and was awarded the commission to paint the mural for the Clinton Post Office on the basis of designs submitted to a mural competition open to artists in seven Southern states conducted by the Section of Fine Arts, Treasury Department, Washington. Day is best known for his portrait, still-life, figural, and landscape paintings.

He studied at the Art Students League in New York City and became director of the Herbert Institute of Art in Augusta, Georgia. His work appeared in many important exhibitions as well as private collections.

Day wrote an extensive guide to his thoughts on mural painting:

It is easy for an artist to assume that everyone knows what a mural painting is; however, a great many people are rather vague about the function of such a painting, so a few remarks in explanation might be in order.

A mural painting is a wall decoration for a specific space, unlike an easel picture which is independent of its setting; and it must take into consideration the architecture of the building. Murals in public buildings usually dramatize the meaning and purpose of an institution or describe in a symbolic way an ideal order.

Mural painters for generations have too often used the same stock symbols for representing justice, force, vice, virtue, etc. Many of these conventions have become as trite as the Republican elephant and Democratic donkey; and seldom have much meaning in our modern world.

With changing times new formulas must be devised to interpret the spirit of the people and the vitality of mural painting today is largely due to this awareness on the part of the artist.

In painting the mural for the Clinton Post Office I chose as my theme the harmonious relationship between industry and agriculture. Clinton has a well balanced economy not too dependent on either industry or agriculture. It is a healthy town and the mural has tried to express the well-being of this community set as it is in a valley as lovely as any in the country.

In the foreground of the painting workers are shown returning home from the mill while others in the family are bringing in the hay. In the middle distance a freight train is carrying coal from the mines not far away. By the river stands the mill where young men have been working and in the distance the mountains frame this panorama of East Tennessee.

I have endeavored to capture as much of the character of this region as possible with the space at hand. Consequently, the scene portrayed is not literal, yet it is probably more completely representative of Clinton for being composite than any single view could be.

I hope that this mural may encourage others to paint and maybe awaken a greater interest in the creative arts in this section of the state.

Day died in 1984.

SOURCES

Falk, Peter H. *Who Was Who in American Art 1564–1975: 400 Years of Artists in America*. Madison, CT: Sound View Press, 1999.

"Horace Talmage Day," Ask Art, https://www.askart.com/artist/Horace_Talmage_Day/115323/Horace_Talmage_Day.aspx

History of Clinton

Clinton is a town in Anderson County, and its population according to the 2010 census was 9,841. The town was initially named "Burrville" after Aaron Burr. However, due to Aaron Burr's arrest and trial for treason in 1807, the town was renamed "Clinton" by the Tennessee State Legislature after Thomas Jefferson's Vice President, George Clinton.

From 1895 to 1936, pearling on the Clinch River was an economic boom for the city. Freshwater pearls were in demand across the United States, and Tennessee was one of only six leading states in the pearl market. Clinton was one of three towns in Tennessee known for its pearls.

The residents of the Clinch River area at the time slowly switched from farming and husbandry to pearl hunting, according to the 1899 *The Jewelers' Circular and Horological Review* of Chattanooga. The industry didn't survive long past 1936, however, due to the construction of the Norris and Melton Hill dams by the Tennessee Valley Authority.

In 1956, Clinton was in the midst of desegregation and is famous for The Clinton Twelve, who were the first African American students to desegregate a public high school. In January of 1956, a federal judge ordered the school board to end segregation by the next semester in the fall. On August 27th, the twelve students met at Green McAdoo Elementary School and walked to Clinton High School. The walk and the unrest that followed made national news, and as a result of the desegregation, Bobby Cain was the first African American graduate of a public, integrated high school in the Southern United States.

Sources

"Clinton, TN Population," Census Viewer, http://censusviewer.com/city/TN/Clinton

"History—Anderson County Chamber of Commerce," Anderson County Chamber of Commerce, https://andersoncountychamber.org/history/

"63rd Anniversary of the Clinton Twelve," Adventure Anderson County, August 26, 2019, https://www.adventureanderson.com/blog/63rd-anniversary-of-the-clinton-twelve/

Tabler, Dave. "A 'Pearl Rush' grips Clinch River residents," Appalachian History, May 1, 2018, https://www.appalachianhistory.net/2018/05/a-pearl-rush-grips-clinch-river.html

The Former Clinton Post Office

362 N. Main St., Clinton, Tennessee 37716

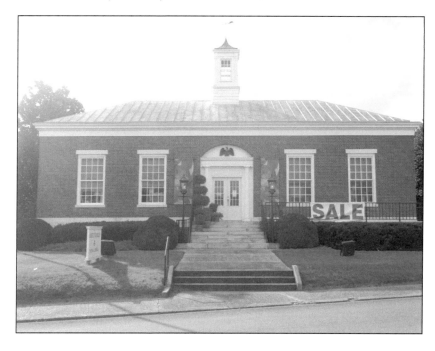

The Clinton, Tennessee, Post Office was constructed by Foley & Maugh Construction Company of McMinnville, Tennessee. The cost of the building when new was about $41,500.

The Clinton Post Office was completed in 1937 as indicated on the cornerstone on the lower left corner of the building, which reads, *Henry Morgenthau Jr., Secretary of the Treasury. James A. Farley, Postmaster General. Louis A. Simon, Supervising Architect. Neal A. Melick, Supervising Engineer.*

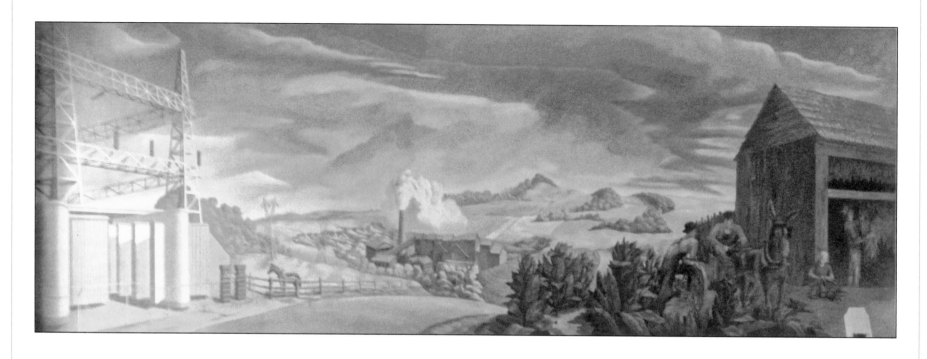

Maury County Landscape, by Henry Billings

The mural *Maury County Landscape* is oil on canvas, measures 17'3" by 6'. The mural depicts industries of Maury County: TVA generators, the phosphate industry, and a tobacco barn. The commission was $1,900.

COLUMBIA (#1)

History of the Mural

The Section laid out the requirements for the mural:

The proposed mural is to be designed for the space 17 feet, 5 inches wide by 6 feet high at one end of the public lobby over the Postmaster's door, as indicated on the enclosed blueprints. Measurements stated here are taken from the blueprints and these and the actual spaces must be verified by you as a preliminary procedure through a visit to the building or through correspondence with the Postmaster.

The total amount to be paid for the mural is $1,900, which is to cover the complete cost of execution and installation, payment to be made as follows: $300 when the preliminary design is approved; $500 when the full size cartoon is approved; $500 when the mural is one-half completed; and $600 when the mural is completed, installed and approved.

It is required that the work be completed and installed within eight months' time from the date of this letter. If it is not possible for you to undertake this work due to other obligations please advise and you will be offered a commission at a later date. The number of commissions is limited and there are numerous artists recommended for appointment on the basis of meritorious competition designs awaiting assignments. Further information for your consideration in connection with this project is attached hereto.

We hope that you will be able to undertake this project and would like the opportunity of reviewing your preliminary designs at your earliest convenience.

After Billings tentatively accepted the commission, the Section wrote back,

Thank you for your letter of May 22 reporting that you will be able to undertake the mural decoration of the Columbia, Tennessee Post Office sometime this summer or at the latest in the early fall.

The Section offers no objection to this, but I trust that once you are free to undertake a study of the subject matter you will be in a position to see the mural through to its completion. I think there is a grand possibility in using the Mule Day subject and would advise you to confer with the Postmaster. It will, of course, be necessary for you to have some photographs of the locale, etc. in order to give the subject real authenticity.

And in a later letter,

It has come to my attention that there is a yearly festival in Columbia which is held on the first Monday in April and is called

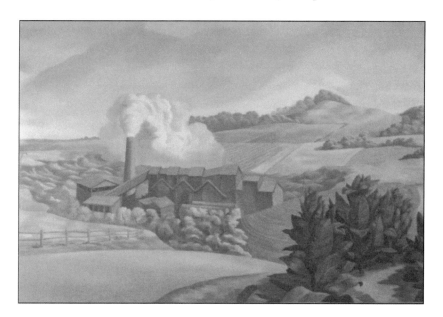

Henry Billings, *Maury County Landscape*

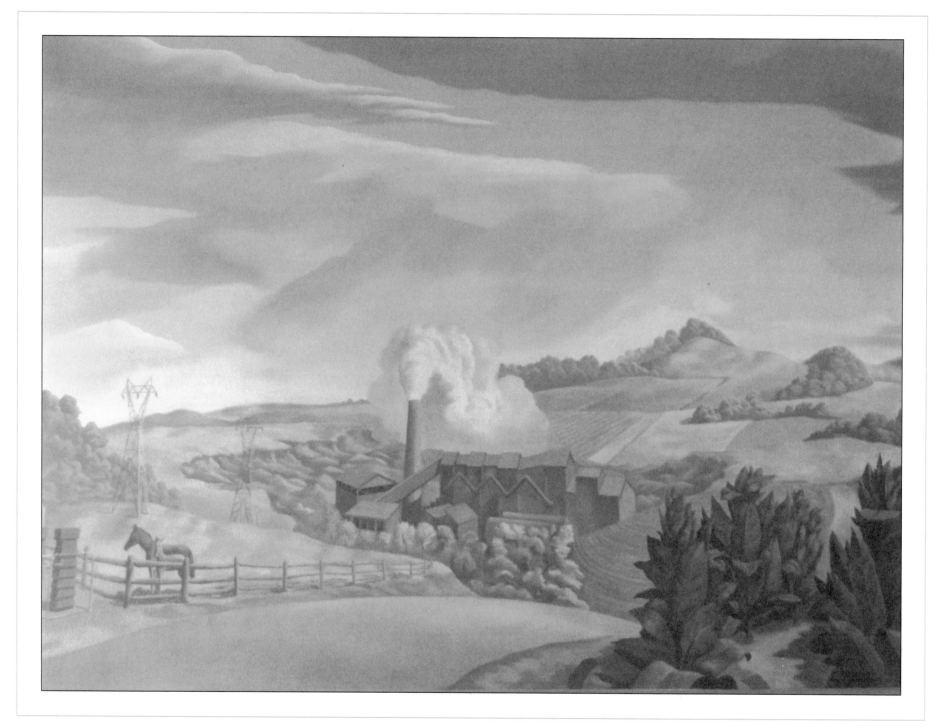

Henry Billings, *Maury County Landscape*

Mule Day. The citizens make a great to do of it, movie stars riding mule back, costumes, music, prizes etc.

It sounds like a very interesting subject and I pass it on to you for what you think it is worth. Wishing you all success.

Billings wrote back,

Greetings from the Columbia, Tennessee, Post Office and Court House.

The mural space above the postmaster's door looks like a good one. Also it is a part of the country I am very interested in.

There is a very good chance that I will be in Washington within the next two weeks at which time I would like to go over with you in detail the fine elements which might be the only thing that would hinder my formal acceptance of this commission. I hope you can postpone the decision that long and if my plans should change I will get in touch with you immediately.

But Billings changed his plans:

I find I will be unable to make the trip to Washington as planned. I am sorry about this because I would have liked to see you fellows and discuss the Columbia, Tennessee job.

I have been terribly busy this winter and have been trying to get together some paintings and drawings for a small show next autumn. I still have about three months' worth to do. The painting seems to be going very well right now and I would like to stick to it till I finish. With this in mind I wanted to ask you if it would be satisfactory for me to wait and make my trip to Tennessee in the late summer or early fall. This would still give me five months to finish the mural which I am sure I could do.

I have finally come to recognize the fact that I have a one-track mind and do my best work when I take that into account.

The Section eventually raised some concerns about the design:

One question was raised relative to cutting off the feet of the animals on the right. If it would be possible to drop the mural down to the bulletin boards on either side, this situation would be corrected. It will be appreciated if you will furnish this office with an architectural rendering in one-half inch scale in color showing the proposed placement of the mural on the wall in relation to the other architectural features.

Enclosed is a technical outline which I appreciate your filling in and returning at your early convenience. Your design is being photographed and will be returned to you under separate cover.

Billings updated the Section:

Sorry to have missed you the other day in Washington. I am glad you liked the preliminary sketch. I think I can make an interesting decoration out of it when I have finished. There are some changes I propose to make, i.e., "The animal" you referred to will be attended to. I think it would be a great mistake to bring the mural down to the bulletin boards. Having seen the lobby, I feel the space as shown in the enclosed sketch will be the handsomest.

I want to do this job as quickly as possible and am planning to start the color sketch next week.

Eventually, the Section raised some further concerns:

This [the architectural rendering] was reviewed by the architect of the building and I regret to tell you that he was considerably worried about it. He feels that architecturally designing from wall to wall is not a good solution for this particular space and that it would be much better to limit the mural space to an area which would allow a border of plaster to go around the decoration. For your information I enclose herewith a sketch which the architect prepared at my insistence for you. One of the other points which

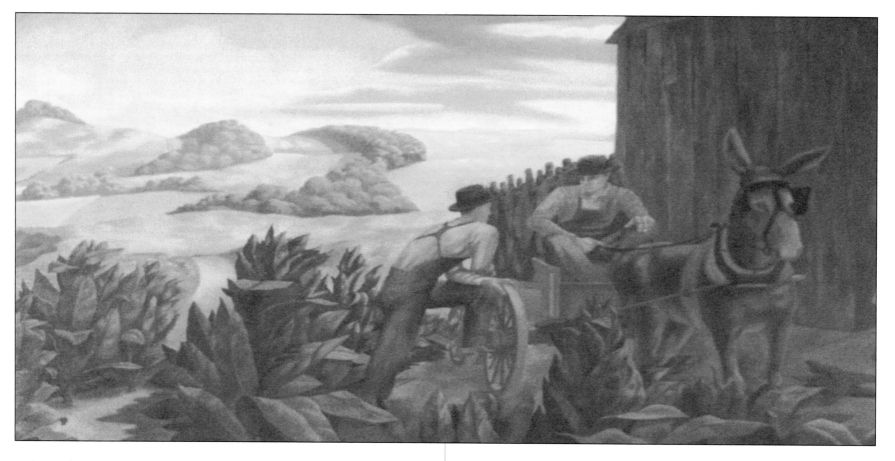

he wishes to stress is that you should avoid a too heavily defined line along the base of the mural. He also stressed the importance of continuing to work the wall color into the design.

I realize that it is a little late to call your attention to this but since you are still in the cartoon stage I am hoping that it will be possible to incorporate these new suggestions. Please let me have a word on this.

Billings suggested that he could confer directly with the architect in Washington, D.C., but

Frankly I find the architect's suggestions absurd, as well as delinquent. Tell him it is too late. If on the other hand it makes it tough on you, I'll chop off the eight inches to suit. Seriously, though, in my judgement the mural would really look best as we had planned it, and from my point of view that is the only consideration.

I have already ordered the canvas and expect to go right ahead as fast as possible so please let me know your decision soon.

Henry Billings, *Maury County Landscape*

The Section answered,

In reply to your discussion of the best procedure for the decoration in question, this office advices you to undertake the solution that you as an experienced mural painter are convinced is the best answer to this problem. I am confident that with you the subject of a little more work, one way or the other, does not enter in.

Billings reiterated his situation:

I have completed at least half the final full size oil painting. I wired Olin asking him to explain this to you, as he saw the mural last week. I also suggested that George Howe might help to straighten things out. Would my coming to Washington with the sketches help? I will be glad to help in any way I can but you understand that any change at this point means practically doing the whole job over. Let me hear from you soon.

The Section countered:

I think you will understand my position when I say that I do not wish to involve Mr. Howe in a controversy between an architect and this office during the first two weeks that he has assumed his duties. The Section is not without some blame on this in view of the fact that when you came in with the preliminary sketches and showed them to Forbes and Inslee, the architect, who was in the building, was not consulted. As you know, I was out of the office and on my return assumed from their report that the preliminaries had been taken care of. This was an oversight on my part which I admit and which I have explained to the architect.

My suggestions, since you cannot concur with the architect in reducing the size of the panel or in fading out the edges, is that you continue to introduce as much of the wall color as possible into the design and treat the foreground in the manner suggested by the architect as relayed in my letter of December 23, namely, that there be an avoidance of a too heavily defined line along the base of the mural.

Kindly proceed accordingly and submit a photograph and negative 8 x 10 of the completed work at your earliest convenience.

The Section added in another letter the following:

I have again talked to the architect and explained that you as the painter did not concur with his opinion. He is unable to concur that the kind of decoration that you are undertaking, going from wall to wall, either without a fade-out at the edges and a recall of wall color or without the border, is a suitable solution for his building.

In view of his feeling so strongly about this, is there not some compromise which you could offer in the treatment of the final painting? You realize that art is coming in for some hard knocks at this time by a great many patriotic people and for this reason we in this office are attempting to do all that we can to keep people sympathetic to the cultural program during this emergency.

I am very sorry that this has arisen, but I feel that it is essential for all concerned to know exactly where the facts stand.

Billings was undeterred:

I didn't get your letter in answer to my request for a conference with Foster until I got back from Washington past week. It doesn't really matter because I ran into a mess down there and had more to do than I possibly could finish in one short trip. I will be coming down again within ten days and will give you ample notice.

In the meantime, I am going ahead with certain parts of the mural, just as you suggested in your letter.

In a later letter, Billings describes the limitations of reproduction:

Enclosed you will find photos and negative of the mural for Columbia, Tennessee, Post Office. It is only a fair reproduction.

The area around the mural is not as dark as is shown and the electric station is not as light. I hope this will meet with the Section's approval.

The Section sent Billings a letter from Franklin Boggs that in turn recommended a Tennessee craftsman, John L. Steel, to install the mural. In the meantime, the Section requested that the postmaster temporarily store the completed mural. Eventually, however, Fred Crittenden of Brooklyn, New York, who had planned to install two other murals, made the actual installation.

The local postmaster wrote to the Section to praise the mural and its installation:

I wish to be permitted to compliment the beautiful mural, which was so splendidly installed by Mr. Fred Crittenden.

It is indeed typical of the industries of this section. This country, Maury, is known in song and story as "The Dimple of the Universe" and it is just about that.

The mural has been greatly admired by all, including several artists, and adds much to the beauty of the lobby.

The architect, though, apparently never was completely satisfied.

ABOUT THE ARTIST

Henry Billings was born in 1901 in Bronxville, New York. He is best known for modernist landscapes, illustrations, and murals. Billings studied at St. Paul's School in Concord, New Hampshire, and also at the Art Students League in New York. He eventually taught at Bard College and created most of his work while in New York.

In addition to the Columbia Post Office and Courthouse mural, Billings also painted *Golden Triangle of Trade* for the Medford, Massachusetts Post Office; *Five Scenes of Winter Sports* for the Lake Placid, New York Post Office; and *First Mill on Wappinger Creek in 1780* and *Textile Mills in Wappinger Falls in 1880* for the Wappinger Falls, New York Post Office.

Billings died in Sag Harbor, New York, in 1985.

SOURCES

"Henry Billings," Ask Art, https://www.askart.com/artist_bio/Henry_Billings/20083/Henry_Billings.aspx#

Falk, Peter H. *Who Was Who in American Art 1564–1975: 400 Years of Artists in America.* Madison, CT: Sound View Press, 1999.

History of Columbia

Columbia is the seat of Maury County in Tennessee just south of Nashville. The census population in 2010 was 34,681. It prides itself on being the "mule capital of the world" and has a Mule Day parade each April as a result of its large agricultural and livestock economy.

Maury County was founded in 1807, and just a year later, Columbia was planned out and lots were sold. It wasn't incorporated, however, until 1817. Economically, it was a rich agricultural center and helped Maury County become the richest county in Tennessee in the early 1800s.

James K. Polk moved there as a child and had a law practice as an adult before he became president in 1845.

The Battle of Columbia during the Civil War was a series of small skirmishes that took place from November 24 to November 29, 1864, which ended in a victory for the Confederates. Fortunately, there were no official casualties recorded.

As a result of its agricultural prosperity, Mule Day began in 1840 as Breeder's Day, which was a meeting for mule breeders in the area to sell and show off their livestock. In 1933, Thomas Marion Brown was responsible for the creation of the day as an annual celebration and parade that would bring attention and income to the county. With the help of W. D. Hastings of the *Daily Herald*, the first Mule Day was on April 2, 1934. The event ceased for years after World War II, but was re-established in 1974 by the Maury County Bridle and Saddle Club. It has been held annually every year since.

SOURCES

Adgent, Nancy L., "Battles at Columbia," *Tennessee Encyclopedia*, March 1, 2018, https://tennesseeencyclopedia.net/entries/battles-at-columbia/

"Columbia," *Encyclopædia Britannica*, August 2, 2011, https://www.britannica.com/place/Columbia-Tennessee

"Columbia, TN Population," Census Viewer, http://censusviewer.com/city/TN/Columbia

"The First Mule Day: 'A Voice from the Past,'" *Columbia Daily Herald*, April 15, 2015, https://www.columbiadailyherald.com/news/local-news/first-mule-day-voice-past

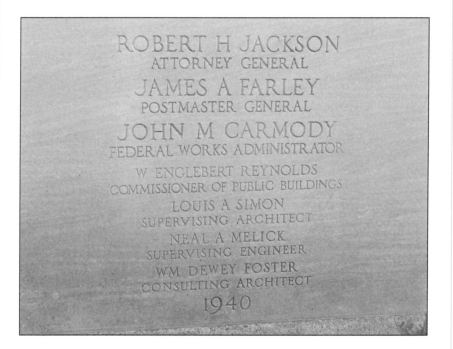

The Former Columbia Post Office

815 South Garden Street, Columbia, Tennessee 38401

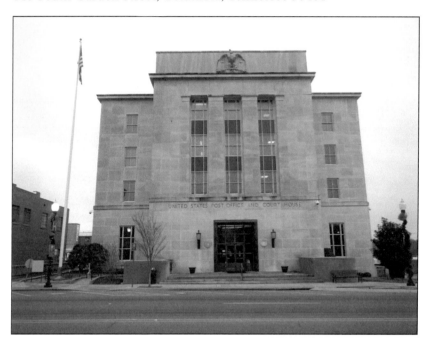

The Columbia Post Office and Courthouse was constructed by H. W. Henke Construction Company of Chicago, Illinois. The cost of the building when new was about $330,000.

The Columbia Post Office and Courthouse was completed in 1940 as indicated on the cornerstone on the lower right corner of the building, which reads, *Robert H. Jackson, Attorney General. James A. Farley, Postmaster General. John M. Carmody, Federal Works Administrator. W. Englebert Reynolds, Commissioner of Public Buildings. Louis A. Simon, Supervising Architect. Neal A. Melick, Supervising Engineer. W. M. Dewey Foster, Consulting Architect.*

American Eagle, by Sidney Waugh

The *American Eagle* is marble, measures 9' by 6' and 3' deep, and was installed in September 1940. The commission was $1,500. The carving was executed by the Georgia Marble Company.

History of the Mural

The Section sent Waugh the following requirements:

The decoration will consist of a model for an American eagle for the main facade of the building. The model will be carved in marble by others. The full size model will be approximately nine feet wide by six feet high with a three foot projection. The amount to be paid for a sketch model, full size model in plaster and shipping to the quarry or site as directed is $1,500. The time limit is most important in the execution of this model in order not to delay the construction of the building. Consequently the delivery of the full size model will be required forty-five days from the date of your acceptance of this project....

You will note from the blue prints which will be forwarded to you tomorrow that the position and composition of the eagle will be very similar to that on the Federal Reserve Bank Board Building, Washington, D.C.

After a number of messages to the Section, Waugh tried to clarify the situation:

I fear that the convenient but deceptive instrument, the telephone, has played us false again. I hope that the enclosed photostat and this letter will set matters right.

Your telegram, received this morning, states "Quite certain we can increase projection of upper blocks one inch." What I meant to ask for was an increase in the projection of the outer blocks by one foot. I have since remeasured the model, which is now in a more advanced stage of development, and find that an increase of 6" at the top of the outer blocks will be sufficient. I think that this is clearly indicated on the enclosed photostat, and urgently request that it have the approval of the necessary powers. Without this increased projection it would be very difficult to properly design the wings of the eagle. I'm expecting Mr. Williams Dewey Foster here on Monday, but hope that either he or you will give me a confirmation of the day and hour.

The Section did raise some concerns:

The decision finally on the stone joint at the base of your sculpture seems to be that it will not be possible to change the jointing from that indicated in the blue prints. I pointed out the complications which you and I discussed if the joint were left this way but it was not considered feasible to make the changes. We shall have to follow the carving through carefully and will you keep this in mind in finishing your model.

Waugh later wrote about possible changes:

Thank you for your telegram of September 13. I had been working so continuously on the model of the eagle for Columbia, Tennessee, Post Office that your suggestions, made with a fresh eye, were very useful. I thoroughly agreed with them all, they have been carried out, and the casting by the end of the week, and allowing a day or two for the plaster to dry, the model should be ready for shipment early next week. Will you please let me know the address to which it is to be delivered.

The shipping of the model to the carvers encountered some problems, however, as noted by the Georgia Marble Company:

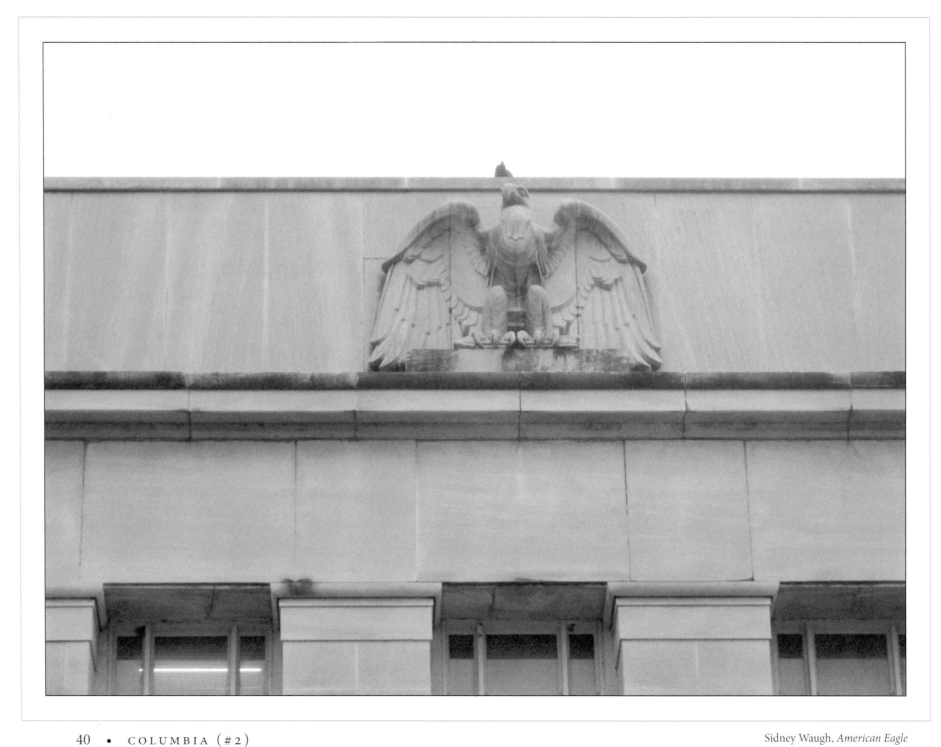

Sidney Waugh, *American Eagle*

In this connection we wish to again call your attention to the fact that we have not yet received any notice of shipment of "Eagle Model." Until we receive this model practically nothing can be done towards the preparation of the large blocks required for this work, and the carving of Eagle is also going to take a considerable length of time. We will appreciate anything you can do to expedite shipment of this model.

The model finally was received, and Waugh wrote:

I am in receipt of your letter of April 24th enclosing a photograph of the carving in marble of my eagle model on the facade of the Courthouse at Columbia, Tennessee. Although the picture is too vague to make it possible to judge of the execution of the detail, it seems to me correctly carried out as regards proportion, and good as to scale and general effect.

As the funds appropriated for this work were unfortunately insufficient to cover the expense of a personal inspection, we will just have to pass it as it is. I would be grateful to you if you could go through the necessary motions to bring about a final settlement of the contract.

About the Artist

Sidney Biehler Waugh was born in 1904 in Amherst, Massachusetts. He is best known as a sculptor, designer, and teacher. Waugh studied at Amherst College and MIT, in addition to spending time in Europe, France, and Italy.

His art has been exhibited in museums such as the Metropolitan Museum of Art and the Chicago Art Institute. Waugh's career spanned three decades as the artistic director of the Steuben Glass Company. Waugh also created *Stage Driver 1789–1836* for the former Federal Post Office Department Building.

Waugh died in 1963.

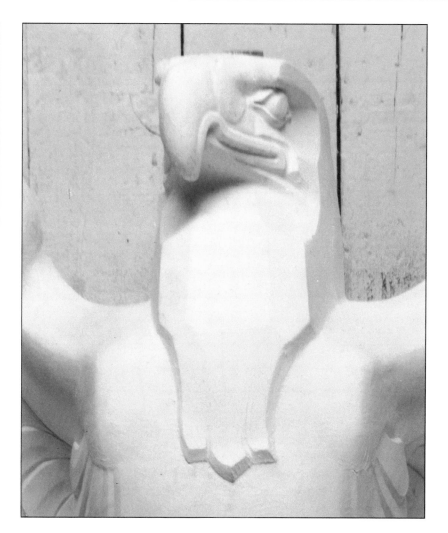

Sources

Falk, Peter H. *Who Was Who in American Art 1564–1975: 400 Years of Artists in America*. Madison, CT: Sound View Press, 1999.

"Sidney Biehler Waugh," Ask Art, https://www.askart.com/artist_bio/Sidney_Biehler_Waugh/60635/Sidney_Biehler_Waugh.aspx#

Sidney Waugh, *American Eagle*

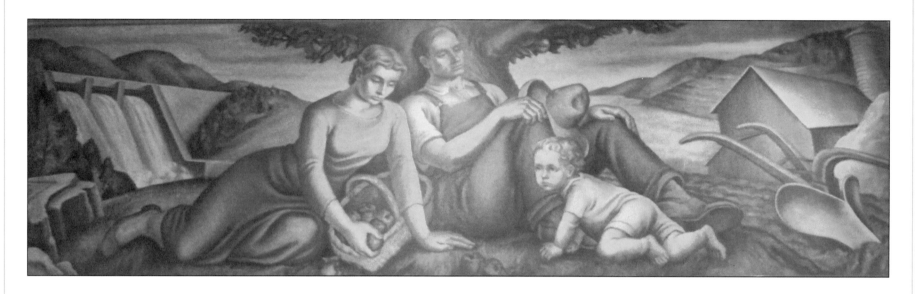

The Partnership of Man and Nature, by Marion Greenwood

The mural *The Partnership of Man and Nature* is oil on canvas, measures 13' by 4', and was installed in January 1940. The mural depicts a man, woman, and child in the foreground and a dam and farm with plow in the background. The commission was $700.

CROSSVILLE

History of the Mural

After being invited to submit a design for a mural that would be installed in the post office lobby, Greenwood wrote back to the Section:

I hope it will be possible for me to visit the actual building in the near future, to become more familiar with the space involved. Any variations in the dimensions of the panel could only be determined after that. I will inform you as soon as I can arrange this.

The Section suggested that Greenwood confer with other artists concerning the actual installation:

Relative to the installation, I am pleased to say that Miss Grace Ames has been invited to paint a similar mural for a post office in the same region. It might be possible for both of you to get in touch with several artists who will be installing in that area about the same time and have one capable craftsman install your several murals in order to cut down on the general expense. This of course, applies only to work which is done on canvas.

After some preliminary work, Greenwood wrote about her plans:

I am sorry this work was unduly delayed. Because of recent and rather severe eye strain it was impossible for me to work for quite a while.
 The design I am submitting shows a family enjoying ease and leisure against a background of ploughed fields, silos and a barn. To the right is suggested the conservation of water, forest, and soil.... Man directs the turbulent current into a dam, from which the river flows out into a peaceful fertile, Tennessee landscape. The

harnessing and integration of power is symbolized by the...dynamo and factory chimneys. Stacked wheat suggests abundance.
 After considering many other subjects I chose this, not only because it seems to me the most significant subject for a Tennessee mural but because when I visited the T.V.A two years ago, I gathered material and therefore feel familiar with it.

The Section responded with some concerns:

In our opinion much of the material is appropriate to the locale, but it is our feeling that the symbolic figure of the man placed over the dam is contradictory to the realistic life approach used elsewhere through the design. It is our suggestion that you take the family group under the tree, with farm, etc., and on the left represent the farm and on the right use the landscape of the dam and river without symbolism. It is our opinion that this would prove much more convincing to the people for whom the mural is designed. It is also our feeling that the design aesthetically could be improved by such treatment.

After reviewing a two-inch-scale color sketch, the Section still had concerns:

While we consider the landscape interesting and the general treatment of color satisfactory, the central figure of the farmer is obviously forced and presented without conviction. Would it not be better to have the man sitting in a more natural position at his ease than to conform the figure to fit a certain arbitrary pattern? It occurs to us that it would be possible to do so without loss of the architectural rhythm which apparently was your aim. The

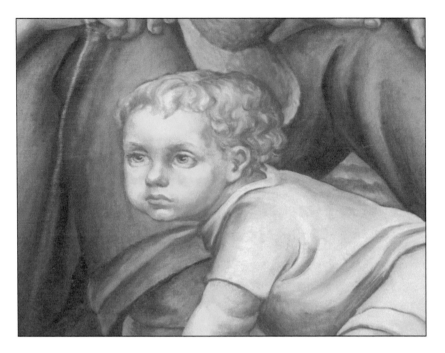

treatment of the child was not satisfactory due to the inadequacy of his costume.

A Section member was especially critical:

It strikes me that the central group is a bit forced in its artiness and that the baby, especially in the head, is far from satisfactory. The man is all pose it seems to be and there is a good deal of pose in the woman too. Would it not be possible to be just as artistic and a little more natural? I do not find the central group satisfactory but especially the man and the baby.

Greenwood responded to the critique:

I will revise the position of the farmer according to the requirements of the Section, although I of course cannot agree that the farmer is either "artificial" in posture or "floating in space" since he

is resting on a grassy knoll which would have been more evident in the finished mural.

I am glad I can change these things on the full size cartoon and I hope the result will be satisfactory to the Section.

The Section defended its views:

It is noted that you do not concur with the opinion of the members of the Section that the figure of the farmer is forced in position in order to conform with the particular rhythm which you wish to emphasize in the design.

I wish to assure you that the opinion of this office was not lightly given since we were aware of the rhythm and compositional qualities which you wished to achieve, but were decidedly of the opinion that these could still be retained and the figure made to conform to the pattern with more subtlety than indicated in your sketch. We

Marion Greenwood, *The Partnership of Man and Nature*

are acquainted with a number of Renaissance murals, for instance, in which latter is unquestionably the case.

You must be aware that great respect is entertained here for your achievements, but when we see the figure of a man in an otherwise realistic approach twisted unnaturally and floating in space in order to fit into a certain design, it is our feeling that the full possibilities of the composition have not been taken advantage of by the artist. In other words, we prefer artificiality to be dispensed with.

I am pleased that you are changing the costume of the child.

Greenwood, however, was not convinced by the Section's reasoning:

I beg to disagree with the Section about the actual figure of the farmer being the least bit forced in position. I have the crayon drawing of it here; as I study it any change in his posture would certainly be at the loss of the architectural rhythm necessary to all mural designs.

If the architectural pattern is not uppermost in the muralist's mind and if (as your letter suggests) the ease and naturalness of the position is more important than the composition, then what would be the difference between mere illustration and a mural?

If the figure of the farmer did appear to me unnatural, I certainly would change it, but my aim throughout this design was especially that of a plastic restfulness combined with understatement of gesture, movement stressed through counteracting lines of composition. The arrangement is the final result of innumerable drawings experimenting with various structural designs for the given area.

The costume of the child, however, can be changed to suit convention, without hurting the composition.

If the Section still feels the farmers figure must be changed, I would like to suggest that the net result would be more satisfactory if I tackle it on the full size cartoon as the tedious miniature preliminary work finally deletes away feeling of mural quality.

Greenwood apologized for the delay in sending a new sketch since it required a new direction in addition to her heavy work commitments from other sources. She described the limitations of the tempera sketch:

The color scheme of the sketch is worked out to harmonize with the surrounding color which I find indicated on the blue prints. The final mural however, will be more luminous in color than the opaqueness resulting from the tempera in the sketch.

I plan to go away the middle of May until the end of July, so unless I could finish this mural before then I will have to complete it when I return. I therefore thought it advisable to name September as the month to complete and install the mural.

Greenwood finally satisfied the Section:

The revisions which you have incorporated over the sketch following the suggestions of the Section are regarded as satisfactory. Your cartoon is approved and I am pleased to enclose herewith a voucher covering the payment due you at this stage. Kindly proceed with the further painting and submit a photograph and negative of the completed work before undertaking the installation.

Greenwood requested a two-month extension of her contract since, because of prior commitments, she would be unable to complete the installation on time. The Section granted her request.

The local postmaster wrote about the mural after its successful installation during the weekend of January 30:

The mural was satisfactory in every way and was installed perfectly and it is certainly a real addition to the decoration of the lobby as well as the building and I continue to hear many favorable comments on same by the people who look at it daily and I am attaching hereto a clipping from the Crossville Chronicle, *that appeared*

on the front page of this paper on February 22, 1940, in regards to same which is self-explanatory.

ABOUT THE ARTIST

Marion Greenwood was born in 1909 in New York City. She is best known for her easel and mural paintings. She studied at the Art Students League, New York City, and then exhibited in Zivy Gallery, Paris, in 1929. She spent two years in Mexico, where she received a commission from the Mexican government to paint an 86′ by 12′ fresco mural for the University of Morelia Michoacán. From 1934 to 1936, she completed four fresco murals, covering 3,000 square feet in the Civic Center in Mexico City. Her murals in the United States include one on Ellis Island and one in Camden, New Jersey. Greenwood's biography appeared in *Who's Who in Art* and *Women of the Nation*. She was a member of the National Society of Mural Painters, the Mural Painters Guild, and the Artists' Congress.

From 1954 to 1955, she was a Visiting Professor of Fine Arts at the University of Tennessee, and while there painted a mural for the school that depicted the music, dance, and folklore of Tennessee.

She died in 1970 in Woodstock, New York.

SOURCES

Falk, Peter H. *Who Was Who in American Art 1564–1975: 400 Years of Artists in America*. Madison, CT: Sound View Press, 1999.

"Marion Greenwood," Ask Art, https://www.askart.com/artist_bio/Marion_Greenwood/20302/Marion_Greenwood.aspx#

History of Crossville

Crossville is the seat of Cumberland County and as of the 2010 census, the population was recorded as being 10,795. Crossville, once known as Scott's Crossroads, was established atop the Cumberland Plateau and, as its name suggests, is a junction for multiple highways, including 68, 70, 127, and 101. It also has easy access to Interstate 40, which runs from North Carolina all the way to California. The town was originally developed at the junction between two well-traveled stage roads, and U.S. Route 70 and U.S. Route 127 largely follow these old paths.

After the Civil War, timber and coal were some of the most prominent products produced by the area. The Tennessee Central Railroad came through in the year 1900, which allowed Crossville's goods to be shipped and made available to a much larger population. The first train arrived in September of that year, but the depot building wasn't completed yet, so a boxcar was used until it was finished. Unfortunately, the depot burned down in 1925 on Valentine's Day.

Under the New Deal, the Subsistence Homestead Division of the Department of the Interior established the Cumberland Homesteads. This provided housing and the ability to farm for over 250 families in the area. Although the project was ended in 1940, the Homestead houses are still in existence today, considered to be some of the most desired properties in Cumberland County.

SOURCES

"About Crossville," Downtown Crossville Inc., http://www.
downtowncrossvilleinc.net/about-crossville

Brookhart, G. Donald, "Cumberland County," *Tennessee
Encyclopedia*, March 18, 2018, https://tennesseeencyclopedia.
net/entries/cumberland-county/

"Crossville, TN Population," Census Viewer, http://censusviewer.
com/city/TN/Crossville

"The Crossville Depot," The Crossville Depot, http://www.
thecrossvilledepot.com/

"Cumberland County Essay," Teach TN History, http://
teachtnhistory.org/file/Cumberland%20County%20Essay.pdf

"Cumberland County," Walton Road, http://waltonroad.com/
historic-context-1

"Cumberland Homesteads Tower Association," Cumberland
Homesteads, https://cumberlandhomesteads.org/

The Former Crossville Post Office

2 South Main St., Crossville, Tennessee 38555

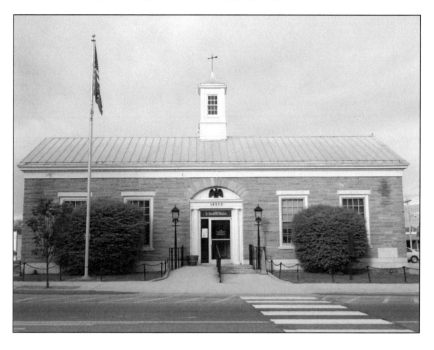

The Crossville Post Office was constructed by Ray M. Lee Company, of Atlanta, Georgia. The cost of the building when new was about $70,000.*

The Crossville Post Office was completed in 1937 as indicated on the cornerstone on the lower right corner of the building, which reads, *Henry Morgenthau Jr., Secretary of the Treasury. James A. Farley, Postmaster General. Louis A. Simon, Supervising Architect. Neal A. Melick, Supervising Engineer.*

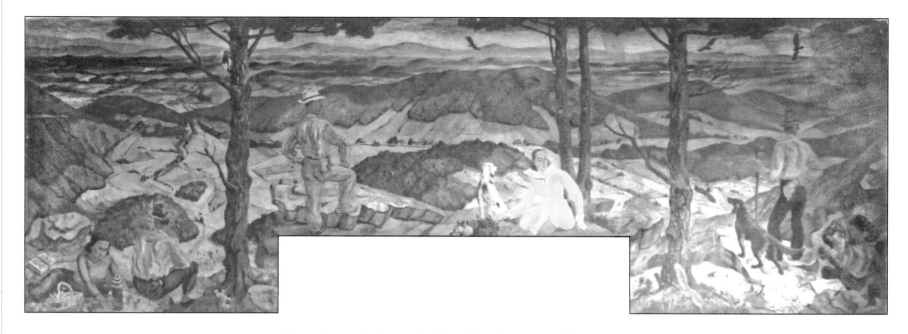

View from Johnson's Bluff, by Bertram Hartman

The mural *View from Johnson's Bluff* is oil on canvas, measures 12' by 4', and was installed on June 12, 1939. The mural depicts a popular location in Dayton referred to as Johnson's Bluff. The commission was $700.

DAYTON

History of the Mural

Hartman described the inspiration for the mural:

It is a development of a painting I made from Johnson's Bluff overlooking a wide expanse of the Tennessee River Valley founded on the horizon with mountains, the Great Smoky Mountains far in the distance.

Dayton lies just beyond the first wooded range of hills.

After the initial communication with the Section, Hartman expressed some concern for his expenses:

Thank you for your letter and blueprints inviting me to submit designs for a mural painting for the Dayton, Tennessee, Post Office.

I think it very important in order to do a good job, to visit Dayton and get the feeling of the country and the people, and to see the building and exact space for the mural.

In doing the mural for the Oneonta, New York Hospital I was allowed all my traveling expenses and as Dayton is a thousand miles away, I inquire if there is any provision for lessening the expense of the trip.

Also does the contract mean installation at my expense of the mural which would mean another trip?

The Section responded,

I regret however to inform you that there are no funds available in this office other than a mural reservation which could be used for transportation expenses on the part of the artist. Further, the installation of the mural must be taken care of under the mural reservation.

My suggestion is that since the Post Office is one of the usual types it would not be necessary for you to make the trip to Dayton, before submitting your designs unless, of course, you feel that the available material on the locale is not sufficient for your purpose. May I suggest that you write to the public librarian for further information on Dayton. It might be possible for him or her to furnish you with adequate material.

Hartman eventually did manage to visit the post office: "One feels T.V.A in the air in Tennessee. It seems a poor and beautiful country with great potentialities and possibilities and it is all that I am trying to express in my mural."

The Section wrote to the artist in regard to the preliminary design:

These have been considered by the members of the Section and it is our feeling that the design which includes the panoramic landscape from Johnson's Bluff would be the more appropriate and acceptable for the building. The sketch which you submitted does not indicate a great deal but we feel as stated above that it has possibilities. We would be interested in knowing [more about] the two figures overlooking the landscape. My suggestion is that you develop this design further, preferably in a 2-inch scale color sketch and submit to this office for our further consideration.

The Section wrote to the artist after receiving a new sketch:

Your design has been considered by the members of the Section and while the color suggested by the water color medium was not particularly liked we have confidence in your ability to strengthen this when the work proceeds in oil. The two men with their backs to the

spectator did not seem particularly interesting and I wonder if you would consider moving the one with the gun possibly over to the tree on the right and presenting him in profile in order to make the work a little more interesting. You may proceed with the full size cartoon a photograph of which should be forwarded to this office for further consideration. No doubt in the cartoon you will be able to introduce small floral motifs in the immediate foreground which will further add to the interest of the work.

Hartman responded,

The foreground will of course have floral detail to make it interesting.
Painting in oil the color will have a depth & richness difficult to achieve in water color. I think your feeling about dropping the end down in the direction of the bulletin boards is advisable and I shall proceed with the cartoon in that manner.
By dropping each side one foot brings it within 2 inches of the bulletin boards. I shall send a photograph of the cartoon as soon as possible.

After the Section received photographs of the work in progress, it wrote back:

The photographs are satisfactory for our purpose and indicate that you are developing the work in a most interesting manner. It is indeed gratifying to watch the development of this panel under your hands and I trust that the actual painting will continue this blossoming.

To which the artist responded, "I am very happy that you are pleased with the development of the panel and you can be assured the painting will be a blossoming."

After approving the mural for installation, the Section noted that

Bertram Hartman, *View from Johnson's Bluff*

The painting appears spirited and free and there are a great many delightful details which you have incorporated to achieve further interest. I am confident the work should be well liked in Dayton.

Hartman was concerned about the logistics, however:

I have your letter of May 16th stating the official authorization for me to install the mural in the Post Office at Dayton, Tennessee has been forwarded to me.

I hope it may arrive soon as I would like to plan leaving here on June 2. I have written the Postmaster about advice on finding help to install the mural but he seems not in the mood for answering letters.

The Section suggested retaining local help for installation:

I wish to suggest in case you do not hear from the Postmaster in reference to an experienced technician that on your arrival in Dayton you confer with some of the paperhanging establishments there to see if they can suggest an individual capable of assisting you in this work.

Hartman was able to retain a "native painter" to help with installation.

After the installation, the local postmaster wrote about the mural's reception:

The mural at this office was installed on June 12th and is very satisfactory to the patrons in general. Of course, there is some criticism, but that is to be expected, and as a whole the people are very proud of this painting.

There was a small write-up in the Dayton Herald *about the mural and I am enclosing this clipping so you may see what was said about it.*

The Section congratulated the artist:

Your approach is a reflection of the deep understanding which you have for human nature. I am often impressed with the fact that through the ages it remains very much the same and I am convinced that the most general tendency among people who have enough to eat and a place to sleep is an effort to be kind and to live in peace. The tribute which has been given your mural in this simple little article brings that message back to me.

Your final settlement is being undertaken.

ABOUT THE ARTIST

Bertram Hartman was born in Junction City, Kansas in 1882. He is best known for modernist landscape and cityscape paintings.

Hartman studied at the Art Institute of Chicago as well as in France.

Hartman's work can be found in several museums, including the Metropolitan Museum of Art.

A local Dayton newspaper ran an article about Hartman after he painted the mural:

Mr. Hartman came here last September and visited scenic country around Dayton for the inspiration of the painting. He turned down even Lookout Mountain in Chattanooga, for he said:

Bertram Hartman, *View from Johnson's Bluff*

"There are not many scenes so beautiful as this view of the Tennessee River Valley, in all the places I have been. The hills, the river and rocks—all make a wonderful setting for a study of nature's beauty. I would like to return to this country some day and put miles of the scenery on canvas with a brush."

Mr. Hartman also expressed deep appreciation for the kindness and interest of the local boys for showing him around the country, and for the companionship of Jim Hughes, a local painter, who accompanied him on many trips to the mountains and the river.

Hartman inquired whether there were further possible mural commissions from the Section:

Because of my success with this mural naturally I am desirous for another commission. Is there no other possibility for me than through the competition?

I have seen some New York Post Offices, with wall spaces ripe for murals. After my painting of the city scene for so many years, I feel I could give a significant expression to the life and tempo of the New York City of Today as it relates to the functions of the Post Office.

Unfortunately, the Section could not help him:

Your request for a further commission for a mural work under this program has been noted. There are no commissions available at this time, but I wish to urge you to submit a design in the 48 state Post Office mural competitions as announced in the last bulletin, as we wish the best talent of the country represented.

Relative to the fine mural spaces in the New York, Post Offices which you refer to, the commissions have either been previously given out or no funds are available for the decoration of the buildings in question. You are aware that there is no lump sum which can be used for these decorations but that one percent of the total limit of cost becomes available on most new buildings for such consideration.

Hartman died in New York City in 1960.

Sources

"Bertram Hartman," Ask Art, https://www.askart.com/artist/ Bertram_Hartman/1204/Bertram_Hartman.aspx

Falk, Peter H. *Who Was Who in American Art 1564–1975: 400 Years of Artists in America.* Madison, CT: Sound View Press, 1999.

History of Dayton

Dayton is the county seat of Rhea County, located in southeastern Tennessee. The town was originally known as Smith's Crossroads, but was renamed Dayton in 1877 after Dayton Ohio. The 2010 census listed the population at 7,191.

Dayton Iron and Coal Company was established in 1883–1884, and by 1887, the facility had two furnaces in operation and spent most of its resources creating "coke," a fuel that is an essential part of iron production. The company employed hundreds of people from the mines to the foundry in the 1880s and 1890s on into the early 1900s.

In 1925, Dayton was the location of the infamous Scopes Monkey Trial, in which John Scopes was tried for teaching Darwin's theory of evolution in school. The trial was a publicity stunt designed purely to challenge the recently passed Butler Act that made teaching evolution a misdemeanor. The trial resulted in a guilty verdict which caused John Scopes to be fined $100. The Butler Act was unaffected.

A reenactment of the trial as a play and festival is held every year in July. The prosecutor in the case, William Jennings Bryan, has a college named after him that was built in 1930. He died just five days after the trial ended in 1925.

In 1947, the Tennessee Strawberry Festival was founded, featuring a strawberry queen pageant and two parades. It's been held every year

since and has a variety of activities and foods, from strawberry treats to fresh produce, games, and live entertainment.

Today, Dayton has a small manufacturing economy, from automobile parts to furniture.

Sources

Benton, Ben, "Mining History," *Chattanooga Times Free Press,* March 4, 2011, https://www.timesfreepress.com/news/news/story/2011/mar/04/mining-history/43958/

"Dayton," *Encyclopædia Britannica*, November 29, 2011, https://www.britannica.com/place/Dayton-Tennessee

"Dayton, TN Population," Census Viewer, http://censusviewer.com/city/TN/Dayton

Gannett, Henry. "The Origin of Certain Place Names in the United States," U.S. Government Printing Office, 1905. https://books.google.com/books?id=9V1IAAAAMAAJ&pg=PA101#v=onepage&q&f=false

Hughes, Zora, "Strawberry Festival in Tennessee," traveltips.usatoday.com, https://traveltips.usatoday.com/strawberry-festival-tennessee-107185.html. 2 January 2020.

"Scopes Trial: Definition, Results, and Significance," History, https://www.history.com/topics/roaring-twenties/scopes-trial

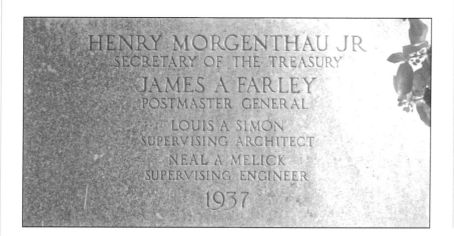

The Former Dayton Post Office

400 Main St., Dayton, Tennessee 37321

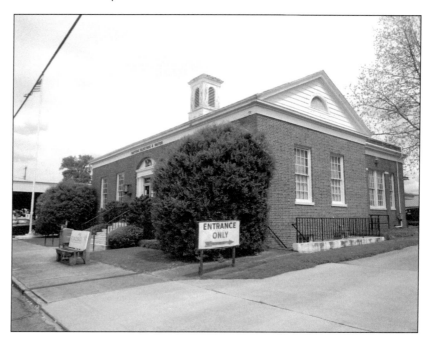

The Dayton Post Office was constructed by Algernon Blair. The cost was about $45,168.

The Dayton Post Office was completed in 1937 as indicated on the cornerstone on the lower left corner of the building, which reads, *Henry Morgenthau Jr., Secretary of the Treasury. James A. Farley, Postmaster General. Louis A. Simon, Supervising Architect. Neal A. Melick, Supervising Engineer.*

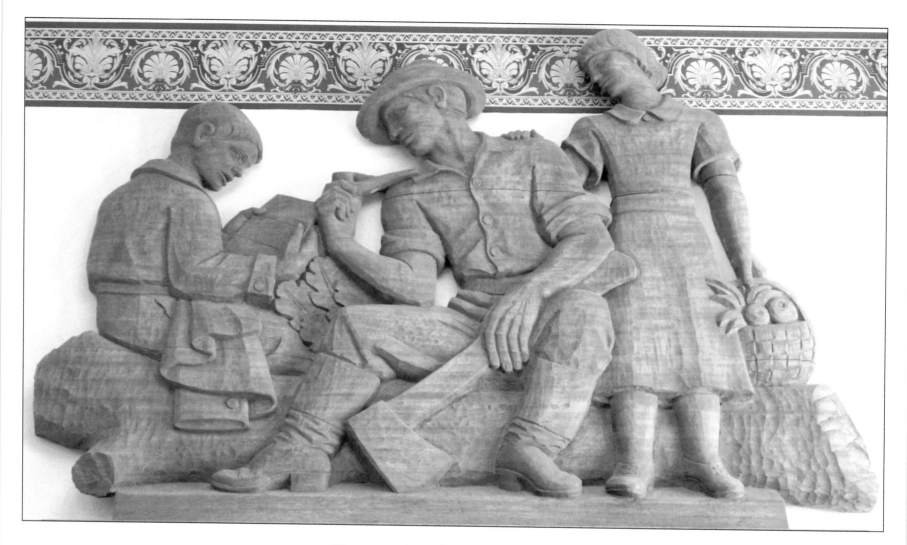

News on the Job, by Enea Biafora

The sculpture *News on the Job* is mahogany wood, measures 3'9" by 5'6", and weighs about 100 pounds. The carving depicts three people seated on a log. The carving was installed in October 1940. The commission was $750.

DECHERD

History of the Mural

Biafora described the carving in a newspaper article:

The decoration shows a woodsman as he pauses in his work at the noon hour. His children have brought him a basket lunch and the boy reads him a letter received at home that morning. The sculpture is in high relief carved directly in mahogany wood, with the lively, clear cut of the chisel giving the work a movement and vitality.

Before Biafora could begin work on the sculpture, the Section made some suggestions:

The proposed sculpture relief is to be situated at one end of the public lobby over the Postmaster's door as indicated on the enclosed blue prints. In sculpture projects of this type we have found that the most successful solution has been arrived at by the sculptors who have considered the end wall of the lobby as an architectural unit and have designed their sculpture as an accent related to both the wall space and the architectural elements.

It is not intended to suggest that the whole end wall be covered with a sculpture relief.

In general, the most successful decorations for spaces of this type have been silhouetted reliefs applied to the wall or, if with a background, installed so that the background of the relief is flush with the surface. The latter method of installation must be carefully studied so that the weight and depth of the relief may safely be carried by the wall. Frequently a central relief with flanking motifs has been successfully used. In the opinion of the Section the dimensions of the relief are not as important as the suitability of the form of the sculpture in relation to the space to be decorated.

Biafora wrote back to the Section:

In accordance with your invitation of March 8, for the sculpture relief for the Decherd, Tennessee, Post Office, I am sending you two pencil sketches for your choice. I have been seeing the 18th Street Post Office in New York City which is similar, and I have had great consideration for the architecture and the wall space in making my drawings. I wish to hear from you soon.

And again:

In answer to your letter of May 17 concerning the medium to be used for the sculpture relief, I intended to use a composition of dextrin, plaster and burlap, reinforced with iron, in order to obtain a faithful reproduction of my work. This composition is very strong, as strong as cast-stone, as well as very light and easy to apply on the wall. In the sculpture section of the W.P.A. Art Project this is largely used as the most satisfactory medium for interior sculpture. For my part I would prefer this composition to cast-stone.

The Section, however, was not receptive to Biafora's ideas:

Your suggestion of the use of dextrin and plaster as a medium for your sculpture relief will not be acceptable for your Decherd, Tennessee, Post Office sculpture. We suggest a more permanent material for your consideration. Your contract information is being held accordingly and your proposed method of installation is being returned to you for revision as doubtless the method will be changed to suit the new medium. The type of installation which you propose is not considered suitable by our engineers due to the

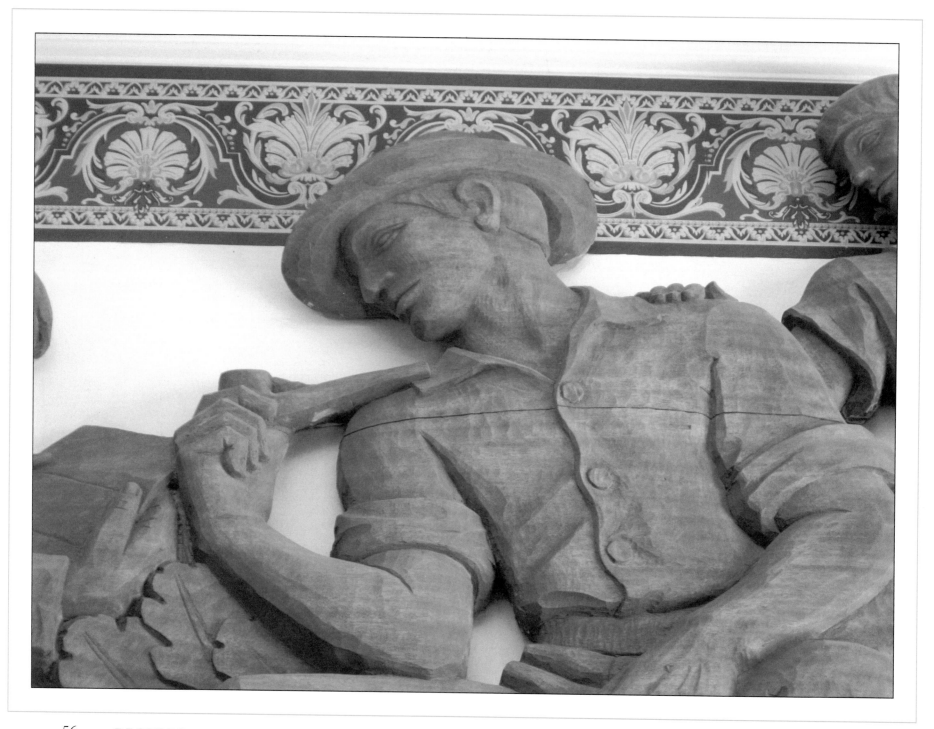

Enea Biafora, *News on the Job*

difficulty of insuring a satisfactory bond while the cement is setting. The use of toggle bolts according to the enclosed method is recommended instead.

The Section later also had some concern about the figures:

The sculpture design, we feel has been improved in the photograph of the half size model which you submitted although it is thought that the foreshortening of the leg of the seated man and the placement of the foot of the girl is still unsatisfactorily solved and details such as the pipe approach caricature which seem out of character with the rest of the sculpture.

After looking over additional sketches, the Section still had reservations:

We feel that rather than use either of the symbols suggested by you which have become rather trite by repetition it would be well for you to look into the history and local character of Decherd, Tennessee, in the hope that more interesting material might be suggested for the sculpture. We do not feel that either of the designs submitted by you would represent your sculpture at its best.

And again:

The general criticism made of both designs, however, was that the figures did not have either the character or dress of an American farm family which presumably you intended to indicate. Doubtless these details you can take care of in developing the design.
We felt that the overhang of the leg at either side of the door was unfortunate and would be more successful if cut off in relation to both the sculpture composition and the doorway. The placement of the woman's feet we also thought was very awkward and the scale of the boy seemed out of relation to the other figures. Details such

as the pipe and the musical instruments seem to lack authentic flavor and would hardly seem characteristic of what one might be expected to find in Decherd, Tennessee.

After the cartoon was sent, the Section replied,

Your full size cartoon has been reviewed and while we feel that it is a distinct improvement over the previous designs and more convincingly realized, there are still several elements which we feel need further study before proceeding with the work.
The hand and posture of the arm holding the pipe seem unreal. The two feet of the woman and the nearest feet of the seated man are still out of drawing. It is thought also that the irregular broken form of the leg at either end might more convincingly explain the presence of the ax if the terminations were cleaned up.
I am sorry but we feel that it will be necessary for you to submit a revised drawing showing alternate treatment of the arm of the man and further study of the feet.
We feel that the decoration would be more satisfactory executed in wood, both in the suitability of theme and the wall space. We feel that the character of the work might lend itself more successfully to carving than to modeling. Will you let me know if you wish to reconsider the medium and execute the work in wood rather than cast stone.

After Biafora made additional changes, the Section finally was satisfied:

We were very much pleased with the revisions made in your design for the wood carving and are also pleased that you are executing it in mahogany. Your patience and courtesy with our suggestions are certainly appreciated and we are altogether happy with the results.

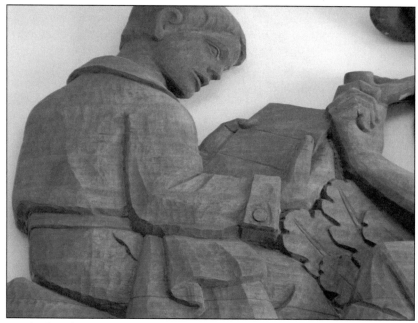

The local postmaster confirmed the successful installation:

In reply to your letter concerning the installation of the sculpture over the Postmaster's door in this Post Office I wish to advise that Mr. Enea Biafora, the sculptor, was here on October 25, 1940 and installed the work in accordance with the instructions as set forth in your letter of August 5, 1940 addressed to him.

The sculpture was attached to the wall by puncturing the shell of the partition blocks on the lobby side and using toggle bolts to hold it in place.

ABOUT THE ARTIST

Enea Biafora was born in San Giovanni-in-Fiore, Italy, in 1892, and received his early training there. When he was a boy, his father—also a sculptor—taught him the basic principles of design, and later he attended the Institute of Fine Arts in Naples.

After immigrating to America, he continued his studies with George Barnard, Paul Manship, and Malvina Hoffman. Biafora was well-known for his commissions for the Federal Government as well as state and local authorities for public building decorations; he also embellished churches and many private buildings. One of his bronzes, *The Centauress*, was acquired for the permanent collection of the Metropolitan Museum of Art.

The artist was a resident of New York when commissioned for the sculpture in Decherd, Tennessee.

SOURCES

"Enea Biafora," Ask Art, https://www.askart.com/artist/Enea_Biafora/10004454/Enea_Biafora.aspx

Falk, Peter H. *Who Was Who in American Art 1564–1975: 400 Years of Artists in America*. Madison, CT: Sound View Press, 1999.

History of Decherd

Decherd is a small town located in Franklin County, Tennessee. The population was 2,246 according to the U.S. census of 2010.

In 1851, the Nashville and Chattanooga Railroad was completed, running through the land of Peter S. Decherd, who gave the railroad right-of-way only on the condition that a railroad depot be built close to his family's plantation.

The city plan was made in May of 1853, which showed the rail lines, streets, lots, and depot. Even though the town had merchants and even a law office by 1854, it wasn't incorporated until the 31st General Assembly of the State of Tennessee. Some sources state that the town was originally incorporated in 1868; this actually was the second time the town was incorporated, albeit with an expanded charter.

In 1885, the incorporation of the city was repealed, possibly because of the "Four Mile Law," which allows sales of liquor within four miles of schools in incorporated cities only. No official record of this being the reason is known to exist. The town was not incorporated again until April 22, 1901.

Union General Don Buell made his headquarters in Decherd in 1862. During the Civil War, nearly 300 yards of railroad between

Decherd and Cowan were destroyed by Union troops under the command of Colonel John T. Wilder.

Trains still pass through Decherd several times a day; however, the train depot and the passenger trains that had stopped there for nearly a century are gone.

Sources

"Decherd," Franklin County Chamber of Commerce, July 7 2015, https://www.franklincountychamber.com/index.php/cities/decherd

"Decherd Timeline," Decherd.net, http://www.decherd.net/files/132989717.pdf

"Decherd, TN Population," Census Viewer, http://censusviewer.com/city/TN/Decherd

HENRY MORGENTHAU JR
SECRETARY OF THE TREASURY

JAMES A FARLEY
POSTMASTER GENERAL

LOUIS A SIMON
SUPERVISING ARCHITECT

NEAL A MELICK
SUPERVISING ENGINEER

1939

The Decherd Post Office

205 E. Main St., Decherd, Tennessee 37324

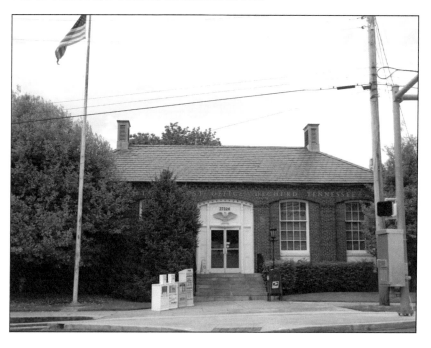

The Decherd Post Office was constructed by Andrew & Dawson of Montgomery, Alabama. The cost was about $44,164.

The Decherd Post Office was completed in 1939 as indicated on the cornerstone on the lower right corner of the building, which reads, *Henry Morgenthau Jr., Secretary of the Treasury. James A. Farley, Postmaster General. Louis A. Simon, Supervising Architect. Neal A. Melick, Supervising Engineer.*

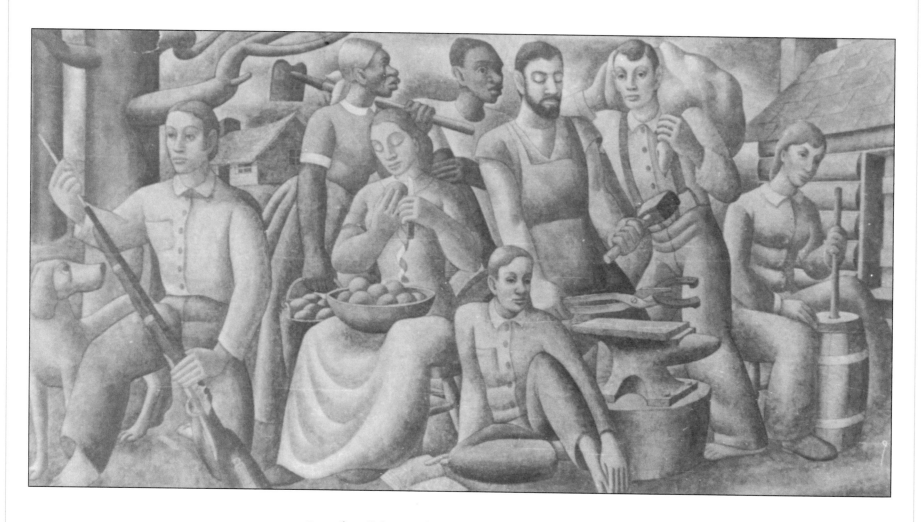

People of the Soil, by Edwin Boyd Johnson

The mural *People of the Soil* is a fresco (painted directly onto the plaster), measures 10' by 5', and was completed on December 14, 1938. The mural depicts a family of early settlers. The commission was $610.

DICKSON

History of the Mural

Johnson sent the Section three pencil sketches—"People of the Soil," "Tennessee Pioneers," and "Rural Free Delivery"—in order of his preference. The Section wrote back:

Permit me to acknowledge the receipt in this office of three black and white studies representing your proposals for the mural decoration of the Dickson, Tennessee, Post Office.

First of all, I want to congratulate you on the beautiful drawing which you have introduced in this work and to tell you that I personally feel that I sense real growth and development in your work. It is always gratifying to have this happen and I am pleased to be able to tell you so.

It is noted in your letter that you prefer developing one of the designs other than that of the Postman on the horse with the family group. Considering the locale, the subject matter presented in this sketch would probably prove the most acceptable to the people of Dickson, but in view of your interest in developing one of the other designs, this office offers no objection to your proceeding with the design depicting the family group with a small boy on a horse. I suggest, however, that if you proceed with this design that you send a photograph of the proposed decoration to the Postmaster of Dickson and obtain his reaction to the work purely for the standpoint of subject matter.

Enclosed is a technical outline which I would appreciate you filling in and returning to this office. Your designs are being photographed and will be returned to you in the near future.

After receiving a two-inch-scale sketch, the Section, though generally positive, made some suggestions:

I was particularly pleased to note the fine attitude of the Postmaster in suggesting that you use the material which you felt you could achieve the finer work of art. The sketch which you have submitted is indeed very handsome and is to be preferred over the design showing the early Postman. The only suggestions offered relative to the second sketch are that the foot of the man on the right might be raised very slightly so that the extremity of the toe is not cut off by the enframement. The same is true of the hand and foot of the seated figure in the center. On the extreme left the shirt of the woman with the churn also should not touch the enframement as this tends to end the composition a little too abruptly.

Johnson became concerned after conferring with the postmaster:

Under separate cover I am sending you a color sketch for the Dickson, Tennessee, Post Office mural. This is the design that I did not want to execute, but it was selected by the Postmaster and I suppose that his word is final.

The other designs submitted were far superior and were more suitable for mural decoration than this one. However, if I am compelled to carry out the Postmaster's choice, then I must fill out a new technical outline as this design is not adaptable to fresco and should be painted either in oil or tempera.

Please allow me to express my opinion on this matter. It seems to me that if the Government desires to embellish its buildings with the best works of contemporary painters and sculptors, the matter of selecting the designs should be left entirely to a jury of artists rather than to the layman whose appreciation of art is usually of the magazine, bill board or calendar cover caliber. I know that art appreciation in the South is not far advanced but we are not helping the situation by giving them the mediocre design they have

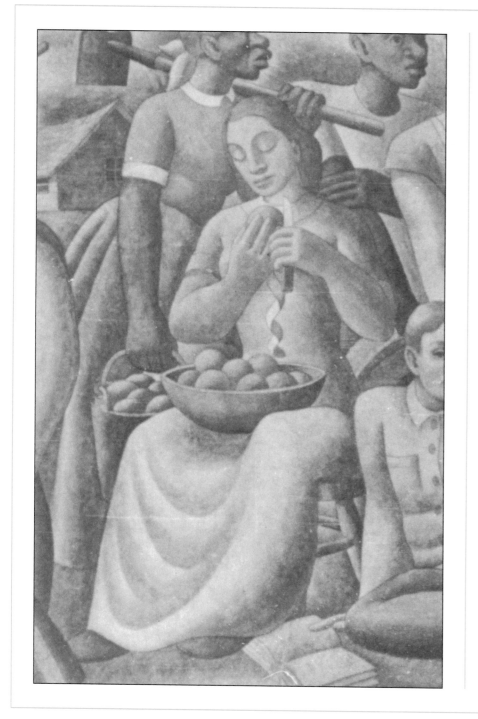
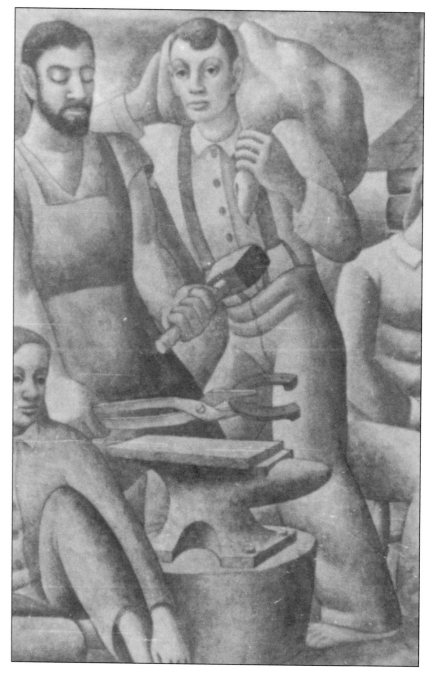

Edwin Boyd Johnson, *People of the Soil*

chosen. If I were not so conscientious about my work it would not matter so much but since I am the most severe judge and critic of my own work, you can understand why I object to carrying out a design that is "weak" and ordinary in conception.

I would appreciate your opinion on this subject before going further. I do not mean to criticize your department so please do not misinterpret the meaning of this letter.

The Section wrote to the postmaster, hoping to intercede for the artist:

May I suggest, before proceeding with the full size cartoon of this work, that you await the reply from the Postmaster. I shall hold the technical outline as well as the contract until the matter is definitely settled. The only suggestion which we would offer relative to the design is that the pony seems a little small in relation to the figures.

In a later letter to the postmaster, the artist pointed out that

It seems we are having a rather difficult time deciding upon a design for your building since you have selected the one sketch that has been considered by artists of repute as second rate. I am therefore returning the photographs of all designs for your reconsideration because I think you will agree that the other two are far superior and will be appreciated by a greater number of people. If you feel that the titles are not appropriate, they may easily be changed.

Since the mural is to be viewed by many people of varied professions and personalities, I cannot stress too much the importance of selecting a design that will meet with the approval of those who have devoted their lives to the study and appreciation of Fine Arts.

I wish to state also that it is to my own interest, as an artist and a native of the State, to produce a work that I consider a worthy fruit of my talent and training.

I trust that you will not feel offended at this trend of affairs and will write me in full your reaction towards this matter.

Eventually, the postmaster left the choice to the artist:

Replying to your letter of the 19th in regard to the mural for the Dickson, Tennessee, Post Office, I wish to state that I do not see any material difference in the three pictures and either one of them will suit me OK. Either one of them that you select will be satisfactory with me, as you know more about the pictures than I do, and I feel that it will be to your interest to pick the one best suited for this office.

Johnson updated the Section on the design:

You will note that I have taken the liberty of changing the drawing of the dog, which I believe is an improvement. I am ready to proceed with the mural if the cartoon meets with your approval, the materials are on hand and the weather conditions are ideal for painting fresco.

After installation of the mural, the postmaster wrote that "the mural he installed is very satisfactory, and we have quite a bit of comment from both white and colored patrons. It really adds very much to the beauty of the lobby." Johnson recommended that the fresco not be cleaned often, "though it can be brushed lightly or washed with a gentle spray of clean water when necessary. Soaps or chemicals should not be used.... Varnish [is] not required for fresco."

About the Artist

Edwin Boyd Johnson was born in Watertown, Tennessee, in 1904, and was raised in Nashville, Tennessee. He is best known for mural and easel paintings. He studied at the Watkins Institute, and later graduated from the Art Institute in Chicago. He also studied at the National Academy of Design in New York City, where he won a number of scholarships, and in Europe for two years, where he received instruction from noted masters.

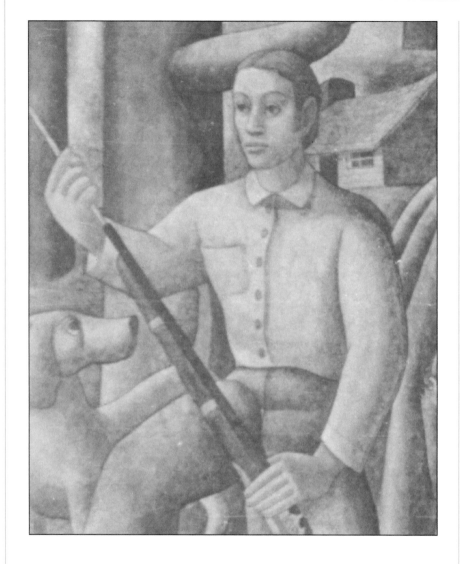

His post office mural was the only fresco painting known at the time in Tennessee. In addition to the Dickson Post Office mural Johnson also painted *Air Mail* for the Melrose Park, Illinois Post Office and *The Old Days* for the Tuscola, Illinois Post Office.

Johnson died in Nashville, Tennessee in 1968.

SOURCES

"Edwin Boyd Johnson," Ask Art, https://www.askart.com/artist_bio/Edwin_Boyd_Johnson/108858/Edwin_Boyd_Johnson.aspx#

Falk, Peter H. *Who Was Who in American Art 1564–1975: 400 Years of Artists in America.* Madison, CT: Sound View Press, 1999.

History of Dickson

The city of Dickson, though located in Dickson County, is not the county seat. The county was created by the Tennessee General Assembly on October 25, 1803. Both the city and the county were named after Congressman William Dickson. The U.S. census of 2010 put the population of Dickson at 14,538.

Located in western Middle Tennessee, much of Dickson's history is tied directly into the history of the county itself. Dickson was a railroad town founded in 1862 by the Union Army, gaining new immigrants from the North after the Civil War. It was initially named Sneedville, but was renamed Dickson in 1873, due to there already being a Sneedville in Hancock County, Tennessee.

Two railroad branch lines ended in Dickson and, as a result, caused it to become the primary economic center of the county. Charlotte, the county seat then and now, suffered as a result, and its population as of the 2010 census was only 1,235.

Dickson County shared its county seat between Dickson and Charlotte until 1927, when it reverted back to a single county seat at Charlotte.

U.S. Route 70, known as the "Broadway of America" Highway, runs through Dickson, as does Interstate 40 which extends from Wilmington, North Carolina to Barstow, California.

SOURCES

Carey, Bill, "Our Forgotten Names," *Tennessee Magazine*, March 2014, https://www.tnmagazine.org/our-forgotten-names/

"Charlotte, TN Population," Census Viewer, http://censusviewer.com/city/TN/Charlotte

"Dickson County, TN," Dickson County TN, https://www.dicksoncountytn.gov/history.html

"Dickson, TN Population," Census Viewer, http://censusviewer.com/city/TN/Dickson

Hellman, Paul T., *Historical Gazeteer of the United States*, Routledge, February 14, 2006, https://books.google.com/books?id=REtEXQNWq6MC&pg=PA1010

Jackson, George E., "Dickson County," *Tennessee Encyclopedia*, March 1, 2018, https://tennesseeencyclopedia.net/entries/dickson-county/

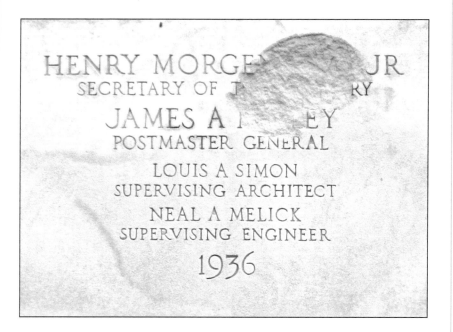

The Former Dickson Post Office

215 W. College St., Dickson, Tennessee 37055

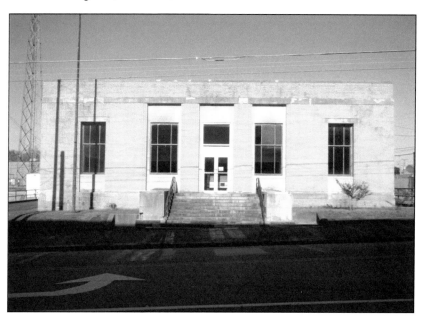

The Dickson Post Office was constructed by Nile E. Yearwood of Nashville, Tennessee. The cost was about $54,890.

The Dickson Post Office was completed in 1936 as indicated on the cornerstone on the lower left corner of the building, which reads, *Henry Morgenthau Jr., Secretary of the Treasury. James A. Farley, Postmaster General. Louis A. Simon, Supervising Architect. Neal A. Melick, Supervising Engineer.*

Retrospection, **by Minnetta Good**

The mural *Retrospection* is oil on canvas and measures 13'6" by 5'10". It depicts the historical courthouse as well as other notable historical themes from Dresden's past. The commission was $580.

DRESDEN

History of the Mural

Good described her plans to visit Dresden:

My plans to visit the Dresden, Tennessee, Post Office have been somewhat delayed—but now believe I can say that I am leaving here Saturday and that I expect to be in Dresden sometime Monday August 30 and Tuesday, possibly longer—and will get all the information and so forth that I will need. I hope you can notify the Postmaster of my visit as I would like to go over the plans with someone there.

In my spare time have been digging out at the public library what local history I could find of Dresden and Weakley county and Tennessee in general. Haven't been able to get very much about the county—but [have] hopes of getting more down there.

After visiting the post office, Good reported her findings:

I found that the door to the Postmaster's office is between two bulletin boards which are the same height—not like the blueprint—and so have planned my designs for the whole space from top of bulletin boards and door to the ceiling.

The designs go back into the history of the county—which seemed to me to be richer in inspiration than present day Dresden.

Personally, I prefer the one marked A.

The Section replied,

I am pleased to tell you that the two designs have been considered by the members of the Section and the Supervising Architect and they are approved. You may proceed with a two-inch scale color sketch, preferably of the one marked "A." The treatment is unusual and we believe that it will be an amusing addition to our program. I would like to warn you to simplify where ever possible in order to avoid any over spotting and confusion.

Every confidence is placed in you, however, as a creative artist perfectly aware of these dangers.

After receiving the sketches, the Section offered some suggestions:

It was felt that the train on the right of the panel was rather a large element and could well be relegated into further distance. The foreground figures on both right and left were regarded as rather large in scale and we would like you to consider reducing them somewhat. This does not apply to their placement as it is felt that you probably need your elements as high in the composition as indicted in the present design. The main criticism offered [about] the design is that the right and left elements are too clearly marked off from the central area. Could you not relate them somewhat more by the possible introduction of figures along the fence in front of the house or even in the yard of the house; I personally feel, as I look at the design, as though you were working for an all over pattern and had not quite realized it in the center area. It is also suggested that the log cabin indicated on the extreme right be eliminated....

Please know that these criticisms and suggestions are offered with great sympathy for your work.

After reviewing another sketch, the Section continued to offer suggestions:

It is our suggestion that distortions in the drawing of the figures, animals, stage coach, etc., be avoided in the larger work. It is also suggested that the cabin on the extreme right be entirely eliminated.

Minnetta Good, *Retrospection*

The architecture of the central building must, of course, be carefully studied in the final work.

Good wrote to the Section with a new problem:

I wonder if you can help me? You recall that I am using an early model of the Court House at Dresden, Tennessee, in the cartoon of my mural.

No one in Dresden had any picture old or new of the Court House but when I was in Nashville, Mrs. J. T. Moore—head of the State Library there—showed me an early picture of the Court House and offered to have a Photostat made of it and have it sent to me when I wanted it. I have written to her three times, am still without the Photostat—now what I wanted to know—do you know if such things exist in Washington—photo records of Court Houses throughout the country?

I am almost in despair—if she hadn't offered to have it done, I might have planned the mural otherwise.

The Section wrote to Moore, asking her to help the artist, but in the meantime suggested that Good check the New York Public Library. However, Moore came through and sent a photograph of the courthouse to Good, which helped her complete the mural.

The Section wrote to Good:

Permit me to acknowledge the receipt in this office of the photograph of your completed mural for the Dresden, Tennessee, Post Office.... [T]he work has been carried out very satisfactorily and I congratulate you on the charm and beauty of the general composition, and have authorized you to proceed with installation. You have done a grand job. I am very proud of it with you and I am sure that it will be well received by the public of Dresden.

The postmaster confirmed the mural's installation and reception:

I am pleased to advise that the installation of the mural in the Dresden, Post Office building has been completed by Miss Minnetta Good, and is entirely satisfactory.

Would like to say that the mural is beautiful and very appropriate for this office, it is highly appreciated by the good people of this city, and that we feel very grateful to the Treasury Department for furnishing this office with such a wonderful painting.

ABOUT THE ARTIST

Minnetta Good (also known as Minetta Good) was born in 1895 in New York. She is best known for her landscape, still-life, figurative, and mural paintings. Good received her training from Cecilia Beaux and the Art Students League.

Good exhibited her works at the Pennsylvania Academy of Fine Arts, the Art Institute of Chicago, and the Corcoran Gallery of Art, among other venues. Good was a resident of New York City at the time she was commissioned for the mural in Dresden.

Good died at the age of 51 in 1946.

SOURCES

"Minnetta Good," Ask Art, https://www.askart.com/artist/Minetta_Good/73653/Minetta_Good.aspx

Falk, Peter H. *Who Was Who in American Art 1564–1975: 400 Years of Artists in America*. Madison, CT: Sound View Press, 1999.

History of Dresden

Dresden is the seat of Weakley County and was incorporated in 1825, two years after Weakley County was created. The population as of the 2010 census was 3,010.

Originally the home of the Chickasaw Indians, the city was named after a town in Germany which was the home of the father of one of the first settlers of the area, Meas Warner. He was sent to survey and plan the township. The city was originally built on two different pieces of property, one a gift of 39 acres from John Terrell and the other 17.5 acres bought from Simpson Orgon and Ewing Wilson.

Nashville and Northwestern Railroad constructed a line that went through Dresden in 1861, connecting Dresden to Martin and Gleason.

During the Civil War, General Nathan Bedford Forrest raided Dresden just after Christmas on December 26, 1862 with approximately 200 troops. The intent of the raid was to capture Senator Emerson Etheridge, but he was absent. As they left town, they destroyed the railroad bridge south of the town. It wasn't until 1907 that the line was replaced with modern upgrades.

In 1948, Bay Bee Shoe Company was established and was one of the first industries to be located in Dresden. The very next year, the Dresden Manufacturing Company was established, making it one of two major industries to come to the area.

Since its incorporation in 1825, the city has been reincorporated and its charter changed and amended multiple times, with the most recent change being in 1980.

SOURCES

"About Dresden," City of Dresden, https://www.cityofdresden.net/community/about-dresden/

"Civil War Dresden, TN Raid," Tennessee History Blog, https://tennesseehistoryblog.wordpress.com/civil-war-dresden-tn-raid/

"Dresden, Tennessee," Discover Weakley, https://www.discoverweakley.com/dresden

"Dresden, TN Population," Census Viewer, http://censusviewer.com/city/TN/Dresden

"Dresden, TN," Weakley Co. History, https://weakleycountyhistory.com/dresden-tn/

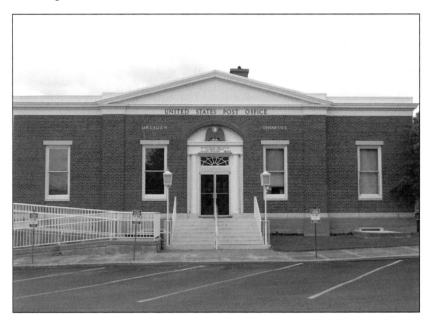

The Dresden Post Office

122 Maple St., Dresden, Tennessee 38225

The Dresden Post Office was constructed by James C. Miller of Campbellsville, Kentucky. The cost was about $44,490.

The Dresden Post Office was completed in 1936 as indicated on the cornerstone on the lower left corner of the building, which reads, *Henry Morgenthau Jr., Secretary of the Treasury. James A. Farley, Postmaster General. Louis A. Simon, Supervising Architect. Neal A. Melick, Supervising Engineer.*

Gleason Agriculture, by Anne Poor

The mural *Gleason Agriculture* is oil on canvas and measures 13' by 5'. The mural depicts workers at the Gleason train station loading and inspecting sweet potatoes. The commission was $700.

History of the Mural

Poor wrote to the Section after some preliminary research:

I am glad that you think the agricultural theme suggested by the Postmaster is an adequate subject. I get to Washington probably in just about two weeks; having seen the locality itself will have given me, I hope, some more definite ideas. We are still in Idaho but slowly but surely inching east and will see you soon. In the meantime best wishes.

The Section later replied,

Thank you for your letter of April 27 reporting on the happy reception which you were given by the Postmaster in Gleason, Tennessee.

You are indeed very fortunate and I look forward with great interest to the preliminary sketch with which I wish you all success.

It is noted that you now intend to paint the mural on canvas and on its completion install it in the building.

This procedure is quite satisfactory. I suggest that you use the white lead and Damar varnish adhesive unless you have the work installed by a craftsman thoroughly familiar with the Dextrine Asbestos. Kindly furnish this office with a sample of the canvas which you intend to use.

In a later letter, the Section generally was pleased with the design:

The explanation of the right hand section of the panel seems entirely logical and I am pleased that the suggestions offered in my letter were regarded as justified. We are all confident that you are going to paint a very handsome mural.

Poor wrote back about simplifying the process:

If this sketch seems fairly clear and logical to you and if as you say due to many considerations time is of the essence, do you think it possible that the second cartoon stage of the work could be done directly on the canvas? This would greatly simplify procedure as in any case I will be painting in color over a completely finished drawing. This drawing I would then photograph for your approval before proceeding to the actual painting.

Does this seem feasible to you? I personally would welcome this way of working not only because of importance of the time element but because I think it will produce a much better result. Whatever your decision I will soon be at work preparing the canvas, a sample of which I will send to you.

The Section wrote regarding a damaged sketch:

Permit me to acknowledge the receipt in this office of your preliminary sketch for the Gleason, Tennessee, Post Office. I regret to tell you that due to improper packing the design was completely broken across on the left and the lower right hand corner was injured. The remains, however, indicate that you have an exciting start on the interesting theme stressing the industry of the sweet potato. This is particularly apparent in the handsome decorative border which you have suggested. It is our feeling that the center and left hand sections are coordinated more convincingly than the right hand section is to the remainder of the panel. For instance, the figure on the extreme right does not seem psychologically caught up with the kneeling figure before him as is quite definitely the case with the figures on the left.

I feel too that it would be well to bring out the fact that the theme is that of the sweet potato. I had forgotten just what vegetable you were dealing with and Forbes and I thought possibly the theme was concerned with peaches. I think this idea was further advanced by the presence of the delicate little tree on the right.

It is our feeling that the trees in front of the station might be treated more generously. Forbes and I both felt that the elements in back of the figures on the right need additional explanation. Perhaps it is your intention to clarify this material in the larger scale.

There is a charming lyricism suggested in the foreground, central section, and it is my hope that this will be retained in the progress of the work.

Poor later expanded on her plans:

I am sending along the color sketch for the Gleason Post Office. I hope that the subject matter and theme more or less explains itself....

The two men standing in front of the cold frame...beds are examining the sweet potato seedlings; the man standing to be a portrait of the Mr. Hawks who started the industry.

....As their plants are ready for shipment in the spring and as the shipping of the plants seems to be a festive occasion for most of the town, I want to concentrate simply on those two subjects and make the whole panel as gay and busy as possible.

The station is Gleason Station done from sketches on the spot, which ought to interest the citizens. As you can see on the left, workers are handling and packing the baskets onto rail cars.

I hope this will prove satisfactory. I want particularly to thank you for your permission to proceed with the drawing directly on the canvas. This gives me greater liberty in regards to time as I will be able to study the details.

I am enclosing a sample of the canvas I am using. I think it is a very fine canvas on all counts. It is Belgian linen and looks very durable to me. I hope you will agree.

I am at work laying out the drawing on the canvas as I have received the returned sketch. I cannot understand how it could have been so damaged. I will see that you receive another undamaged sketch.

Thank you very much for your fine suggestions.

She wrote yet another letter about possible changes:

In your letter of May 23rd you make a number of suggestions that I think are well taken. I am studying them and feel I'll solve these in the cartoon....

...I realize with the character and detail of the background there must be more done in roughly working it out and when this is done I hope this will come out satisfactorily.

After some back and forth, the Section authorized the final painting:

The photograph indicates that the work is continuing to grow in its progress and I particularly wish to congratulate you on your handsome achievement in revisions incorporated in the right hand section. This now is one of the most beautiful and meaningful passages of the entire design.

Two minor suggestions are offered for your consideration in proceeding with the final painting which you may now do. One is that the boy with the basket, center of the composition, and the seated girl in the center are almost too similar in the drawing of the heads. Perhaps a little more variation would prove more entertaining, especially since the types are rather unusual. The second suggestion is in relation to the need of a little more explanation of the relation of the table or truck on which the girl is seated and the platform against which the boy with the basket is leaning. It is my opinion that the solution has not been convincingly presented.

After the mural was finished, the Section wrote about its concerns over installation:

I must ask you not to put the responsibility of installation on the Postmaster as the Post Office Department has objected in several recent letters to artists asking the Postmaster to furnish nothing more than a couple of step-ladders and a blank wall.

I believe, however, that I have some news which will be of value to you relative to the installation. Mr. Crittenden who has successfully installed a great many murals for artists under this program is planning a trip next week or perhaps ten days from now to Tennessee to install some other murals and if your mural were in Gleason I am sure that arrangements could be made for you to have him install the mural at that time. You would be assured of an A #1 job. Further, in case anything did happen to the installation, Mr. Crittenden would be completely responsible to you for it. He is in Washington at the present time and I suggest that you write to him in care of this office.

The local postmaster wrote to Poor about the installation:

Mr. Crittenden has been here and installed the mural and it looks like it has been put up in first class shape. It looks like a wonderful piece of work and I am well pleased with it with the exception of one thing. I am very much disappointed that the picture of W. R. Hawks does not appear in it. I feel sure that you have some good reason for leaving it out and will hear that from you when you come by in December.

Mr. Crittenden told me that he had never installed one of your paintings before but he also said that he had never installed one before that was any better work than this one.

He asked me to see to having a picture made and send you two prints and the negative. As we do not have a photographer here, I will have to get one to come from some other town and as soon as I can get this done will send you the prints and negatives.

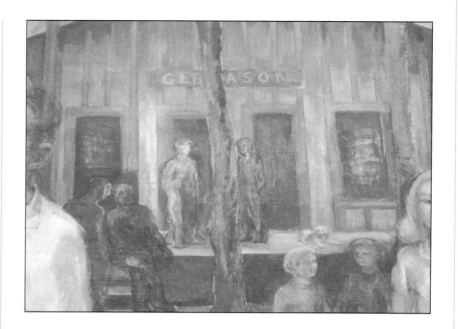

Poor wrote to the Section and detailed how she had explained to the postmaster how adding the portrait of Hawks would have harmed other figures in the painting; apparently, the postmaster was satisfied by her explanation.

ABOUT THE ARTIST

Anne Poor was born in 1918 in New York City. She is best known for still-life paintings and town landscapes. Poor studied at the Art Students League in New York. She also assisted her stepfather, noted artist Henry Varnum Poor, with several works.

Anne Poor and Marion Greenwood were the first two female war-correspondent artists.

The Section wrote to Poor about its philosophy of public art:

We are not desirous of antagonizing the public in matters of art and, as you are aware, there are two schools of thought on this subject. There are those who believe that all art should be terminated for the duration and others who are convinced that the arts should

be continued as a stimulus to morale and as a growing evidence of the things for which we are now at war. In case there is serious local objection to the decoration at this time, I will appreciate your notifying me with the understanding that the work will automatically be terminated for the duration.

Poor wrote to the postmaster for his views:

I am particularly anxious that my mural should have vital relation to the people and the town where it will be, and I am writing now for an expression of opinion from you, in a very general way, as to the subject matter you think most suitable. For example, I recently completed a mural decoration for the Depew, New York, Post Office where the Guild Foundries are located showing workmen in the foundry. This appealed to the postmaster and the citizens as having more present day significance than any scenes drawn from the past history of the town. I am enclosing a clipping from the local paper. However, there might well be cases where some historical incident in the past history of the town would be of outstanding importance.

I expect to come to Gleason sometime this spring, to see your post office, learn more about the town and look forward then to talking more fully with you about the mural. In the meantime, however, I would appreciate hearing from you.

The Section, after receiving Poor's letter, as well as an attached letter from the postmaster, was encouraged:

I am convinced that you will be able to create a fine decoration using an agricultural theme. The specific theme of Sweet Potato Plants is unusual and, to my knowledge, has not been used in any of the other murals executed under the Section. I hope you will concentrate on that.

During wartime, some postmasters and citizens had been less than enthusiastic about the mural projects for their towns. However, Poor's experience was entirely positive:

The Postmaster was most enthusiastic; his attitude seemed to repeat the attitude of the townspeople. From stories that I heard about the difficulties you have had with the public since the war started, I must consider myself extremely lucky.

Poor died at the age of 84 in New York in 2002.

Sources

"Anne Poor," Ask Art, https://www.askart.com/artist/Anne_Poor/11152765/Anne_Poor.aspx

Falk, Peter H. *Who Was Who in American Art 1564–1975: 400 Years of Artists in America.* Madison, CT: Sound View Press, 1999.

History of Gleason

Gleason is a town in Weakley County and as of the 2010 census, the population was 1,445. When it was first established as a community, it was called Oakwood after a large oak tree that was next to W. W. Gleason's general store. It was incorporated in 1871 and its name changed to Gleason after the owner of the general store and other businesses in the area.

In the beginning, tobacco and cotton were most essential to the local economy, although the largest contribution became the Nashville & Northwestern Railroad in 1861. After the railroad was completed and the Civil War was over, cotton and tobacco ruled as the area's biggest exports.

The sweet potato was one of Gleason's largest agricultural products in the early 20th century, and the town was known as "Tater Town"

ever since, as well as the sweet potato capital of the U.S. In 1913, the first potato hampers for shipping sweet potatoes were introduced by W. R. Hawks.

The time of taters has passed, however, and now the town's central economic contributor is ball clay that is shipped around the world by five different companies located there. It has been an source of economic stability since the mid-1930s.

Sources

"Gleason, TN Population," Census Viewer, https://censusviewer.com/city/TN/Gleason

"Early History of Gleason," Gleason Online, http://www.gleasononline.com/early_history_of_gleason.htm

"Gleason," https://www.utm.edu/departments/special_collections/wc_hist/gleason.pho

"Facts About Gleason," Gleason Online, http;//www.gleasonline.com/facts_about_gleason.htm

"Gleason Industries," Gleason Online, http://www.gleasononline.com/gleason_industries.htm

Vaughan, Virginia Clar, "Weakley County | Tennessee Encyclopedia," Tennessee Encyclopedia, March, 1, 2018, https://tennnesseeencyclopedia.net/entries/weakley-county

JAMES A FARLEY
POSTMASTER GENERAL
JOHN M CARMODY
FEDERAL WORKS ADMINISTRATOR
W ENGLEBERT REYNOLDS
COMMISSIONER OF PUBLIC BUILDINGS
LOUIS A SIMON
SUPERVISING ARCHITECT
NEAL A MELICK
SUPERVISING ENGINEER
1940

The Gleason Post Office

100 N. Cedar St., Gleason, Tennessee 38229

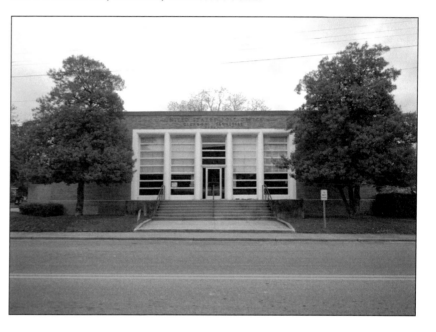

The Gleason Post Office was constructed by Andrew & Dawson Construction Company of Montgomery, Alabama. The cost of the building when new was approximately $65,000.*

The Gleason Post Office was completed in 1940 as indicated on the cornerstone on the lower right corner of the building, which reads, *James A. Farley, Postmaster General. John M. Carmody, Federal Works Administrator. W. Englebert Reynolds, Commissioner of Public Buildings. Louis A. Simon, Supervising Architect. Neal A. Melick, Supervising Engineer.*

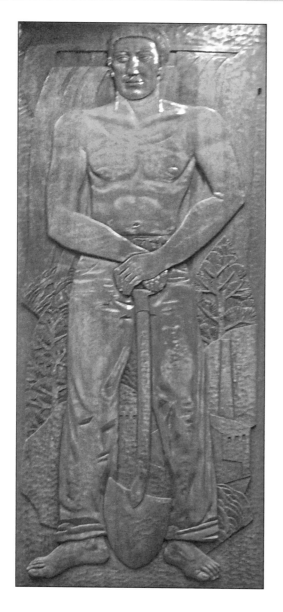 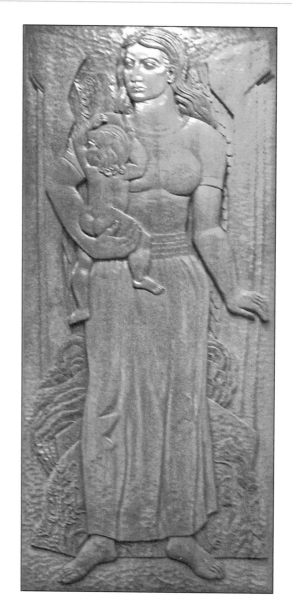

Man Power and *Natural Resources*, by William Zorach

The wood carvings *Man Power* and *Natural Resources* are teak wood and each measures 3' by 7'; the panels were installed on March 9, 1940. One panel depicts a man with a shovel, and the second panel depicts a woman and a baby. The commission was $2,500.

History of the Mural

Zorach wrote to the Section about a possible subject:

In thinking over the Greeneville, Tennessee decoration I thought it might be an interesting idea to depict in some symbolic fashion an important contemporary event or happening for which the present administration was responsible. That would interest future generations of Tennesseans.... Also I could depict some important historical event or historical figures in Tennessee History.

Zorach had been interested in securing some work for his daughter, who had, in his opinion, great artistic talent and could help him with the project. He did accept the post office commission, as confirmed by the Section:

Thank you for your two letters of September 23, 1938, in which I was pleased to learn that you had reconsidered doing the sculpture decoration for the Greeneville, Tennessee, Post Office and Court House.

All of the members of this office are confident that you can create a handsome design and yet one which will be commensurate with the amount of the reservation.

Zorach was having some difficulty in working on his new house, apparently:

Some friends' lawyer found us a contractor when contacted to build with us or rather renovate it. This man turned out to be a crook, took our money and paid none of his men or for any of the materials.... We had to fire the contractor, the workmen arrested him, and he's on a thousand dollar bail, and we had to subcontract each thing and attend to each detail ourselves mostly which fell on Marguerite's hands.... So you see we have been a little dizzy, and when I came down to see my World's Fair enlargement, I almost passed out. The World's Fair is in the clutches of Union Markets these fellows worked for over 10 years. All they are is monumental garbage makers, and what they did to my beautiful sketch that I made all last winter was unbelievable. So I've been working on a picture where ever since I've been back trying to get some of my quality back into it.

ABOUT THE ARTIST

William Zorach was born in 1887 in Eurburg, Lithuania. He is best known for abstract sculpture, as well as modernist landscapes and paintings. Zorach studied at the Cleveland School of Art and the National Academy of Design in New York, as well as in France.

Zorach married Marguerite Thompson who also was a noted WPA artist. The two had a daughter Dahlov who painted the mural for the La Follette, Tennessee Post Office.

His work was exhibited widely, and he earned many awards during his career. In addition to the Greeneville carvings, Zorach also executed the terra cotta relief *Shoemakers of Stoneham* for the Stoneham, Massachusetts Post Office.

Zorach died in Bath, Maine, on November 15, 1966.

SOURCES

New York Times Obituary, November 17, 1966.

Falk, Peter H. *Who Was Who in American Art 1564–1975: 400 Years of Artists in America.* Madison, CT: Sound View Press, 1999.

"William Zorach," Ask Art, https://www.askart.com/artist/ William_Zorach/35112/William_Zorach.aspx

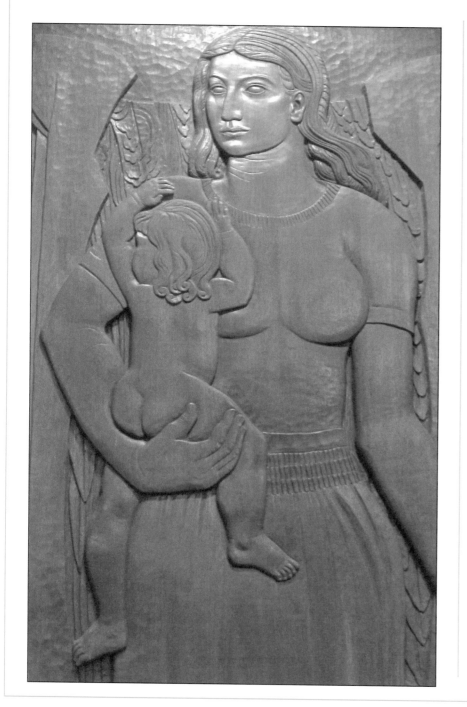

History of Greeneville

The city of Greeneville is the county seat of Greene County in north-eastern Tennessee. The population according to the 2010 census was 15,062. It is Tennessee's second-oldest incorporated town and was named after Revolutionary War hero Nathanael Greene. As a result, it is also the only town in the United States with the spelling of "Greeneville."

Greeneville was settled in 1772 as Jacob Brown and some others came to the area from North Carolina and established a camp next to Nolichucky River. In 1775, the Cherokees leased land to Brown and, in 1777, Elmwood Farm was established there. Most of the early economy was made up of farming, but most goods produced weren't shipped outside the area.

Greeneville became the capital of the State of Franklin in 1784, which was a short-lived and unrecognized state located in what was North Carolina from 1784 to 1789, when it finally rejoined North Carolina. In 1789, Greene County was ceded to the United States as a part of Tennessee and Tennessee became the 16th state of the Union on June 1 of that year.

Andrew Johnson moved to Greeneville in 1826, served as the mayor of Greeneville in 1834, and spent 30 years in both Tennessee and United States legislatures. He became the 17th President of the United States in 1865 after the assassination of Abraham Lincoln. His

William Zorach, *Man Power* and *Natural Resources*

tailor shop and home in Greeneville remain open today to the public and are national historical sites.

During the Civil War, Greeneville and its county was largely Unionist, even though the state of Tennessee had voted to secede from the Union. A pro-Union meeting was held at the Greeneville Convention in 1861.

Sources

"Battle of Blue Springs," Civil War Wiki, May 15, 2013, https://civilwarwiki.net/wiki/Battle_of_Blue_Springs

Eschner, Kat, "The True Story of the Short-Lived State of Franklin," *Smithsonian Magazine*, August 23, 2017, https://www.smithsonianmag.com/smart-news/true-story-short-lived-state-franklin-180964541/

"Greene County, Tennessee History," Greene County TN, https://www.greenecountytngov.com/greene-county-tennessee-history/

"Greeneville, TN Population," Census Viewer, http://censusviewer.com/city/TN/Greeneville

The Former Greeneville Post Office

101 W. Summer St., Greeneville, Tennessee 37743

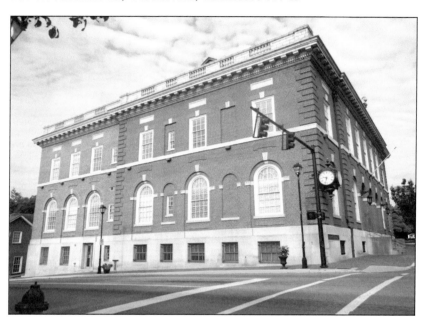

The construction cost for the Greeneville Post Office and Court House when new was about $2,500,000.*

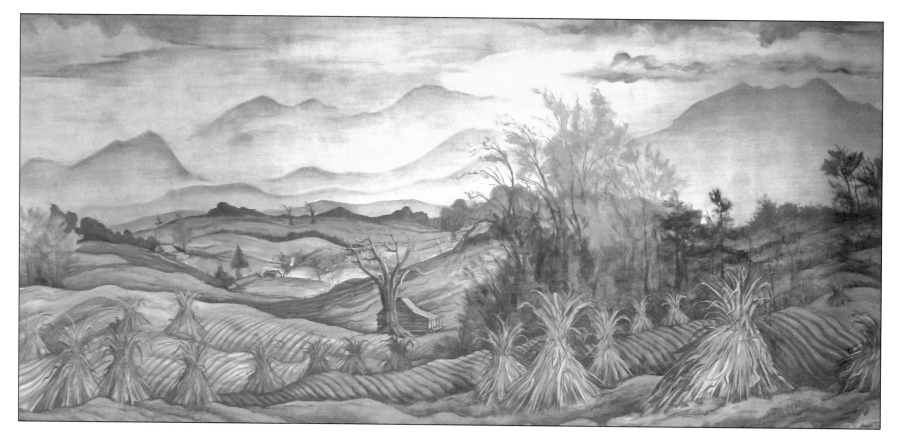

Great Smokies and Tennessee Farms, by Charles Child

The mural *Great Smokies and Tennessee Farms* is oil on canvas and measures 12' by 5'6". It depicts typical farms near the Great Smoky Mountains. The commission was $700.

Charles Child, *Great Smokies and Tennessee Farms*

JEFFERSON CITY

History of the Mural

Child wrote to the Section about the two-inch-scale painting he had just mailed:

If you remember, I stopped in on my way back through Washington from Jefferson City and showed you several pastel roughs in color of the district, one of which in particular I proposed to use as material for the design. This met with your approval, and I have now gone ahead with it, and am sending you the scale painting which I hope you will not construe exactly as being a little miniature of the finished work. However, I hope that this, taken together with the pastel roughs, will clarify my intentions, so I can get a green light, a cheque, and your official blessing, and can get to work.

The Section replied,

The sketch is very handsome and carries a great deal of appeal. We are confident that it will please the visitors to the Jefferson City Post Office. The design is in every way satisfactory and is approved at this stage. It is being photographed and will be returned to you under separate cover. Kindly proceed with the full size cartoon and submit a photograph and negative 8 x 10 for our further consideration.

Child appreciated the positive response, but he had some concerns:

I am glad you liked the sketch. However, there is for me a slight ambiguity in what you say about proceeding with the full size cartoon. I have mentioned to you several times in the course of our letters and conversations that in this case of large landscapes such as this one, I do not make a practice of making full size cartoons

but proceed to work directly from the small sketch on the basis of a simple full size indication or layout, not a careful cartoon. I have also several times stated the reasons for this procedure. Would it not be possible for me to go ahead on this basis and furnish you with a photo when an appropriate stage has been reached, which in your estimation was equivalent to a cartoon? What I would actually prefer to do is as follows (on the assumption that you have sufficient confidence in me as an artist to allow me to proceed): I would like to simply start painting the canvas in my usual way, and bring it to a conclusion, then send you a photo of the finished work, or if you must, the half-finished work. I feel that a cartoon, in the case of landscape in particular, crystalizes the conception too rigidly beforehand. If it is not supposed to hold the conception to a carefully prearranged set of forms, then I see no useful purpose in going to the expense of a photo at that stage.

The Section allowed Child to make just a photograph, though Child would do so reluctantly:

In view of the fact in a landscape of this nature you do not make a practice of making full size cartoons but proceed to work directly from the small sketch, I suggest that a photograph of the half completed work be furnished this office together with negative enabling us to recommend the work for a payment at that stage.

Child continued to have reservations about the reproduction process:

I would like to go on record as being opposed in principle to having to furnish negatives as large as 8 x 10 for the following reasons: In the first place, the overwhelming majority of photographers in

Charles Child, *Great Smokies and Tennessee Farms*

the USA now use cameras equivalent to a Speed Graphics 4 x 5 or 5 x 7. The lenses on these instruments are rapid and clear in the extreme and are absolutely adequate to make perfect enlargements up to eleven mural sizes (150 diameters). Big old-fashioned box or studio cameras such as use 8 x 10 negatives to produce contact prints of the same size are almost always equipped with a relatively soft-focus lens as they are meant for portrait work primarily. By requiring 8 x 10 negatives as well as final prints, you are automatically [limiting] all the photos you get to one type of camera, and that's not the best for the job. This is a step backwards of about fifteen years. It seems to me that the important thing is to get and to be able to reproduce an 8 x 10 print by the means that are standard at the present time. I believe any good photographer will bear me out. As a matter of record I happen to know that a good number of artists in this vicinity that have done work for you have furnished you with 8 x 10 prints and smaller negatives, which you have accepted....

Of course if you absolutely require the larger negative, my photographer is ready (but protesting, believe me) to make one up for you. I await your instructions.

After installation, Child wrote to the Section about possible additional commissions. The Section replied,

The photographs indicate that the work looks very well on the wall, and I congratulate you on your achievement. The limited number of mural commissions makes it necessary to reserve these for runners up in the competition.

The local postmaster wrote to the Section after installation of the mural: "The installation is satisfactory and we have had lots of fine comments on same by the public, since it is a very beautiful painting."

ABOUT THE ARTIST

Charles Child was born in Montclair, New Jersey, in 1902. He is best known for portraits, nudes, landscapes, and fabric designs. Child's education included attending Harvard University where he became the art editor of *The Harvard Lampoon*. Child also spent five years in Europe studying and perfecting his craft.

Child was a prolific artist who created many works during his long career. In addition to the Jefferson City Post Office mural, Child also painted *William Markham Purchases Bucks County Territory* for the Doylestown, Pennsylvania Post Office.

Charles Child had a twin brother, Paul Child, who was also an artist and poet, and would eventually marry Julia McWilliams, the famous French chef Julia Child.

He died February 8, 1983, in Pennswood Village, Pennsylvania.

Charles Child, *Great Smokies and Tennessee Farms*

SOURCES

"Charles Child," Ask Art, https://www.askart.com/artist/Charles_Child/134156/Charles_Child.aspx

Falk, Peter H. *Who Was Who in American Art 1564–1975: 400 Years of Artists in America*. Madison, CT: Sound View Press, 1999.

History of Jefferson City

Jefferson City was originally known as Mossy Creek, but was renamed in 1901 for Thomas Jefferson, the third President of the United States. It's located in Jefferson County, and the 2010 census population was 8,047.

The town was originally a point of supply for early explorers, and possibly served this purpose since around 1788, when Adam and Elizabeth Sharkey Peck had traveled there from Virginia. Over the next 20 years, somewhere between 75 and 100 families had settled within four miles of the Pecks' original settlement. The first store was opened around 1795 by Thomas Hume, while the first grist mill was opened at about the same time by Adam Peck. The first iron works was established by Christopher Haynes in 1798.

The first post office was opened in 1816, with Willie Zount Peck as the first postmaster. Until this post office was established, the mail had to be retrieved from Greeneville.

During the Civil War Battle of Mossy Creek, the Confederates lost approximately 400 troops and were forced to move back to Morristown. Union troops remained at Mossy Creek from the beginning of the attack on December 29th to the middle of January.

In 1901, the city was incorporated as Jefferson City, a name change supported by businessmen who were called "Mossbacks," which they thought was a slur, when they traveled.

On August 1, 1940, the construction of Cherokee Dam began, which would erase most of the town's historic Mossy Creek when the lake was full.

Sources

"City History," Jefferson City, Tennessee, http://www.jeffcitytn.com/cityhistory.htm

"The Historic Mossy Creek District," Old Mossy Creek, http://oldmossycreek.com/

"Jefferson City, TN Population," Census Viewer, http://censusviewer.com/city/TN/Jefferson%20City

King, Spurgeon, "Battle of Mossy Creek," *Tennessee Encyclopedia*, March 1, 2018, https://tennesseeencyclopedia.net/entries/battle-of-mossy-creek/

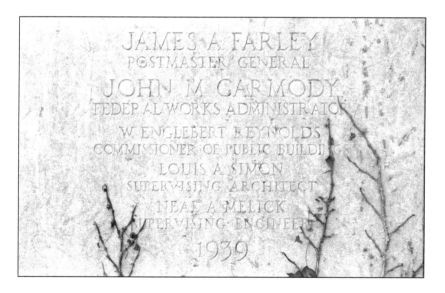

The Jefferson City Post Office

101 E. Old Andrew Johnson Hwy., Jefferson City, Tennessee 37760

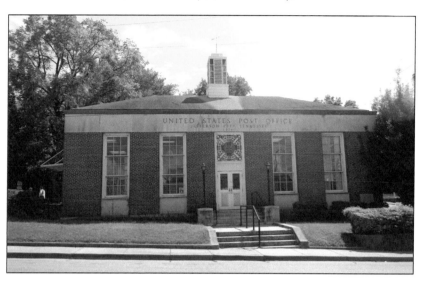

The Jefferson City Post Office was constructed by L. B. Gallimore of Greensboro, North Carolina. The cost was about $46,400.

The Jefferson City Post Office was completed in 1939 as indicated on the cornerstone on the lower right corner of the building, which reads, *James A. Farley, Postmaster General. John M. Carmody, Federal Works Administrator. W. Englebert Reynolds, Commissioner of Public Buildings. Louis A. Simon, Supervising Architect. Neal A. Melick, Supervising Engineer.*

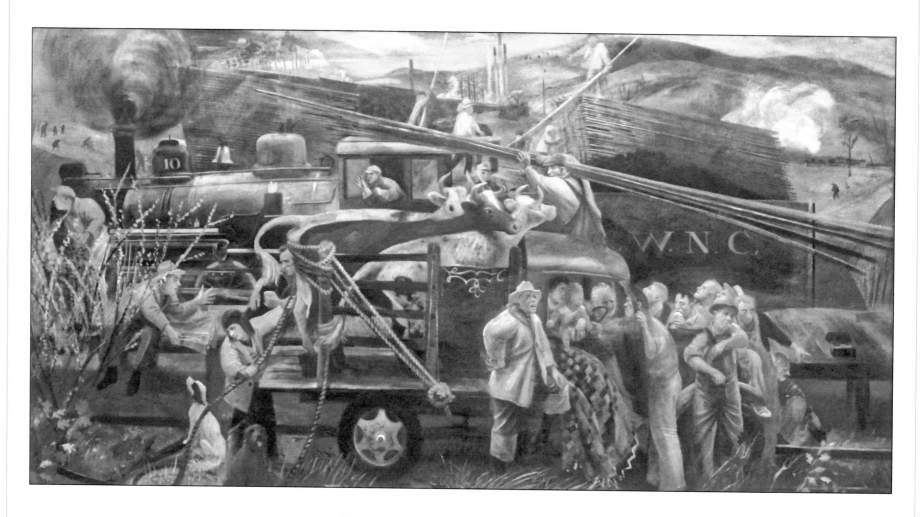

Farmer Family, by Wendell Jones

The mural _Farmer Family_ is oil and tempera on canvas, measures 16' by 8', and was installed on September 9, 1940. It depicts a farmer's family in the foreground with a train in the background. The commission was $1,570.

JOHNSON CITY

History of the Mural

The artist had a less than enthusiastic view of the Johnson City area and its people:

I'm sending you a sketch which I wish were self-explanatory, but I haven't realized it up, and we're leaving for Woodstock in a few days. I want you to see if you see anything in it. What I expect to realize in the mural is a very simple little epic. The background is the ever-present lumber stacks of Johnson City. Tis a drab little city where vitality and spirit [are] pretty mediocre. I don't mean to characterize anybody. The people look to me like the drab little people you can find anywhere.

Madonna and her unselfconscious baby calmly taking the attention of the father who regards the child as somewhat of a miracle and several train men and lumber yard men who show varying degrees of interest. The episode is a small part of the pattern of the picture which I hope will be beautiful in its simplicity. The Madonna and child I hope will be exquisitely painted.

The farmers are little more than subsistence farmers. You seldom see farm machinery. There's a . . . mill some eight miles out on a shallow river, German financed where Rayon is made. But the hard wood flooring industry is Johnson City's biggest symbol. . . .

Here's an idea of what I'd like to do. You'll find a locomotive, the narrow gauge E.T.&.W.N.C. . . . I've got a poor title but one completely [descriptive]: a farmer brings his child to town to show to his friends. Here is the plan.

There's some truth in the saying that realists are cynics and vice versa, but mine seems to be blown with sentiment. I think I know where sentimentality begins; however, the sketch got too dark, but the pink gray color bears a good relationship with the marble around the room which is pink grey. The walls are that awful yellow paint you see on camel cigarette packaging.

The Section initially was very concerned about the lack of detail in Jones's design for the mural competition:

The material which you submitted arrived on time and was reviewed by the jury. The compositional sketches were highly praised but the detail was downright distressing and when I realized, after the envelopes were opened, that it was your work I could have wept over the inadequacies of the detail. It was as though you did not have time enough to devote to it and in my humble opinion, as well as that of the jury, it was inferior in every way to the high quality and beauty of the smaller sketches.

The purpose of a detail in an anonymous competition of this kind is to give those who are judging the work some idea of the consummate quality that the artist intends to obtain in the finished work. . . .

I realize that I am stressing this at length with you due to my chagrin at the detail which you submitted. I do wish to stress, however, that I regard the little sketches among the most beautiful mural sketches it has been my pleasure to see. The jury has recommended you for consideration for another appointment under this program on the basis of these. This will be undertaken when you complete the Johnson City, Tennessee mural.

After receiving a two-inch-scale color sketch, the Section wrote to Jones,

Your design has been considered by the members of the Section, and I am pleased to tell you that we regard it as unusually beautiful.

Wendell Jones, *Farmer Family*

You have selected and organized your subject matter with great intelligence and feeling and I want to congratulate you on your achievement. The work is approved and you may proceed with the full size cartoon, a photograph of which should be forwarded to this office for our further consideration....

Please take good care of the color sketch as we will wish to use it later for exhibition purposes, and I hope that the pristine quality is preserved.

Jones wrote back,

Mr. Moe has asked me to send in any additional work I have for a meeting of the committee on March 10, so I am hopping to Woodstock to scare up something "in color." I'd like to have them see the Johnson City preliminary sketch if you're through with it in time.

Jones became concerned over the location of the sketch, which the Section addressed:

The delay in returning your design was due to the pressure of work which the packers of this office faced in connection with the large sculpture competition for the Evanston, Illinois Post Office which has just been terminated. I am very sorry that the delay caused you any uneasiness or inconvenience. You have, no doubt, received my complimentary letter relative to your hands-on design.

The Section raised some concerns over the canvas for the mural:

I am pleased that my letter proved encouraging to you. Your technical outline is satisfactory, but a question has been raised relative to the sample of canvas which you submitted. This office prefers a pure grade of linen canvas similar to one of the two samples attached herewith as we are assured by technical experts that such will guarantee the greatest longevity for the work and will particularly serve

to preserve the painting in case circumstances should arise in the future necessitating the relocation of one of the murals under this program into a new building. This office is looking ahead fifty years or more but it is our belief that some of the work done under the program at the present time will justify such consideration. In the interest of the artist we are taking similar precautions with all.

I very much regret that you did not receive a Guggenheim Fellowship this year but pleased to note that having failed to do so has not discouraged you. Your contract is being prepared and will be forwarded for your signature in the near future.

Eventually, however, the Section approved Jones's canvas sample.

Jones encountered some difficulties with his materials, but still was happy with the work: "The cartoon is on a very unsatisfactory paper. I gave up trying to work any detail in it.... This mural work is the greatest satisfaction I've ever had."

Later correspondence with the Section reveals that there must have been an unforeseen delay, which later appeared to be connected to an illness:

Your contract provides that all work shall be completed within two hundred and forty-one calendar days after the date thereof, unless such time shall be extended by the Director of Procurement.

It is found that unavoidable delays have prevented you from making normal progress on your work. Accordingly, your contract is hereby modified so as to change the time for completion thereof from two hundred and forty-one to four hundred and eighty-five calendar days from the date of the contract.

The Section was interested in using a preliminary sketch as part of an art exhibition:

I am delighted to know that you will be through with the preliminary sketch so that it may be included in the Whitney Show. If you send it directly to the Whitney would you kindly have it framed

with a one inch molding and painted white. If this is not possible, please send the design to us and we will have it framed.

Jones's illness turned out to be from a ruptured appendix, as a letter from his wife, Jane, indicates:

I can't tell you how much I appreciate your wonderful letter. Wendy was so happy, he asked me to please thank you for the beautiful letter; this is the first moment I've had to tell you how much better Wendy is. I'm glad to have good news for you: he is doing very well and looks much better.

I mailed the sketch yesterday express to the Section, and I hope it reaches you in plenty of time; you were very thoughtful to suggest framing it there. I think perhaps the border should be cut off if it is to be framed in a white frame, but you'll know best.

You know how happy I am now, but I can't quite believe it, just as I could hardly believe what was happening during the ambulance

trip to Kingston. I want to tell you again how much your letter meant to me, as well as to Wendy, I read it to him Saturday and again Monday when he was feeling better and it was a wonderful tonic.*

Jones directly asked for an extension:

May I request an additional eight months on my contract? This was a most unwelcome interruption. But I have a mind full of simmering improvement and can't wait to get back to it..... Would it be possible to re-date my contract to July 30th?

Later, the Section verified Jones's earlier suggestion that he might not need an extension after all:

It is noted that an extension of time on your contract will not be necessary. May I suggest that as soon as the mural has been completed you forward a photograph and negative (8 x 10) of the work so that we can have other prints made and furnished these with a press release to be distributed by you at the time the work is installed. This should be done somewhat in advance of the date of installation.

In reply to your statement of misgiving we are not washing under and we never will be nor are these nations that have already felt the crushing heel of the tyrant. Democracy lives on and will come forth like plants in spring for a new blossom. Nothing that is really good ever dies.

In a follow-up letter, Jones comments on the mural's appearance: "The damn thing got too greenish. I think with vitality restored I can iron out and elevate it to what I originally intended. A tired talker tells incidents and a tired painter paints green."

While inquiring about whether and how to provide color photographs of the mural, Jones comments on the local postmaster, who

received him "very cordially": "Mr. O'Shea said he didn't know anything about art. He just liked pictures of pretty women with babies."

The Section was concerned about documenting and installing the mural:

> I cannot understand why you have failed to furnish us with the negative, however, as this is a requirement of your contract as the negative is important at this time so that prints may be made to accompany the press releases to be distributed at the time the work is installed. Our previous correspondence verifies this procedure.
>
> Relative to technical advice on placing the mural, it is our feeling that this must be done only by an experienced craftsman. I certainly do not advise you to rely on the local paper hangers.

The Section went on to suggest local craftsmen who could install the mural. Eventually, it was installed and photographed in place, which satisfied the Section: "It is gratifying to know that the mural is considered by many to be a real addition to the decoration of the building."

The Section forwarded an admiring letter from Grace Shell, Postmaster of the Elizabethton, Tennessee Post Office to the Postmaster of Johnson City:

> This week I had my first opportunity to see the handsome mural "Eastern Tennessee" done by Wendell Jones, of New York. This mural is certainly a very fitting one, and has added an elegance and dignity to the already beautiful lobby of the fine Johnson City, Tennessee Post Office.
>
> The Postmaster Mr. Chase is to be complimented on giving the Artist so correct a word picture and true facts on the locality that he was able to produce this marvelous mural. Then to give this section its only mural is another point for pride. The mural is receiving much favorable criticism as well as being enjoyed.
>
> You will be interested to know, that the train in the picture is the train on the East Tennessee & Western North Carolina Rail Road,

> lettered and numbered correctly No 10, E.T.&.W.N.C.R.R and is probably the only Narrow Gauge R.R. in operation in the United States today....
>
> I am personally very happy that the artist was able to see our beautiful hard wood forest, our cattle farms, our fine stalwart men, and that he pictured us as healthy hard working Anglo-Saxon people. I wish it were possible for every public building to have wall space for one of these marvelous murals.
>
> I have had artists approach me and say 'Those last pictures are really a masterpiece.' It must be a source of the greatest satisfaction to know that one has done at least one incomparable work.

ABOUT THE ARTIST

Wendell Cooley Jones was born in Galena, Kansas, in 1899. Jones is best known for genre, figural, landscape, and mural painting. His education included attending the Art Students League in New York,

where he became part of the art scene. Jones also traveled south and west, practicing and exhibiting his work.

He lived in Woodstock, New York, when he was commissioned for the Johnson City, Tennessee Post Office mural. Jones also painted *First Pulpit in Grandville* for the Grandville, Ohio Post Office and *Barn Raising* for the Rome, New York Post Office.

Jones died in Rome, Italy, in 1956.

SOURCES

Falk, Peter H. *Who Was Who in American Art 1564–1975: 400 Years of Artists in America*. Madison, CT: Sound View Press, 1999.

"Wendell Jones," Ask Art, https://www.askart.com/artist/Wendell_Cooley_Jones/105985/Wendell_Cooley_Jones.aspx

History of Johnson City

Johnson City is located in three different counties in Tennessee: Washington, Carter, and Sullivan. The 2010 census put the population at 63,152.

Originally named "Johnson Depot," the town began as a railroad station along the East Tennessee and Virginia Railroad. The first store, depot, and post office were built at the proposed junction of the existing stage road and railroad line. It became also known as Johnson's Tank due to the water that trains took from there.

During the Civil War, the town began to be called Haynesville after Confederate Senator Landon Carter Haynes. In 1869, the town was chartered as Johnson City.

The population of the town grew significantly between 1870 and 1890, due to both the railroad and the local mining industry. By 1890, the city's population had reached 4,000 people.

The Mountain Branch of the Soldiers Home (now the Mountain Home VA Medical Center) was opened in the city in 1903. By 1911, East Tennessee State University was established, which caused the population to grow once again. Today, there are approximately 15,000 students enrolled at ETSU, which supports a strong economy of shops, housing, restaurants, and more.

By the 1920s, Johnson City was nicknamed Little Chicago—supposedly, Al Capone had a primary alcohol distribution network based in the city. The city also hosted Columbia Records recording sessions in 1928, known as the Johnson City sessions, that included Clarence Ashley and The Bentley Boys. It was some of the first recordings of traditional "hillbilly" music ever made.

SOURCES

Haskell, Jean, "Johnson City," *Tennessee Encyclopedia*, March 1, 2018, https://tennesseeencyclopedia.net/entries/johnson-city/

"History," Downtown Johnson City, https://downtownjc.com/history/

"History," *Johnson City SourceBook*, July 11, 2017, http://johnsoncitysourcebook.com/history/

"Johnson City, TN Population," Census Viewer, http://censusviewer.com/city/TN/Johnson%20City

Lawless, John. "90th Anniversary of the Johnson City Sessions this Weekend," *Bluegrass Today*, October 14, 2019, https://bluegrasstoday.com/90th-anniversary-of-the-johnson-city-sessions-this-weekend/

Tabler, Dave, "Al Capone Comes to Appalachia," *Appalachian History*, September 14, 2018, https://www.appalachianhistory.net/2018/09/al-capone-comes-to.html

HENRY MORGENTHAU JR
SECRETARY OF THE TREASURY
JAMES A FARLEY
POSTMASTER GENERAL
LOUIS A SIMON SUPERVISING ARCHITECT
NEAL A MELICK SUPERVISING ENGINEER
LORIMER RICH ARCHITECT
1937

The Former Johnson City Post Office

338 E. Main St., Johnson City, Tennessee 37601

The Johnson City Post Office was constructed by Algernon Blair of Montgomery, Alabama. The cost was about $197,571.

The Johnson City Post Office was completed in 1937 as indicated on the cornerstone on the lower left corner of the building, which reads, *Henry Morgenthau Jr., Secretary of the Treasury. James A. Farley, Postmaster General. Louis A. Simon, Supervising Architect. Neal A. Melick, Supervising Engineer. Lorimer Rich, Architect.*

On the Shores of the Lake, by Dahlov Ipcar

The mural *On the Shores of the Lake* is oil on canvas, measures 12'4" by 5'9", and was installed on August 23, 1939. It depicts fishermen and a hunter near the lake. The commission was $650.

LA FOLLETTE

History of the Mural

Ipcar wrote to the Section about visiting the city:

We have decided to drive down to Tennessee and see La Follette, and the post office where I am to do a mural. I cannot seem to find anything out about La Follette any other way. It may not be necessary to know anything about La Follette, but I think we will enjoy a trip for a change....

After visiting, the artist followed up:

I am sending you under separate cover 4 pencil sketches for the proposed mural in the La Follette, Tennessee Post Office. We enjoyed our trip down there, and these sketches are based as far as the scenery is concerned on sketches that I made while there. Everybody was very helpful, but it was rather hard to dig up any particular historical facts, so I have only included what I could find.

Sketch no. 1 shows a scene in the early 1800's at which time La Follette was mainly an agricultural community. A hunter is descending the hill to the valley leading a horse. On the saddle are hung various game birds etc. Another rider is coming up the hill. Below there would be panoramic view of the valley with corn fields, cattle grazing, a few houses, etc. You might consider this a meeting with the mail, in which case the rider coming up the hill would be the mail man.

Sketches 2 and 3 are both modern scenes, on the shores of Lake Norris. La Follette happens to be the only town that actually touches on the new lake. In sketch no. 2 two fishermen are returning with their catch and a hunter with his dogs comes out of the woods to greet them. In sketch no. 3 there are two hunters meeting

a fisherman. In both scenes there would be the lake and its shores in the background.

Sketch no. 4 represents a battle in the Civil War; which is supposed to have taken place in the mountains above the town. The sketch shows the Union troops capturing the Confederate battery on the hill top. The trees were felled to make the approach difficult.

After receiving the full-size cartoon, the Section wrote with some suggestions:

The photograph indicates that the work is progressing satisfactorily, and you may proceed with the final painting. One suggestion offered is that the lower extremities of the figures in your composition should not be dwarfed in relation to the torsos as they seem just a little small. The other suggestion is that the boat in which the fisherman stands should be given the appearance of being completely realized in back of the bank. Allow enough space in your initiation to include those elements.

The artist thought about some changes, too, as well some possible problems with the installation:

I've been thinking of removing the fish that the boy at the extreme right is holding up. Do you think that this gesture is too trite or does it add interest? I could have him just waving his hand. Of course, that's just a minor detail, but I though perhaps you might have some suggestions to make.

Am having a hard time trying to make arrangements for installation. I remember that you mentioned another artist who was doing a mural nearby and I wondered if you could send me their address. I've been thinking that you must have been referring to my

Dahlov Ipcar, *On the Shores of the Lake*

mother, but since her mural is about 400 miles away that wouldn't be much help. Hope there is somebody nearer.

The Section replied,

Your acceptance of the suggestions offered by the Section relative to the certain revisions in the design is greatly appreciated. The gesture of the man holding the fish to which you refer was not regarded by us as too trite. It occurs to me that the gesture as it now stands would probably have more meaning than having the figure merely waving his hand. It is suggested, however, that you use your own good judgement in this instance.

In answer to your question relative to arrangements for installation I would like to suggest... Miss Bernadine Custer who is installing a mural in the Summerville, North Carolina Post Office and has gone there with her husband and the two of them are interested in procuring commissions from other artists to install their work while they are in the South. I believe that Miss Custer would be interested in hearing from you and I would suggest that you write directly to her in care of the Postmistress of Summerville.

The postmistress, Irene Miller, wrote to the Section with some concerns about the installation:

I understand from the artist and men that have been out here to see about the installation of the mural, that the mural is to be glued to the wall (in the lobby over the postmaster's door).

I have recently written the Department that I would like to put the mural in a stretcher and then the stretcher mounted to a frame, and the mural removed from the wall when the wall is repainted. If the mural was not covered when the wall is painted, I am very much afraid the mural will be splattered with paint. The only way the mural could be covered up as I understand would be to pin a cloth on the mural, which I would not do without your permission, as I would be afraid the extra weight would loosen the mural on

the wall. It is damp here where the office is located and there are a few cracks in the upper walls of the lobby and I thought if the mural was glued on, if the wall cracked there, it might damage the mural. There is a radiator under one end of where the mural will hang, if it is hung over the postmaster's office in the lobby, where I understand it is to be hung and which I believe to be the most practical place for the mural. I also wondered if the heat from the radiator might loosen the mural at one end, if the mural is glued to the wall. I am also concerned as to whether the average painter, who might receive a contract for painting the walls would do a neat job of painting around the mural and not damage the mural in doing the work.

I would appreciate an early reply, as I do not know just when the artist might send someone to mount the mural. It does not seem to me that it would be at all satisfactory to glue the mural to the wall for various reasons, but most of all because of damage to the picture, either in splattering it with paint while repainting the lobby or in covering the mural up by pinning a cover over it [would] probably loosen... it from the wall.

I thought the Department might not have a fixed way of mounting murals, but the suggestion or idea, might only be one of the artist's ideas.

The Section wrote back to reassure the postmistress:

The intention of this office is to have the mural in question glued permanently to the wall in accordance with our usual procedure, which has been found through experience to be satisfactory.

I can guarantee that the mural will not pull away from the wall at the corners. At the time the walls are re-painted a covering of thick wrapping paper can be put over the mural which procedure has been found on several occasions to have no ill effect to the painting.

Your concern and interest in the safety of the mural are greatly appreciated and I am pleased to tell you that in the opinion of the

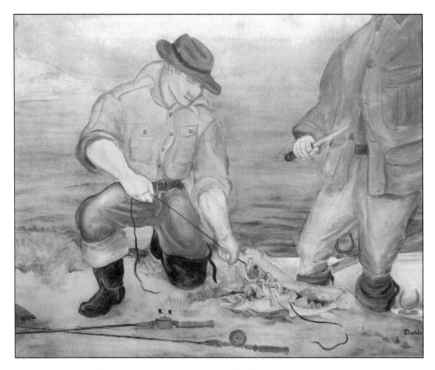

members of the Section the work which you are to receive by Miss Dahlov Ipcar justifies this interest. Miss Ipcar has a distinguished painting at this time in the Corcoran Biennial exhibit which has brought forth many favorable comments. I am taking the liberty of forwarding a copy of your letter to Miss Ipcar for her further consideration.

The Section then wrote to Ipcar:

Enclosed is a copy of a letter forwarded to this office from the Postmistress at La Follette, Tennessee relative to the proposed method of installing your mural, together with a copy of my reply. I think it would be well for you to consider the use of white lead and Damar varnish as the adhesive, and plan to place a small molding as an enframement around the mural in order to guarantee its permanent adhesion. Kindly let me know your intention in the matter.

Ipcar wrote back about the postmistress as well as the installation:

She's been splendid. It's always been my intention to have the mural put up as you suggested, with white lead. I only hope I'll be able to find someone to do it. Have written to the people you suggested, but so far have not heard from them. I rather doubt if they will still be down South when my mural will be ready. Am also trying to get replies from other parties without much luck. It's very discouraging.

She followed up in a letter with similar concerns:

The mural is just about finished and would be ready to install on time; but I am still unable to find anyone who will do the installation. I have written to everyone I could, and consulted my postmistress but have not been able to find anybody even interested enough to reply.

Unless you have any suggestions, I think the best thing I can do is wait until my parents take a trip down to Tennessee, this fall to install their Post Office projects. They both expect to have them finished by fall, and they could install mine too while they were there. However, I would need a short extension of my contract, because they may not be ready until October; at the latest the mural would be up by the end of November.

If you could arrange this, I think it would be the best way. However, will keep on trying to get some contact in Tennessee. And if I succeed I'll send the mural right off. But I'm not very hopeful.

The Section did grant an extension, after which Ipcar wrote back:

You will be pleased to hear that I have succeeded in making arrangements with a man in Knoxville, Tennessee to install my mural in the La Follette Post Office. I have the extension on my contract here, which I am very grateful for your trouble in obtaining. But am holding it as I may not need to use it, if it is possible to have the work installed this month.

We are sending off the mural to La Follette, and expect it will be up shortly. Am also returning to you by express the color sketch. Will send you the photograph and negative under separate cover.

Hope this will all be alright. I have followed the suggestions that are offered as best I could; and if the torsos of the men still seem a little large for the legs, I think it will be an advantage, as they will tend to be dwarfed slightly when viewed from below, as they will be when installed.

The mural was installed successfully on August 23, 1939. The postmistress wrote that

The mural is beautiful and a lovely piece of art, I judge. The patrons of the office seem to appreciate it and admire it very much.

Mr. Bamberg has glued the mural to the wall, without a wrinkle, as far as I can see. He put molding around the edge of the mural, which I believe would be the color of the walls, if the walls were not sooty. (The Department is considering painting the walls this Fall.) The mural with the molding around it, fits the space exactly, which is in the lobby over the Postmistress's door and from wall to wall. The work is complete and in first-class condition I judge.

There was one reservation that the Section expressed:

There is one element in your mural that I wish to call your attention to for your consideration in future work. The spatial relations

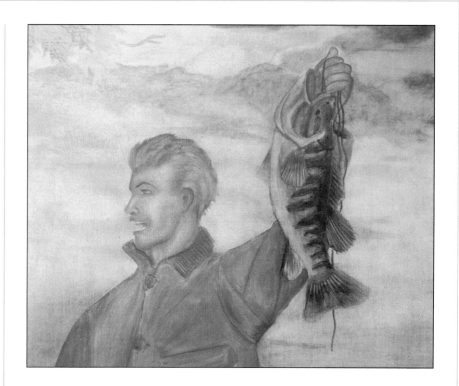

of the boat and river bank and the lower extremities of the man on the right are not entirely convincing in that they do not follow through with the conviction that characterizes the rest of your work. The panel, notwithstanding, is extremely beautiful, and it is not my intention to ask for any revisions.

The artist wrote to the Section about suggestions that had been made about repainting the post office interior:

I think it is an excellent idea to repaint a different color, as I was very unfavorably [affected] by the present color of the La Follette Post Office walls (but I took it for granted that that was the standard departmental colors). The walls are a very unpleasant yellow buff that doesn't at all harmonize with the marble, which is very handsome and of a dark purplish brown color. I would suggest

repainting the ceiling white to brighten the place up, and painting the walls a very light, very warm grey, (using burnt umber to get the proper warm tint, I am enclosing a sample from a Sherwin-Williams wall paint chart that comes nearest the color I have in mind).

I don't know whether or not you intend doing anything about the woodwork, but that is also a pretty bad color: dark brown stain, I think, and very depressing. Would suggest repainting it an off-white if that were possible. Or a light grey, the same as the walls, but perhaps a shade darker (these colors would bring out the mural much better, I'm sure).

A local article described the mural:

The mural is done with oil on canvas and is painted thin. Particularly striking is the artist's subtlety with colors. Warm tones are a characteristic of Mrs. Ipcar's painting, and in this mural she has successfully blended… rich earthy browns with the cold green of pines, spruce and evergreens.

Noticeable in this mural, as in much of her work, is the naturalness of the human figure, its lifelike poses, and the impression of "back to nature." Perhaps the latter is better defined by saying that the artist stresses natural environment, that she has the power or ability to make one fully aware of nature without making nature offensive to non-nature lovers.

About the Artist

Dahlov Ipcar was born in Windsor, Vermont, in 1917. Ipcar is best known for illustrations, landscape paintings, and fantasy paintings. Her parents also painted murals for the Section of Fine Arts. She was a resident of Robinhood Farm, Robinhood, Maine, at the time she was awarded the commission for the La Follette, Tennessee, Post Office.

Ipcar grew up in Greenwich Village in New York and attended the City and Country School. She briefly attended Oberlin in Ohio on a scholarship, but found the curriculum limiting and quickly left. In addition to the La Follette Post Office mural, Ipcar also painted the mural in the Yukon, Oklahoma Post Office.

Ipcar's career spanned many decades in which she produced a number of works. She died on February 10, 2017, in Georgetown, Maine, at the age of 99.

Sources

"Dahlov Ipcar," https://www.dahlovipcarart.com/biography

"Dahlov Ipcar," Ask Art. https://www.askart.com/artist/Dahlov_Ipcar/100958/Dahlov_Ipcar.aspx

Falk, Peter H. *Who Was Who in American Art 1564–1975: 400 Years of Artists in America.* Madison, CT: Sound View Press, 1999.

History of La Follette

La Follette is located in Campbell County and, as of the 2010 census, its population was 6,737. The town was originally called Big Creek Gap and was founded in 1893 by Harvey La Follette, who was an educator and engineer from Indiana. He and his brother, Grant La Follette, purchased the land due to it being rich in natural resources such as iron, coal, timber, and water. Over 37,000 acres were purchased, and they founded the La Follette Coal, Iron, and Railway Company.

The city was incorporated in 1897 and drew people from all around to work for the La Follette brothers. By 1920, the population had increased to 3,000 people, half of that workers. Unfortunately, the furnace closed in 1926.

In the 1920s, La Follette was the largest city in Campbell County, and when the Norris Dam was completed in 1936, Norris Lake gave the city and the county a new industry: tourism. Because of the dam, electricity to the area was inexpensive, and the county had 600 miles of shoreline on the lake.

The first post office in La Follette was opened in 1835 when the area was called Big Creek Gap. Unfortunately, the trading post failed, and it was discontinued. It wasn't until 1875 that another post office was established. In 1894, the name of the post office was changed from Big Creek Gap to La Follette. The current post office building was

constructed in 1936 under the New Deal, and it served the city until 2008 when a new one was built.

Located not far from Interstate 75 in northeastern Tennessee, La Follette remains today the largest city in Campbell County and is just down the road from the county seat of Jacksboro.

SOURCES

Baird, Adrion, "Campbell County," *Tennessee Encyclopedia*, March 1, 2018, https://tennesseeencyclopedia.net/entries/campbell-county/

"Campbell County, TN LaFollette History," TNGenWeb, https://www.tngenweb.org/campbell/history/lafoll.html

"Going, Going, Gone: Historic Post Offices on the GSA's Auction Block," Save the Post Office, https://www.savethepostoffice.com/going-going-gone-historic-post-offices-gsas-auction-block/

"History of LaFollette, Tennessee," City of LaFollette, https://www.lafollettetn.gov/about-lafollette/history-of-lafollette-tennessee

"La Follette, TN Population," Census Viewer, http://censusviewer.com/city/TN/La%20Follette

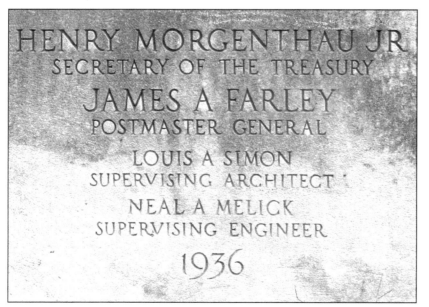

The Former La Follette Post Office

119 S. Tennessee Ave., La Follette, Tennessee 37766

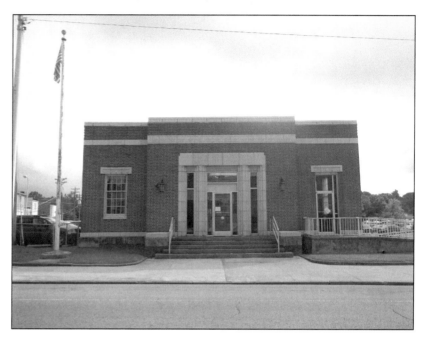

The La Follette Post Office was constructed by Di Blasio Building Company of Canton, Ohio. The cost was about $51,400.

The La Follette Post Office was completed in 1936 as indicated on the cornerstone on the lower left corner of the building, which reads, *Henry Morgenthau Jr., Secretary of the Treasury. James A. Farley, Postmaster General. Louis A. Simon, Supervising Architect. Neal A. Melick, Supervising Engineer.*

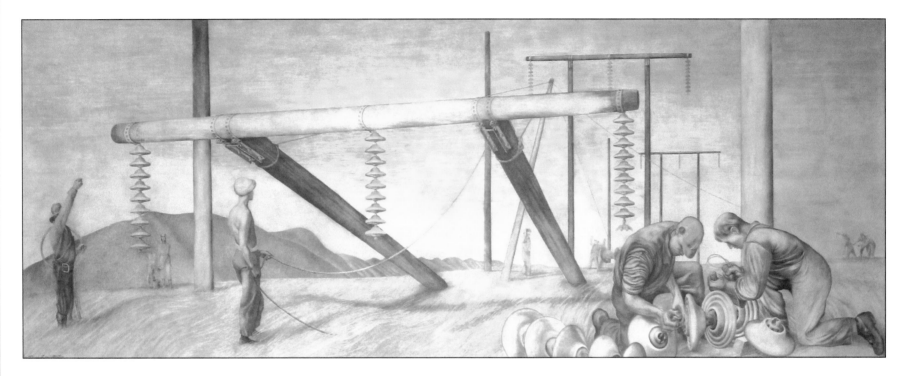

Electrification, by David Stone Martin

The mural _Electrification_ is casein tempera and measures 12' by 4'5". It depicts men from the Tennessee Valley Authority working on power lines. The commission was $740.

History of the Mural

A newspaper article detailed excitement over a possible mural: "The mural is a new step in preserving American art, and since local history and landscape are suggested subjects of the picture, it is highly possible that it shall be an attraction to the traveling public."

Accepting the commission could have posed a conflict for the artist as evidenced in several letters to and from the artist and Section of Fine Arts:

Mr. David Stone Martin has asked that we inform you of his recent resignation from the Tennessee Valley Authority to become effective at the close of business July 31, 1941. We understand that Mr. Martin has made this decision in order to pursue certain phases of his work in art which he would otherwise be unable to accomplish because of the dual-compensation regulations applicable to employees in the Federal Service.

Mr. Martin's personal record shows that he was appointed with the Authority as an Assistant Exhibits Artist, at $2,900 per annum, April 2, 1936. His present position is that of Assistant Exhibit Artist at $3,500 per annum which is the maximum rate for his grade. This maximum rate was granted Mr. Martin in accordance with the salary policy of the Authority following his accumulation of merit points as an award for outstanding work. During this employ with the Authority Mr. Martin's services were made available to the Department of Commerce for work in connection with the St. Lawrence Water-Way Survey....

Supervisors have rated his services in the performance of these duties as exceptionally satisfactory, and have commented, "Mr. Martin has consistently done outstanding work for the Authority. He has brought freshness and originality to the art work in this department and has been given merit points so that he is now at the highest rating for his classification."

Mr. Martin has accumulated annual leave which will permit his name to remain on the payroll of the Authority until early in October.

Martin's plan was to temporarily leave his employment at the Authority, complete the mural, then be rehired afterward.

The Section continued to be concerned about Martin's status:

Before Mr. Rowan left the office for his vacation, he asked me to write you to tell you that it will not be possible to execute your contract until we have a statement that you have resigned from your position with the TVA due to the ruling which we discussed with you whereby a Government employee cannot hold a contract with the Government at the same time.

Your plan of proceeding with the full size cartoon is satisfactory to us. However, the contract will have to be executed before formal approval of the cartoon can be given at which time you will, of course be ready to proceed with the painting of the mural. The additional time which you may require can be taken care of in the contract.

Martin wrote to the Section:

With regards to your letter of November 30, which dealt with the expediency of my signing a contract to execute a mural at the Lenoir City, Tennessee Post Office.

I have met with the proper people in TVA to discuss the matter, and, as a result, received the enclosed memorandum which clearly

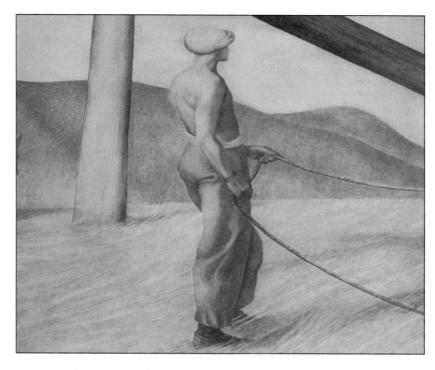

states the position of my employer. This memo was written before I received your letter.

After further conferences with TVA's Personnel Department I am confident that some arrangement can be worked out which will be to our mutual satisfaction.

I am proceeding with the cartoon while using my accumulated annual leave. When that is exhausted, I intend to resign in order to finish the mural and negotiate the contract with you.

This procedure may necessitate the use of more time than usual, but I gather from your letter that it will not inconvenience you. Thank you for your cooperation and indulgence.

Martin's employment created ongoing problems with the Section as we can see from the following letter to Mr. Rowan:

David S. Martin has asked the United Federal Workers, as his representative, to explore with you ways and means of securing the prize of $740 in the 48 State Mural Competition.

I believe we both agree that statutory limitations…and interpretive decisions by the Comptroller General make it impossible for the Section of Fine Arts to properly award a contract to Mr. Martin for executing a mural for the Lenoir City, Tennessee, Post Office so long as he is employed by the Tennessee Valley Authority. Nevertheless, since the jury selected his design and the mural has been completed and installed in the Post Office at Lenoir City, we agree also, I believe, that Mr. Martin is justly entitled to receive the cash prize offered by the Section of Fine Arts.

I should like, if I may, to offer a solution for the problem. The law states in part,

"No officer in any branch of the public service, or any other person whose salary, pay or emoluments are fixed by law, or regulations, shall receive any additional pay, extra allowances, or compensation, in any form whatever, for the disbursement of public money or for any other service or duty whatever, unless the same is authorized by law, and the appropriation therefore explicitly states it is for such additional pay, extra allowances, or compensation."

The $740 under discussion is obviously "additional pay, extra allowance, or compensation…for the disbursement of public money" and cannot be received by Mr. Martin unless "the same is authorized by law, and the appropriation therefore explicitly states that it is for such additional pay." The usual manner of handling such cases is through the introduction in Congress of a private claim bill authorizing that this payment be made to Mr. Martin.

It is our observation that private bills are handled most expeditiously when Federal agencies, rather than private individuals, request them. Federal agencies requesting large volumes of private bills are handled by Congress each session. These requests are processed in an entirely different manner than private individuals.

Accordingly, I suggest that the Section of Fine Arts, through whatever administrative channels are appropriate, have a private claim bill introduced during the next session of Congress.

Martin wrote to the Section before the mural installation:

I received a telegram from Life *magazine today stating that they wish to take a photograph preparatory to reproducing the painting in color. They want to take the photograph about August 5th. I had hoped to have the mural installed before July 31st to comply with the request you sent me. The picture should be taken before installation, however, because of the position of the Post Office vestibule. In view of these facts, is it possible that you can allow me a little more time before it is hung?*

Perhaps you remember that when I was in Washington the last time, I spoke to Mr. Hopper and Miss Ealand about the distressing business of compensation. As I explained to them, the complications to be encountered in resigning my job outweighs the amount of compensation, even in actual money.

Forrest Allen told me to look into the case of Mr. Ackerman, a T.V.A. Engineer, who sold a patent he held personally to T.V.A. while working for the Authority at the same time. I have inquired here about the case and there seems to be no details available because it was done without fanfare. Mr. Ackerman simply received the check and delivered the patent. Someone should be congratulated or given a job with the Procurement division.

Martin's case was submitted to the General Accounting Office, and Martin was advised to delay installing the mural until after a decision was made.

In a follow-up letter, Martin wrote,

Unfortunately, the mural has already been hung in the Post Office of Lenoir City. I hung it the day after the Life *photographer was here which was the 3rd of August. I had many calls from Lenoir*

City asking about when it would be hung; they were somewhat impatient to see it since there has been a good deal of publicity about it locally.

I hope the accounting office looks with approval on my case because it would be very distressing to find that the kind of work I love best is being stigmatized just because I have found it practical to hold onto a job which I am also very fond of.

Martin wrote to the Section, concerned about the delay in his compensation:

I do not wish to imply that there has been delay on your part in expediting the payment for the Lenoir City mural because I must first supply you with the negative and prints of the finished job. This I will do at once. But it has been over a year since the mural was finished and although I have a number of 8 x 10 prints, I cannot locate the negative.

A Mr. Lennie wrote an extraordinary letter about acquiring a copy of the finished mural:

I am a bedfast lineman in a tuberculosis sanatorium. I greatly admire the mural by David Martin for the Lenoir City, Tennessee Post Office in the December 4 issue of Life *magazine.*

Life's editors all [tell] me you may be able to let me know where I can get an inexpensive print for same, suitable for framing.

The Section wrote back,

We are enclosing a print of this mural which we think will be suitable for framing, and for which there will be no charge.

Your interest in this work is very much appreciated and it is a pleasure to be able to send a print to you.

About the Artist

David Stone Martin was born in Chicago, Illinois, in 1913. He is best known for music theme illustrations and African American portrait paintings. Martin received his training from the Art Institute of Chicago. Martin's work has been exhibited in the Museum of Modern Art, the Metropolitan Museum of Art, the Art Institute of Chicago, and the Smithsonian.

During the 1930s and 1940s, Martin worked for various government agencies, including as art director for the Tennessee Valley Authority, graphic arts director for the Office of Strategic Services, and art director for the Office of War Information.

David Stone Martin was a resident of Lambertville, New Jersey, at the time he was commissioned for the mural at Lenoir City, Tennessee. Martin's wife (Thelma Martin), also a noted artist, was commissioned to paint the mural in the Sweetwater, Tennessee Post Office.

Martin died in New London, Connecticut, in 1992.

Sources

"David Stone Martin," Ask Art, https://www.askart.com/artist/david_stone_martin/21716/david_stone_martin.aspx?stm=david%20stone

Falk, Peter H. *Who Was Who in American Art 1564–1975: 400 Years of Artists in America*. Madison, CT: Sound View Press, 1999.

New York Times Obituary, March 8, 1992. https://www.nytimes.com/1992/03/08/nyregion/david-stone-martin-78-illustrator-of-jazz-albums.html

History of Lenoir City

Lenoir City is a city in Loudon County and is a suburb of Knoxville, Tennessee. The 2010 census put the population at 8,642. It was first known as Lenoir's Station after the family that founded the settlement. The city was incorporated in 1907.

The city's origins lie in 5,000 acres of land that was deeded to William Lenoir by the state of North Carolina as payment for his Revolutionary War service. His son, General William Ballard Lenoir, founded the station in 1810 that would become the city.

During the Civil War, the city was targeted by Union soldiers because the Lenoirs were known to be pro-Confederate. The railroad depot and the general store were burned down, but the cotton mill was saved due to Dr. Benjamin Ballard Lenoir approaching the Union troops and giving a secret Masonic Order handshake. The mill operated in the city until the late 19th century.

Lenoir Car Works was founded in 1904 for the purpose of building and repairing railroad freight cars and was for nearly 50 years the most important business in the Loudon County area. Southern Railway purchased it in 1905, and, by 1907, the company employed close to 500 people. The number employed by the company grew to 2,700 during World War I, making it the largest employer in the area. Iron wheels became largely obsolete, and by 1957, the iron foundry had closed.

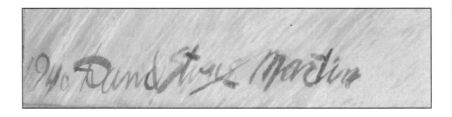

SOURCES

Downs, Rachel, "Hometown Spotlight: The History of Lenoir City," WBIR, February 13, 2017, https://www.wbir.com/article/news/local/hometown-spotlight/hometown-spotlight-the-history-of-lenoir-city/407993299

"The Lenoir City Cotton Mill," Lenoir City, http://www.lenoircity.com/lccottonmill.htm

"Lenoir City Museum and Cotton Mill Site," Visit Loudon County, https://visitloudoncounty.com/lenoir-city-museum-and-cotton-mill-site/

"Lenoir City, Tennessee (37771)," City Data, http://www.city-data.com/city/Lenoir-City-Tennessee.html

"Lenoir City, TN Population," Census Viewer, http://censusviewer.com/city/TN/Lenoir%20City

Spence, Joe, "Lenoir Car Works," *Tennessee Encyclopedia*, March 1, 2018, https://tennesseeencyclopedia.net/entries/lenoir-car-works/

Spence, Joe, "Loudon County," *Tennessee Encyclopedia*, March 1, 2018, https://tennesseeencyclopedia.net/entries/loudon-county/

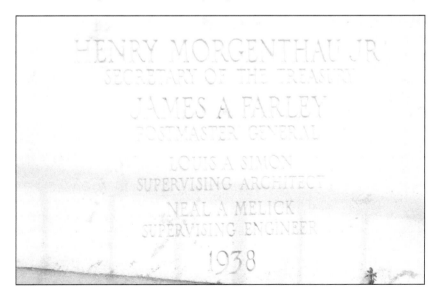

The Lenoir City Post Office

217 E. Broadway St., Lenoir City, Tennessee 37771

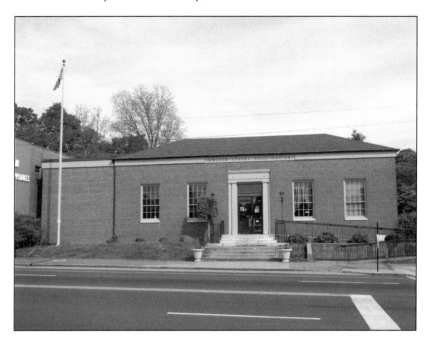

The Lenoir City Post Office was constructed by Charles H. Barnes of Logansport, Indiana. The cost was about $37,298.

The Lenoir City Post Office was completed in 1938 as indicated on the cornerstone on the lower right corner of the building, which reads, *Henry Morgenthau Jr., Secretary of the Treasury. James A. Farley, Postmaster General. Louis A. Simon,Supervising Architect. Neal A. Melick, Supervising Engineer.*

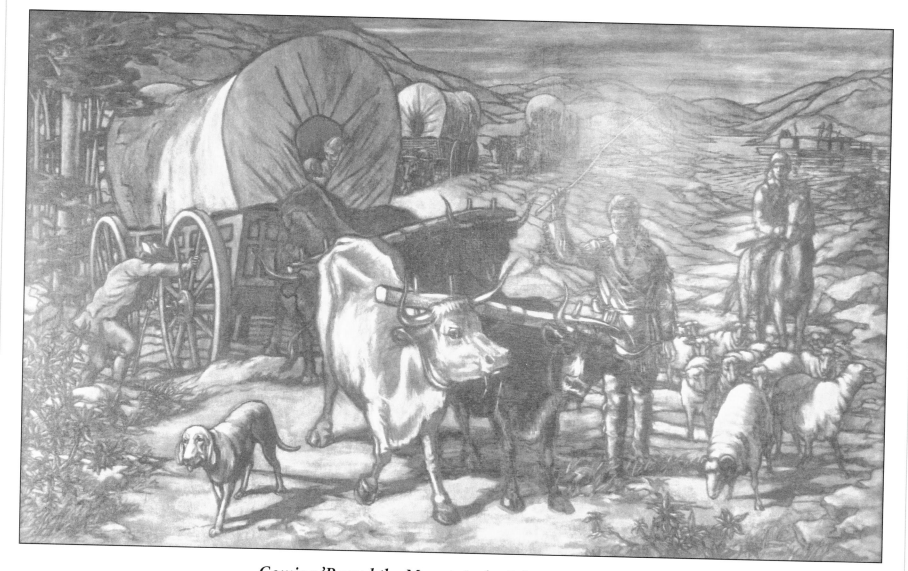

Coming 'Round the Mountain, by John H. R. Pickett

The mural *Coming 'Round the Mountain* is oil on canvas and measures 10' by 6'. It depicts early settlers traveling into Lewisburg. The commission was $620.

LEWISBURG

History of the Mural

The Section was concerned about Pickett's two preliminary sketches:

These have been considered by the members of the Section and the Supervising Architect and while we recognize the possibilities which each possesses, we are not wholly satisfied with either design and wish you to develop a further design incorporating the preferred material taken from the two.

We are not desirous of including further designs of warfare either between the Indians and Whites or of a revolutionary nature. We like that part of one of the panels dealing with the comings of the covered wagons and wish you to retain that in the new sketch. Similarly we like the treatment of the River Boats. It is our idea that you incorporate these two elements into a design dealing with the transportation and arrival of the settlers in the Tennessee Valley....

We are confident that you will be able to take care of the center portion of your panel in a way that will relate the two elements of the sides.

Pickett agreed to revise the design:

I realize that an accurate and historically correct small painting in color is necessary. Am therefore requesting that you allow me to execute this important ground work under contract. My reasons for this are obvious as I am undertaking no other work until the two murals are in place.

I am submitting the title "Coming 'Round the Mountain." The phrase aptly describes the passage of the earliest pioneers who migrated from North Carolina to the "Miro District" (Middle Tennessee) via the Cumberland Pass and who pulled and paddled a torturous course down the Holston, Tennessee, Ohio, and Cumberland rivers. Mountain fiddlers played this tune—hope you will find the new designs not off key.

Pickett asked for and received an extension for completion of the mural:

I have probably given this more time and consideration than necessary, but I wanted particularly to do a credible job in Tennessee, which as you may remember is my birth place. I have taken the warring elements out of the plan as you suggested and after studying the blue prints of the space decided, due to the height the painting will appear above the eye, that the space is better treated as one, rather than two strips as originally planned.

I have tried to get the spirit of the migration of the early settlers from North Carolina over the Cumberland Pass and around the mountains into Middle Tennessee. In submitting this design I have presented as honestly as possible the symbols familiar to every Tennessean: 1. The scale-bark tree, 2. Mountain laurel, 3. The hound, 4. The ox drawn wagon, 5. Mounted shepherd, 6. Flat boat, 7. sweep, and 8. winding streams.

I hope the material submitted meets with the standard of the Section of Painting and Sculpture and that my application for the two initial vouchers will be approved by you so that the painting may be installed within the period covered by my contract.

The Section approved the design: "The design is very handsome and is, in our estimation, a marked improvement over the original sketches, and I wish to congratulate you on your achievement."

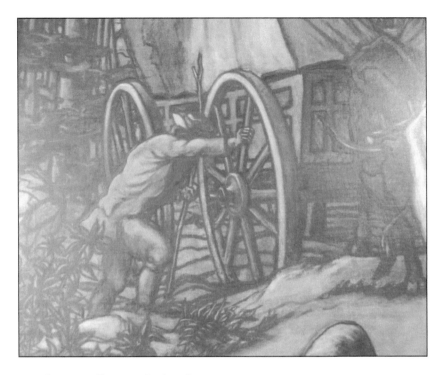

After installation, the local postmaster wrote,

This is to notify the Superintendent that the mural, the installation of which was authorized in a letter from the Fourth Assistant Postmaster General, Dated May 2nd, 1938, was installed today and is satisfactory in every respect.

It is believed that the people, judging from the expressions of those that have already observed it, will be highly pleased with the work.

It is considered excellent by the postal employees of this office and is greatly appreciated.

ABOUT THE ARTIST

John H. R. Pickett was living in Richmond, Virginia, at the time he was commissioned for the mural in Lewisburg. In addition to the Lewisburg mural, Pickett also painted *Old Dominion Conversation Piece* for the Virginia Beach, Virginia Post Office.

SOURCES

Falk, Peter H. *Who Was Who in American Art 1564–1975: 400 Years of Artists in America.* Madison, CT: Sound View Press, 1999.

"John H. R. Prickett," Ask Art, https://www.askart.com/artist/j_h_r_pickett/10042412/j_h_r_pickett.aspx?stm=pickett

History of Lewisburg

Lewisburg is the county seat of Marshall County in Middle Tennessee. The 2010 census put the population at 11,100. The city covers an area of approximately 15 square miles and is located to the east of Interstate 65 between Nashville, Tennessee, and Huntsville, Alabama.

Lewisburg was named after Meriwether Lewis, famous for the Lewis and Clark expedition that began in 1804 and that explored the land that was part of the Louisiana Purchase. The town was brought into existence due to a donation of 50 acres by Abner Houston, and it was incorporated on December 16, 1837. It did not receive its official city charter, however, until the passage of the Private Act, Chapter 36 in 1961 by the Tennessee General Assembly.

Most of the city's income came from agriculture, livestock, tobacco, and poultry. Most of these goods weren't exported early on and so remained locally sold.

Manufacturing didn't come to Lewisburg until the Red Cedar Pencil Company set up business in 1909. The Borden Company built a condensed milk plant to process milk in 1926, along with many other companies.

In 1935, the Tennessee Walking Horse Breeders' and Exhibitors' Association was founded in Lewisburg and remains in operation to this day.

By the 1960s, Interstate 65 was completed, and this caused much of the economic growth seen in Lewisburg and Marshall County today, as much of the area's transportation before this relied on the Louisville and Nashville Railroad, the Duck River, and some basic routes across the land.

SOURCES

"About Us," Tennessee Walking Horse Breeders' & Exhibitors' Association, https://www.twhbea.com/association/

"Lewisburg, TN Population," Census Viewer, http://censusviewer.com/city/TN/Lewisburg

"Slide 1," Lewisburg, TN, https://www.lewisburgtn.gov/images/pdf/lewisburg-history.pdf

West, Carroll Van, "Marshall County," *Tennessee Encyclopedia*, March 1, 2018, https://tennesseeencyclopedia.net/entries/marshall-county/

The Former Lewisburg Post Office

121 S. 1st Avenue, Lewisburg, Tennessee 37091

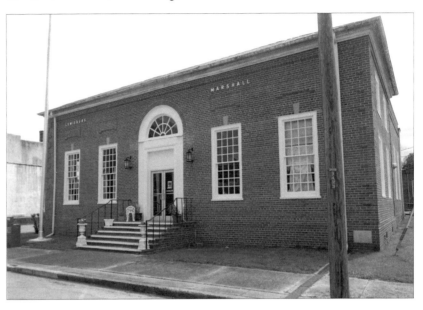

The Lewisburg Post Office was constructed by Forcum-James Company of Memphis, Tennessee. The cost was about $36,471.

The Lewisburg Post Office was completed in 1935 as indicated on the cornerstone on the lower right corner of the building.

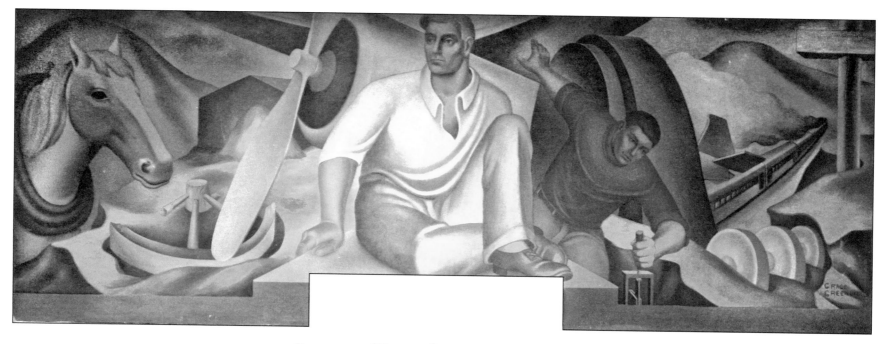

Progress of Power, by Grace Greenwood

The mural *Progress of Power* is oil on canvas and measures 13' by 4'. It depicts a man as the central figure with horse, airplane, train, and worker on either side. The commission was $700.

LEXINGTON

History of the Mural

After Greenwood submitted a preliminary sketch, the Section wrote,

The sketch has been studied by the members of the Section and it is our feeling that the indications are satisfactory enough to allow you to proceed. The design seems slightly heavy from center moving to the right and it is suggested that the lower part of the figure of the man with the motor [be] given indication of being completely realized. Taking these suggestions into consideration kindly proceed with the two-inch scale color sketch which should be forwarded to this office for our further consideration.

Greenwood wrote back,

In studying the blueprint, I found it necessary to make a slight variation in the dimension of the panel—to unify the space above the postmaster's door and the bulletin boards.

The central figure symbolizes the evolution of power in this area of the country. The horse and the broken wheel: the old order, which is being gradually eliminated. Also there is suggested the progress made, in the delivery of the mail, by the airplane and propeller. Modern industrial development though the generation of power through natural resources, resulting advantageously to both man and animal, as well as the chance given man for cultural improvement: symbolized by the turbine, the streamlined train and the transmission of power as shown by the installation of electric at the lower right side of the figures.

After considering the Section's suggestions, Greenwood wrote,

I have revised my composition in accordance with your suggestions. The figure (right center) is now more than a torso but in scale with the other forms. It is my plan, as shown in the sketch, to use a simple palette of color that is cheerful, with a tonal balance of white areas. All forms are essentially symbolized and simplified.

After receiving a new sketch, the Section wrote,

The sketch has been reviewed by the members of the section and has been found satisfactory with one exception.

It is our feeling that the scale of the figure working with the lever is not related to the seated figure in the center of the composition. Would it not be possible for you to move the working figure and the dynamo either slightly deeper into the composition or slightly right? While I am aware that the elements introduced in the composition are symbolic, it is always disturbing to me personally to have the feeling that the elements aren't completely realized throughout. Consider, for instance, the termination of the airplane. No logical explanation is given for the complete disappearance of the form in back of the dynamo. As stated above, this is a personal reaction and I offer it to you for what it is worth....

Greenwood wrote back about further revisions:

I have read your letter carefully and I fully agree with you regarding the termination of the airplane. I am revising the sketch by changing the perspective and this revision will also redistribute the weight balance so that the figure with the dynamo will not over weigh the right side of the composition.

When I receive the contract, I will as you have indicated start working on the cartoon. Enclosed please find the required

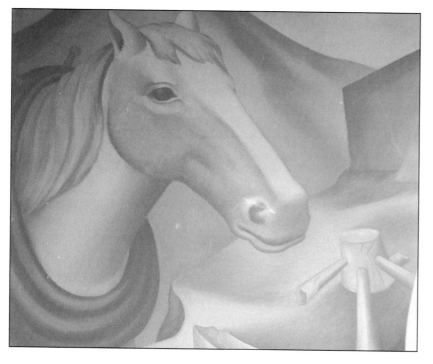

information concerning media etc. Thanking you for your suggestions.

After receiving a photograph of the full-size cartoon, the Section wrote back to say that the progress was satisfactory with one caveat:

The only suggestion offered relative to the further painting is that the gesture of the man pulling the lever be not over-forced, as he appears slightly forced in the drawing. This is particularly true of the relation of the head to the shoulders.

Greenwood wrote back,

I received all the letters including the voucher. Thank you very much. Your suggestion about the figure (to the right) seems to be a logical one and I will make a more careful study of the position of the head, in relation to the shoulders, in the final painting.

About the "gesture" of this figure appearing to be slightly forced in the drawing—it appears to look more so on eye level—but studied from 8 ft. below, the figure takes its place very well on the wall. However, you may be sure that I will study the problem more carefully in the painting.

The Section found her "explanation of the drawing of the figure on the right...entirely logical."

Greenwood asked to be considered for a mural commission "somewhere in the vicinity of New York state...I would like to paint it in fresco—I haven't had a chance to paint fresco since my return from Mexico." An internal Section memo, however, made this a faint possibility: "I think there are dozens of the 48 state designs runner-ups that are better than Miss Greenwood—they should get the job first." The Section did agree to place her on a waiting list.

Greenwood requested and was granted an extension for installation so that she could first exhibit the mural independently, after which she would transport the mural to Lexington. The postmaster, in a letter dated February 2, 1940, reported that the mural had been installed, though the lobby lighting fixtures had to be raised to accommodate the proper viewing of the mural.

Greenwood wrote about the mural's reception:

I received a letter from the Postmaster's assistant showing his appreciation. In the letter there was a clipping from the local newspaper, a sentence which I quote: "Lexington is the proud possessor of a beautiful mural—it should afford the people of this section much enjoyment and is interesting enough to keep fine arts alive."

It is gratifying to know that the work was well received. Concerning future work (I hope it will be the near future) would it be possible to give me one in this part of the country? Could you hasten the $300 payment? This soy bean diet is getting monotonous, to say the least.

One of the post office clerks wrote about the process and reception of the mural:

Allow me to take this opportunity to express my thanks and appreciation for the fine mural painted by Miss Grace Greenwood of New York City and installed in the lobby of our post office building by Mr. James Giangrasso. The mural has caused a great deal of interest around here and we have received many nice compliments from the general public. I am a post office clerk here and many local citizens call at my window and ask about the mural. I describe it to the best of my ability and it seems that it is being well liked by the people of this community, especially those civic minded citizens who appreciate the finer things in life.

I had the pleasure of assisting Mr. Giangrasso in installing the mural, and my associations with him have caused me to believe that he is a high class gentlemen and well trained in his work. Since

I am an amateur photographer, I took several pictures of the mural and I am sure that copies of them have been sent to your office. There is one obstruction to viewing of the mural, and it is a light fixture that should be raised and I am sure that will be done by your department.

Again let me say "Thank you" to you, Mr. Giangrasso and Miss Greenwood, whom I am sure is a very talented artist, judging from the mural she painted for our office.

ABOUT THE ARTIST

Grace Greenwood was born in Brooklyn, New York, in 1905. She is best known for her mural paintings. Grace was raised in a family of artists: Her father was a painter, and her younger sister, Marion, painted the mural in the Crossville, Tennessee Post Office.

Greenwood studied at the Art Students League in New York, along with her sister. She later studied abroad in Italy in the 1920s.

The commission was awarded to the artist under her maiden name, Grace Ames. By the time the mural was completed, her name had changed to Grace Greenwood, and she was living in New York City.

In addition to the Lexington mural, Greenwood's work includes the following:

Camden Ship Year mural, oil, 500 sq. ft., painted for Treasury Art Project.

Fresco mural in the Mercado Rodriguez Mexico City, 1,500 sq. ft.

Fresco mural in State Museum of Morelia, Michoacán, Mexico, 250 sq. ft.

Mars Cycle, Egg Tempera.

Inventor, oil on gesso.

Lady Godiva, oil.

Head, crayon.

Young Archimedes, oil.

Greenwood died July 21, 1979, in New York City at the age of 74.

SOURCES

Falk, Peter H. *Who Was Who in American Art 1564–1975: 400 Years of Artists in America*. Madison, CT: Sound View Press, 1999.

"Grace Greenwood," Ask Art, https://www.askart.com/artist/Grace_Greenwood/10021640/Grace_Greenwood.aspx

History of Lexington

The city of Lexington is the county seat of Henderson County in western Tennessee. Its population in the 2010 census was 7,652. It is the highest elevation of all West Tennessee county seats.

Lexington was founded in 1821 by Samuel Wilson soon after the creation of Henderson County and was incorporated in 1824. It was named after Lexington, Massachusetts, and the first governing body of the city was comprised of Abner Taylor, James Purdy, Job Philpot, and J. J. Hill.

In the lead-up to the Civil War, Henderson County voted not to secede from the Union. Unfortunately, Lexington would be one of three locations that were targeted in the West Tennessee Raids conducted by Nathan Bedford Forrest, along with the towns of Jackson and Parker's Crossroads.

During the Civil War, the Battle of Lexington was fought on December 17, 1862, resulting in a loss for the Union. The Confederates were led by Nathan Bedford Forrest, while the Union troops who were forced to surrender were led by Colonel Robert Ingersoll, who it is said had a pleasant time being captive because he had played poker with some Confederate soldiers. He was paroled three days after his capture.

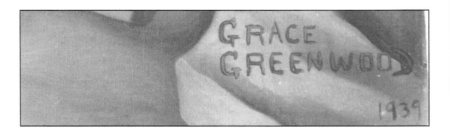

Nearby Parker's Crossroads was the site of a battle between the troops of Brigadier General Nathan Bedford Forrest and Union Brigadier General Jeremiah C. Sullivan on December 31, 1862. Although the Confederates lost more troops, both sides claimed victory.

Lexington today sits at the crossroads of Tennessee State Routes 22 and 114 and U.S. Highway 412 and is approximately 10 miles south of Interstate 40.

Sources

"Battle for Lexington Historical Marker," Historical Marker Database, https://www.hmdb.org/m.asp?m=81884

"The Battle of Parker's Cross Roads," American Battlefield Trust, https://www.battlefields.org/learn/maps/battle-parkers-cross-roads

"Full Text of Tennessee County History Series: Henderson County," Archive.org, https://archive.org/stream/tennesseecountyh39stew/tennesseecountyh39stew_djvu.txt

"Henderson County: Land of History and Promise," *TN Yesterday*, https://www.tnyesterday.com/yesterday_henderson/hchs.html

"Lexington, TN Population," Census Viewer, http://censusviewer.com/city/TN/Lexington

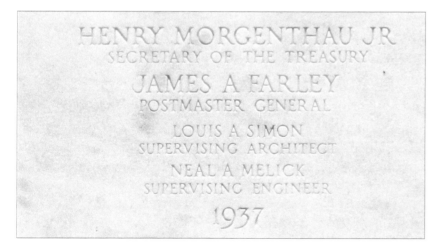

The Former Lexington Post Office

26 S. Broad St., Lexington, Tennessee 38351

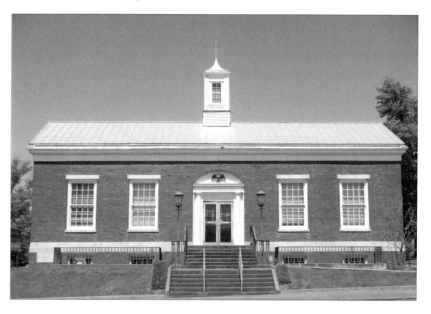

The Lexington Post Office was constructed by Bonded Construction Company of New York City, New York. The cost was about $51,067.

The Lexington Post Office was completed in 1937 as indicated on the cornerstone on the lower right corner of the building, which reads, *Henry Morgenthau Jr., Secretary of the Treasury. James A. Farley, Postmaster General. Louis A. Simon, Supervising Architect. Neal A. Melick, Supervising Engineer.*

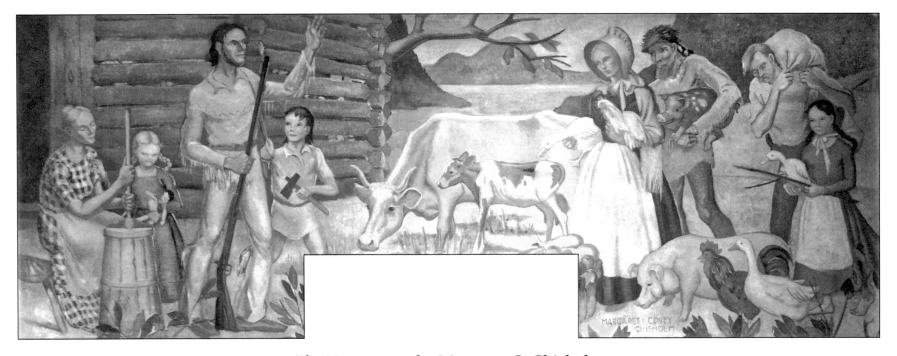

The Newcomers, by Margaret C. Chisholm

The mural *The Newcomers* is oil on canvas, measures 13' by 4'. It depicts settlers delivering offerings to the new residents. The commission was $560.

LIVINGSTON

History of the Mural

After Chisholm was given the commission, the Section was concerned that she had not submitted a progress report. She wrote,

In reply to your letter of June 8th requesting a report on progress on the Livingston, Tennessee, Post Office, I wish to say that I have done a great deal of research in order to get the most interesting decoration possible. I have written to several people and still feel that the material found in "The Annals of Tennessee" by Ramsey is the most interesting—I have had sketches ready to send, and delayed, in order to get better ones, and lately of a necessity have been doing some portraits, and am getting prints made of these to forward to you.

The only information I received from Secretary Hull's secretary was who the oldest living inhabitant of Livingston, Tennessee was.

The Section replied with some suggestions:

Thank you for your letter of June 21 and permit me to acknowledge the receipt in this office of three preliminary black and white sketches representing your proposal for the mural decoration of the Livingston, Tennessee Post Office. Your designs have been considered by the members of the Section, and we prefer the subject of "The Newcomers," as this offers entertaining opportunities for a lively decorative pattern and the implication of a way of life which should carry a message of sympathetic understanding and hospitality that might well serve as a valuable lesson today. You have selected material which is valuable from this standpoint and yet does not obviously carry a moral tacked to it.

Relative to your design, some confusion exists between the placement of the owner of the cabin and the cabin itself. Was it your intention to show him leaning against the cabin? If so, do you not feel that the building is out of scale with him? My suggestion would be to represent him in a gesture of welcome and place the cabin further into the composition.

Relative to the borders around the bulletin boards I suggest that they be treated in the charming manner in which they were treated in the design of "Journey by Water."

After receiving the technical outline and sample of canvas, the Section was concerned that "the sample of canvas does not appear to be heavy enough in weight for a mural of this size." However, Chisholm eventually provided a satisfactory canvas sample, and the Section moved ahead with her contract.

While working on a small color sketch, Chisholm wrote,

I am very pleased that you preferred "The Newcomers," as that is the one I was interested in most working out. In regards to the perspective of the cabin in the design, I believe it is quite straightened out.

I wrote to the H.S. Principal at Livingston, and sent a drawing of the elevation on which to indicate colors, I have received excellent information from here, so am ok to get at the color sketch, which I am enjoying doing.

The scale drawing on the blueprint and given dimensions do not tally very well, so that I have written to the local postmaster for source measurements from the building itself, which is the best way; there has also been changes in materials used for the building.

I should like to have gone down to the post office, but it is impossible because I have no one to leave my small boy with, and it doesn't seem necessary as the people in Livingston have been most helpful on furnishing information.

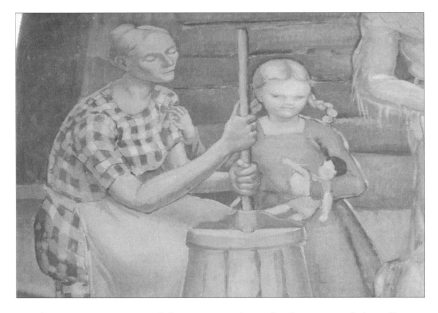

The Section approved her two-inch-scale drawing while offering some criticisms:

The hide mounted on the log cabin to dry does not take its place properly and comes forward to surround the father of the family a little too insistently. You, no doubt, have checked on the strange sun bonnets which you used for the woman. The general treatment of the decoration around the bulletin boards carries much charm and the color was…nicely related to the architecture.

Later in the process, Chisholm responded to the Section's concerns:

This is to let you know that I am sending today under separate cover, photograph and negative of the cartoon for Livingston, Tennessee Post Office decoration.

In reference to your letter of August 5, 1939: I wish to say that I have decided to eliminate the hide placed on the cabin back of the father of the family. It did not appear in the preliminary sketch— and I feel the decoration looks far better without it.

Also, you will see that I have changed the details, to make them more understandable to people—and better for the period.

Because of illness, Chisholm asked for, and eventually received, an extension:

The mural for Livingston, Tennessee Post Office was finished October 15, 1939 with the exception of finishing the borders, which go around the bulletin boards. Since that date I have been laid up and now on crutches with "water-in-the knees," a bad business.

According to my contract the mural should be installed by February 1, 1940, which I hope to accomplish, my physical condition permitting—my father expects to go to Tennessee with me to install.

Chisholm did finish the mural and later installed it with the help of her father, Arthur, after which the Section requested that she forward public reactions to the artwork. The comments she sent included the following:

Janitor (middle aged man, toothless): "I didn't think you could have found a better design for a picture than that, you find a lot of sections back in these hills that put us in mind of that picture. See it, puts me in mind of an old fellow I saw here in town about a month ago, wearing one of these coonskins caps with a tail."

From a conversation begun by a woman who came in when wall was covered with white lead, picture still rolled up: "Looks like you're changing your color scheme." Janitor: "Wait till tomorrow and then look at it." Woman; "Well, don't paint it red, that's all I ask." A child by her side: "Please do!"

The janitor (again): "You couldn't find a picture more appropriate to this place. Most of the people here are mountain people, with only a common school education. Lots of em can't read or write—the kind of pictures artists like they think are terrible. But

I'm sure they'll like this. They're all good cows and farm animals. It sure looks mighty pretty."

Active, middle-aged man: "I see you're gonna fix things up. How I know that represents the old pioneers (accent on pi) and the modern ladies of today? You don't show em." (Studies it all carefully.) "Now, what's that man behind there carrying in his sack? Corn, likely. Wouldn't you like to see one of them old-fashioned churns like that—they used to make em out of cedar."

One woman said she never saw a pink pig before.

The most frequent comment is "Ain't that pretty," "Mighty pretty!" "That sure is pretty."

Mr. Taylor (the high school principal): "Oh! They're large figures.... quite surprised and had expected figures to be 6 or 8 in. high."

And one comment: "Each man should have a wife!"

Rowan wrote back,

I have read these [comments] with great interest and amusement. They have a homey tang which gives them an air of the authenticity.... My congratulations on the happy reception of your mural. It is due entirely to the serious study which you gave the subject matter and the industry applied in working it out.

ABOUT THE ARTIST

Margaret Sale Covey was born on July 6, 1909, in Englewood, New Jersey, and is best known for her portrait painting. He father was the well-known artist and painter Arthur Covey. She married Robert K. Chisholm.

Covey's education included the Art Students League in New York, the Pennsylvania Academy of Fine Arts, and a year at the School of Fine Arts in Fontainebleau, France. She eventually graduated with a fine arts degree from Yale University.

A newspaper article discussed the painting as well as Chisholm's background:

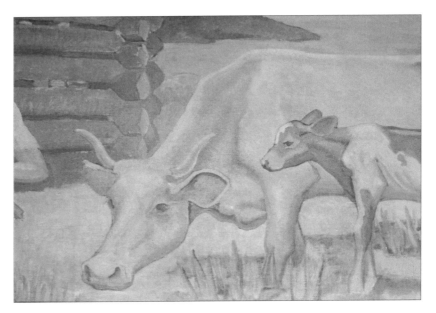

In the "Annals of Tennessee," a word picture by John Donaldson in his journal of a voyage from Fort Patrick Henry to French Salt Springs helped to suggest to Mrs. Chisholm the scene depicted in "The Newcomers."

After the cabin is raised, and the new comers are in it, every family near at hand, bring in something to give them a start. A pair of pigs, a cow, and calf, a pair of all the domestic fowls, and any supplies of the necessaries of life which they have, all are brought and presented to the beginners. If they have come into the settlement in the Spring, the neighbors make another frolic, and fence a field for them.

All these acts of kindness and beneficence are ... performed without ostentation, and cordially. The stranger so appreciates them, and the first occasion that presents they are ready with like spirit, to extend similar kind offers to emigrants who come next. The performance of them thus becomes a usage and characteristic of the frontier state of society.

Mrs. Chisholm's portrayal of her subject is at once simple and moving. The "newcomers" depicted outside their log cabin at the

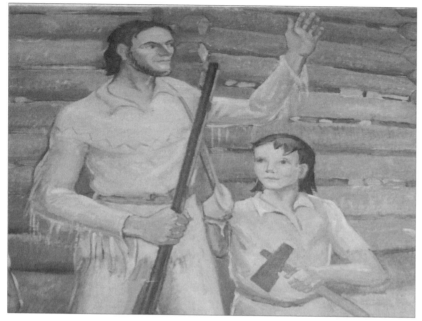

left are welcoming their neighbors who are driving a gay profusion of farm animals before them. The solemnity of the occasion is reflected in the offices of the adults, and the excitement in the movement of the children. The tall, Lincoln-like father of the pioneer family has raised his hand in a gesture of greeting patterned after the Indian sign of peace.

Mrs. Chisholm's work is characterized by a sensitivity sometimes lacking in contemporary art. The shyness of the little girl carrying the goose as offering is one of the many touches that contribute to the depth of richness of her painting.

Daughter of the well-known artist Arthur Covey, Mrs. Chisholm has painted for many years under her maiden name. Her training and professional career have not been imitated, however, and her work has been accorded widespread recognition independent of her father's.

Chisholm died January 24, 1965, in Pleasantville, New York.

Sources

Falk, Peter H. *Who Was Who in American Art 1564–1975: 400 Years of Artists in America*. Madison, CT: Sound View Press, 1999.

"Margaret Covey Chisholm," Ask Art https://www.askart.com/artist/Margaret_Sale_Chisholm/10011688/Margaret_Sale_Chisholm.aspx

History of Livingston

Livingston is the county seat of Overton County and at the 2010 census, its population was 4,058. The city was named after Edward Livingston, who assisted in drafting the Louisiana Civil Code of 1825. Multiple communities in the United States are named after him.

Even though Livingston is the county seat of Overton County today, it is not the original county seat. The original seat was located in Monroe, but Overton County representative Alvin Cullom suggested the change. The town was growing at the time and new roads being built made the move make sense. The county residents voted to move the county seat to Livingston in 1835. One story says that a man named Jess Eldridge who was traveling with six to eight of his neighbors was so intent on the county seat moving to Livingston that he let the horses of his traveling companions to the election loose in the night and, by the time they found them, they were too far from Monroe to be able to vote. The vote to move the county seat to Livingston succeeded by four votes.

In the spring of 1865, the Livingston courthouse was burned down by Confederate guerrilla troops from Kentucky due to records that federal authorities were storing there to use against residents who

were thought to be involved in Confederate activities. The courthouse was rebuilt between the years 1868 and 1869.

The historic post office in Livingston was constructed in 1936 as a part of the New Deal project. It remains in operation today.

SOURCES

Birdwell, Michael E., "Overton County," *Tennessee Encyclopedia*, May 28, 2019, https://tennesseeencyclopedia.net/entries/overton-county/

"Livingston Tennessee in 1933," *Josephine's Journal*, http://www.josephinesjournal.com/livingston1933.htm

"Livingston, TN Population," Census Viewer, http://censusviewer.com/city/TN/Livingston

"Overton County Courthouse, Livingston, TN, US," Historical Marker Project, October 14, 2014, https://historicalmarkerproject.com/markers/HM1AKR_overton-county-courthouse_Livingston-TN.html

"Post Office, Livingston, TN," *Living New Deal*, https://livingnewdeal.org/projects/post-office-livingston-tn/

The Livingston Post Office

105 S. Court Sq., Livingston, Tennessee 38570

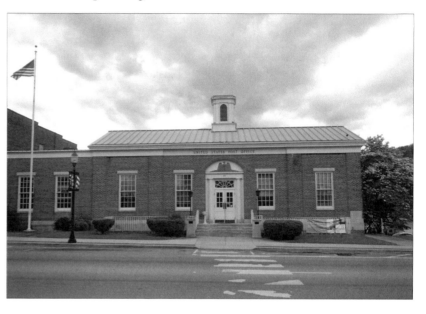

The Livingston Post Office was constructed by Foley Brothers of McMinnville, Tennessee. The cost was about $50,419.

The Livingston Post Office was completed in 1936 as indicated on the cornerstone on the lower right corner of the building, which reads, *Henry Morgenthau Jr., Secretary of the Treasury. James A. Farley, Postmaster General. Louis A. Simon, Supervising Architect. Neal A. Melick, Supervising Engineer.*

HENRY MORGENTHAU JR
SECRETARY OF THE TREASURY
JAMES A FARLEY
POSTMASTER GENERAL
LOUIS A SIMON
SUPERVISING ARCHITECT
NEAL A MELICK
SUPERVISING ENGINEER
1936

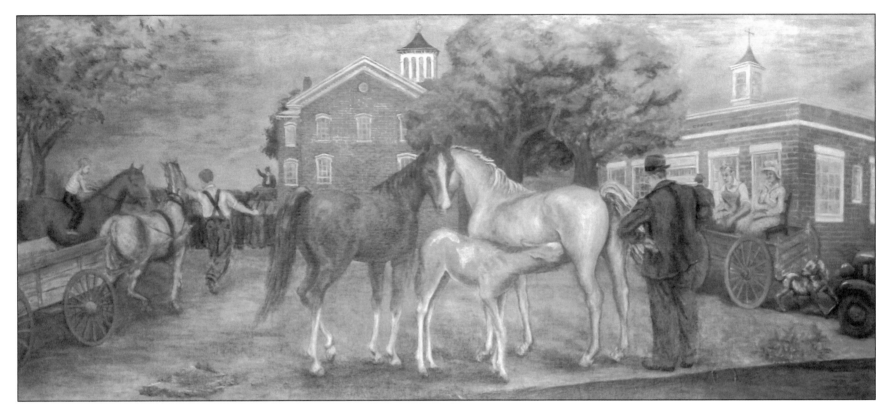

Horse Swapping Day, by Minna Citron

The mural _Horse Swapping Day_ is oil on canvas, measures 11'11" by 5', and was installed in April 1942. It depicts a weekly get-together in Manchester to swap horses. The commission was $750.

MANCHESTER

History of the Mural

After being selected for the commission, Citron wrote to the Section:

The eight-month time limit doesn't frighten me, but I could wish the letter were dated April 7 instead of February 7. You see, I prefer to visit Manchester before proceeding and since it is an agriculture building it seems to me that early spring planting season etc. would be a more rewarding time of year for observations and sketches than the tail end of the winter when mud prevails. I know you will adjust this if you can....

The Section replied,

The eight-months time limit on your contract will not begin until your preliminary sketches are approved and your contract is written and no objection is offered to your visiting the building during April which sounds like a good idea.

The Postmaster has been informed of your commission so you may feel free to call on him at that time to discuss suitable subject matter and to check the mural space.

Wishing you success.

In a later letter, Citron discussed her inspiration as well as details about the actual subject matter:

In Manchester, Horse Swapping Day is a weekly event and very close to the lives of the people since it is market day—social life and political meeting all at once. And Manchester is the seat of Coffee County. This subject gives me opportunity, I think, for some good natural humor as well as the chance of painting in the local buildings that I found.... Incidentally, there is a yearly festival in nearby

Columbia which... should be a swell mural for the Columbia Post Office.... This idea intrigued me but I decided Manchester would prefer subject matter more indigenous to itself.

The wall measures 11'11" by 5' (your letter had it 12 x 4—I assume that was an error). It's a good space for a decoration—good light and good fixtures. However, there is a side bracket which will have to be removed. Mr. Doak said there would be no difficulty about that, as it should be lower down just over the desk anyway. But you will know what the procedure is on that.

Citron wrote about her progress:

I've had a lot of fun with the color sketch I just mailed you. This second mural (naturally I guess) goes along much easier that the first. It's only 1/4 the size, the space is uninterrupted, 1 long horse and the blood, sweat, and tears of the T.V.A job make the difference. I hope I can sustain this free, direct, joyful mood to the end. What do you think?

The Section followed up with a suggestion:

This office concurs with you that you have achieved a free, direct and joyful mood in the design. It is extremely handsome in color and it is approved at this stage. The only suggestion is that in the final work you will probably wish to make certain sections such as the further walls of the buildings a little more substantial but this, of course, will depend on the general treatment throughout.

Citron continued to detail her progress as well as ask for a recommendation for a Guggenheim Fellowship:

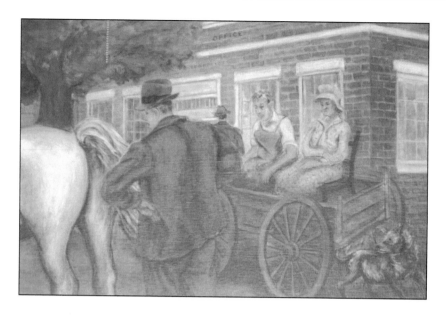

In a short while I shall have finished the cartoon for Horse Swapping Day! Will it make any difference if I photograph it and send that as I did for the T.V.A mural instead of searching for a roller and wrapping it etc. Etc. The cost will be about the same to me but it will be less bother and will save you the expense of photographing.

I have reserved the canvas which you oked. One of these days, my first check will come through.

I'm working on my Brazilian idea but can't report much progress. Mr. Thomson of the State Department wrote a nice letter for me but the cultural and commercial Relations committee (according to Mr. Mac of the Guggenheim) isn't using its funds in that way. A letter from you to…Nelson Rockefeller or the Brazilian Ambassador might help.…May I again use your name as reference? Truly this year you will have to do better. Wasn't [it] you who told me that you have a 100% record negatively speaking on those you have recommended?

The Section's Rowan assured Citron that a payment voucher would soon be sent and addressed the possible recommendation:

Certainly you may use my name as reference in your application for a Guggenheim Fellowship. I am afraid it was I who told you I have a 100% negative record on those I have recommended.

I do not feel that this office can undertake to write a letter to Mr. Ford [which Citron had suggested] recommending an individual to do water colors. If the letter originated with us it would be necessary to suggest a group rather than an individual, and I am sure you understand this attitude.

After receiving the cartoon, however, the Section expressed strong reservations about the mural:

The photograph has been reviewed by the members of the Section and it is our feeling that the design has been improved but we are still very much distressed over the drawing of the horses. It is our sincere feeling that what is needed more than anything else is direct observation of these animals by you. The drawing of the animals on the left carry no authority. The necks of the adults are not attached convincingly—there is some lack of flow—in other words they give no reflection of facility or acquaintances on your part with the subject matter. Merely to be of some assistance to you I enclose a small marked tracing.

I must warn you not to proceed with the painting on canvas as the cartoon is not approved and cannot be until the drawing of the animals has been convincingly realized. I am terribly sorry, but it will be necessary for you to send a further photograph at this stage showing the revisions.

In a later criticism, the Section discussed other unsatisfactory details:

Your cartoon has been studied by the members of the Section and I regret to inform you that in our opinion this is not up to your standard. The drawing is entirely unsatisfactory in the central portion of the cartoon. The three animals are questionable and particularly

the colt which in part has the characteristics of a calf. The man leaning on the horse is not convincingly drawn to begin with and secondly question is raised at his apparent familiarity. Most men who handle horses would hesitate to lean on the animal at this point. On the right the body of the animal and the front part of the wagon to which he is harnessed are not realized. The wagon on the extreme left seems out of scale with the animals in front of it.

The cartoon has shown improvement in the treatment of its buildings, particularly the center building. The side view of the Post Office is questioned. If a specific building is introduced into a design it is essential that it be a truthful presentation of that building. It is frankly our feeling that this work does not reflect sufficient checking with the elements introduced into the composition and I look forward to a photograph showing the revisions.

In addition, there were concerns over the exact placement of the mural:

The Postmaster refused to give authorization for the installation of this mural until this matter has been settled.

I recall that a small architectural rendering showing the proposed placement for your mural in relation to the architectural features was requested at the time of your last visit. Your delay in submitting this is causing me some inconvenience as it is not possible to reply to the Postmaster's letter in question. Kindly comply by rushing the rendering at your earliest convenience.

Citron relayed both her progress as well as her concerns:

Here is a new photo of my mural cartoon on which all of the suggested alterations have been made. I trust you will find that my stay at the Rodeo has proven beneficial to my horses. Gene Autry (and his publicity man) are delighted that his Tennessee Walker Champ Jr. is being immortalized. You may find the enclosed studies of interest. At any rate please return them post haste as I want

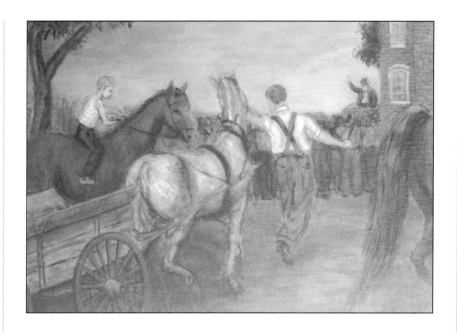

to mat several for my Corcoran exhibition. A check (post haste) would also be very welcome as I am framing a batch of paintings for my exhibition of oils at the Midtown in December and that's only the beginning as you know.

I do not regret the extra time put in on the mural cartoon and the time spent (3 full weeks) at the Rodeo, but because of these delays I shall need an extension of time in painting the canvas.

The Section did approve Citron's request for a delay, but there continued to be problems with the lighting fixture:

This office is of the opinion that the lighting fixture now occupying the mural space should be relocated but it has been determined that no funds are available with which to undertake this change. The artist has been requested to attempt to design the mural in such a way that the relocation of the fixture will not be necessary.

Just as soon as this office has a statement from the artist relative to this, I shall be happy to relay it to you.

Rowan followed up with the artist's suggestion:

No funds are available for the relocation of the fixture, but the artist has stated that she would be glad to undertake the expense of lowering the fixture to the wood paneling over the desk.

The challenges concerning the lighting fixture continued:

About that interfering fixture. I shall of course arrange the design around it as well as possible. But if I would stand the small expense of lowering it to the wood paneling over the desk where the light would better reach the writer, would there be objections? The fellows in Manchester expressed their willingness when I was there to do the job themselves. It certainly will be better for the mural and the Post Office to have it lowered. Let me know about this as soon as possible please. I do hope permission can be granted.

However, the Section could not obtain permission for relocating the light fixture, so eventually the artist agreed to modify the mural so that the fixture (and accompanying public bulletin board) could remain in place. After receiving a photograph of the completed mural, the Section approved its installation.

The local postmaster confirmed in a letter dated April 10, 1942, that the mural had been installed.

About the Artist

Minna Wright Citron was born on October 15, 1896, in Newark, New Jersey. Citron is best known for her abstract work, graphics, and mural paintings. Citron studied at the Brooklyn Institute of Arts and Sciences, the New York School of Applied Design for Women, and the Art Students League in New York.

Citron had a successful and rewarding career which spanned several decades. With the rise in government-sponsored art in the 1930s, Citron taught painting for the Federal Art Project in New York City.

From 1930 to 1940, she was commissioned for two post office murals, one in Newport, Tennessee, and one in Manchester, Tennessee.

Citron died December 23, 1991, in New York.

Sources

Falk, Peter H. *Who Was Who in American Art 1564–1975: 400 Years of Artists in America.* Madison, CT: Sound View Press, 1999.

"Minna Citron," Ask Art. https://www.askart.com/artist/minna_wright_citron/73930/minna_wright_citron.aspx?stm=citron

"Minna Wright Citron," *New York Times,* https://www.nytimes.com/1991/12/24/arts/minna-citron-95-artist-whose-work-spanned-2-schools.htm

History of Manchester

Manchester is the county seat of Coffee County and the 2010 census put the population at 10,102. The existence of the town predates the creation of Coffee County, as a post office has been in operation there since 1817. The city was originally called Mitchellsville, but it was renamed Manchester after the city in England of the same name.

Approximately one-half mile southwest of Manchester is the Old Stone Fort, which is the remains of an ancient stone fortification believed to have been built around 1,500 to 2,000 years ago. When Europeans arrived in the area, there wasn't much evidence remaining of what the location was used for, so it was incorrectly named a fort. It wasn't an officially protected site until 1966 when the state of Tennessee purchased 400 acres and formed Old Stone Fort State Archaeological Park.

The McMinnville and Manchester Railroad line was operated by the Nashville and Chattanooga Railroad from January 1, 1857 to August 1862, when it was occupied by the Confederate Army.

Manchester, along with the rest of Coffee County, was chosen to be a part of the Tennessee Maneuver Area during World War II for troops to conduct training maneuvers. Maneuvers were conducted in Manchester by Major General George S. Patton, and his tactics, which were based on the cavalry doctrine of Civil War General Nathan

Bedford Forrest, were successful in defeating the opposing forces during the maneuvers.

Since 2002, Manchester has been the host of the annual Bonnaroo Music Festival. The city draws nearly 100,000 people every year for the event that spans four days across an area of 700 acres.

SOURCES

"Bonnaroo Music and Arts Festival," *Encyclopedia Britannica*, July 2, 2019, https://www.britannica.com/art/Bonnaroo-Music-and-Arts-Festival

"Coffee County Historical Society," Coffee County Historical Society, http://www.cctnhs.org/History.html

"Manchester, TN Population," Census Viewer, http://censusviewer.com/city/TN/Manchester

"Old Stone Fort State Archaeological Park," Tennessee State Parks, https://tnstateparks.com/parks/old-stone-fort

"The Tennessee Maneuvers: A Temporary Operation," The Tennessee Maneuvers, https://tennesseemaneuvers.org/maneuvers/

"USPS: Postmasters by City," USPS, https://webpmt.usps.gov/pmt002.cfm

The Former Manchester Post Office

200 N. Spring St., Manchester, Tennessee 37355

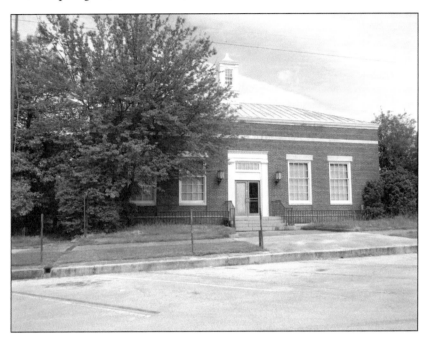

The Manchester Post Office construction when new cost about $75,000.*

The Manchester Post Office was completed in 1940 as indicated on the cornerstone on the lower right corner of the building, which reads, *James A. Farley, Postmaster General. John M. Carmody, Federal Works Administrator. W. Englebert Reynolds, Commissioner of Public Buildings. Louis A. Simon, Supervising Architect. Neal A. Melick, Supervising Engineer.*

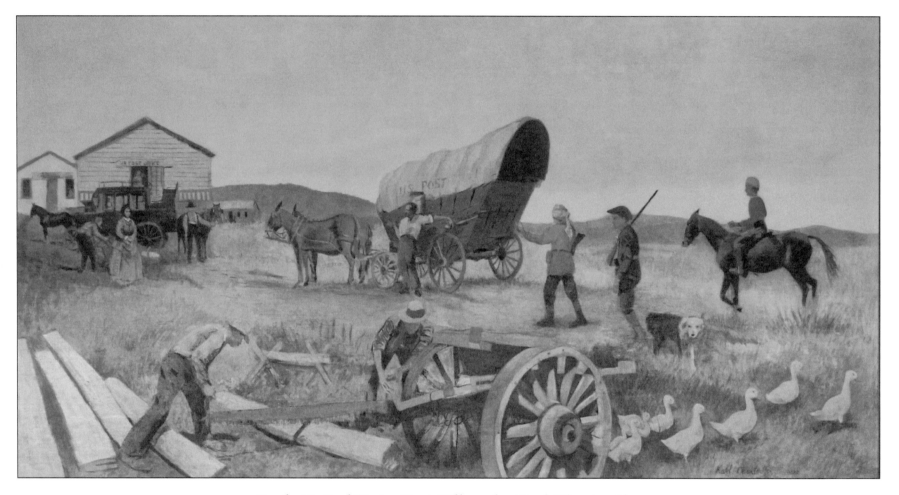

Early United States Post Village, by Karl Oberteuffer

The mural *Early United States Post Village* is oil on canvas and measures 9'6" by 5'. The mural depicts the early pioneer days in Tennessee. The commission was $520.

History of the Mural

After being selected to submit a mural design, Oberteuffer wrote to the Section with a possible plan:

I am very anxious to start working on this mural design. I am living in New York temporarily, in an apartment loaned to me by a friend but I am free to go back to Tennessee immediately. In any case before starting even the pencil sketches I feel I should go to McKenzie to study the locale and general character of the country so that my first drawings would have some relation to my finished mural rendering. I hope that you agree with me that a personal contact with the surroundings of this post office and country is vital to the execution of a composition of this sort. Whether these first pencil sketches that you suggest are done with pencil or color matters little to me, but I feel they must be inspired by the actual aspect of that section of Tennessee. In my opinion, sketches conceived elsewhere would not embody the qualities desired.

The artist also inquired about covering his traveling expenses, but, as usual for such projects, the Section denied the request:

We concur that it would be advisable for you to visit the building in McKenzie, but there are no reservations to cover your traveling expenses for such work. All expenses must be included in the original amount stated for the mural decoration.

It occurs to me that your experience in Tennessee would serve you in a good stead, however, and you might wish to proceed with the preliminary designs with the understanding that you would visit the building later.

Upon receiving the preliminary design, the Section conveyed some misgivings:

These have been considered by the members of the Section and frankly we do not feel that you have yet indicated a design suitable for wall painting in any of those designs. There are, however, indications of material which in our opinion could be assembled into an appropriate design and that is in the sketch which you have labeled A2. This includes the rider on the right, the coach on the left and the covered wagon in the center. We would like you to take this material and incorporate the three elements into a continuous landscape. No indication of such treatment is given in the sketches which you have submitted and it is our opinion that the finished work would appear too unorganized to hold together on a wall.

After further adjustments on the artist's part, the Section tentatively approved:

The design has been considered by the members of the Section and the Supervising Architect, and I am pleased to tell you that it is felt that there are enough indications in this work to warrant a tentative approval at this stage. Frankly the presentation was regarded as slight, but it is felt that when you undertake the work in oil you will be able to give it more vitality.

There were charming areas such as that including the Post Office building on the left and the treatment of the elements in the immediate foreground center. Your design is being photographed and will be returned to you under separate cover. You may proceed with the full cartoon or the full size drawing on canvas, a photograph of which should be forwarded to this office for our further consideration.

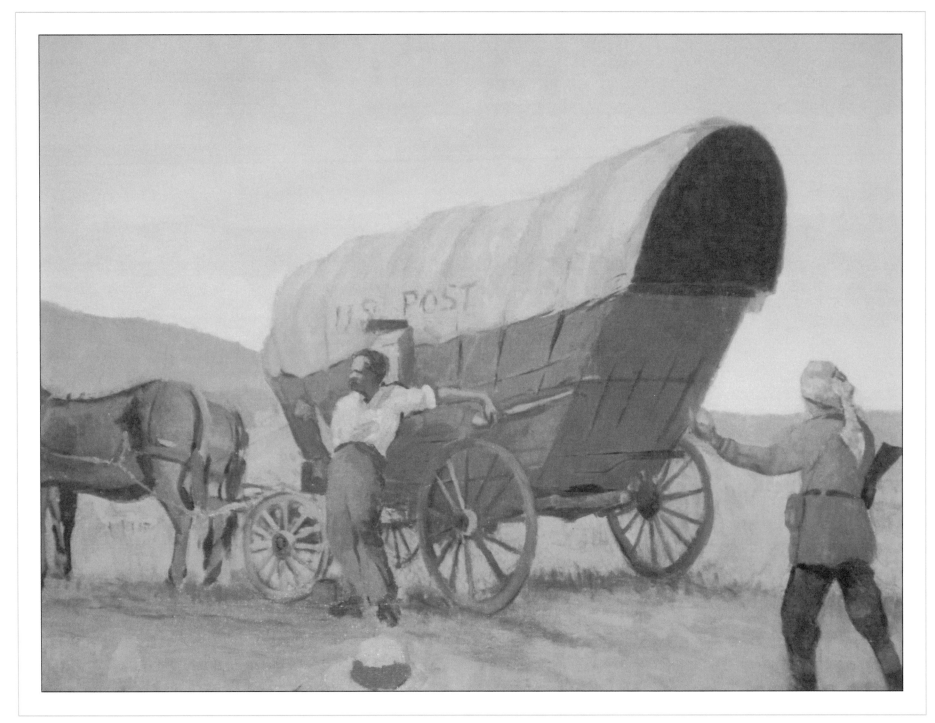

Karl Oberteuffer, *Early United States Post Village*

After receiving a full-size drawing, the Section made a minor suggestion:

The photograph indicates that the work is being carried forward satisfactorily and the only suggestion offered is that possibly the lower right hand corner may need the introduction of some small element in order not to appear too empty. You may regard the work as approved at this stage and proceed with the further painting.

After finishing the mural, Obertueffer wrote that

I was aware that my decoration for the McKenzie Post Office was being done for the Treasury Art Project and you may be sure that I will stress this fact to newspapers reporters and others.
 I am now awaiting authorization to install it.

The local postmaster, in a complimentary letter, reported on August 19, 1938, that the mural had been satisfactorily installed. The artist wrote about its reception:

The McKenzie, Tennessee, Post Office Mural is now installed. I left the work of installation with a capable man whose letter to me I quote as follows:
 "There were many who saw the mural and all seemed to be pleased with it. All comments are favorable and the postmaster was obviously proud of it. He and his employees cooperated with us to the limit. The postmaster liked it so well that he expressed a desire for decorations all around the lobby."

An article in *The Weekly McKenzie Banner* detailed the mural scene:

The scene is laid at the foot of Tennessee mountains which, with the wide expanse of blue sky, form the wide background of the painting five feet by nine feet in size. Varied activity goes on in the foreground. The mail has just arrived at the small U.S. Post Office, a

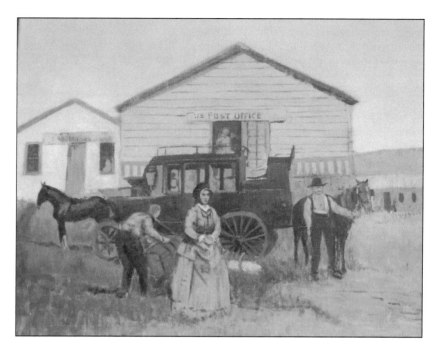

log cabin, in the covered wagon, the government's method of transporting mail in the pioneer days has been the stage coach which was painted from life.

Near the stage coach stands a woman who has just alighted, and stands in her black bonnet and dress of many yards of gray material over hoops while her valises are removed from the coach. The modes of dress of the men and women of that day is outstanding. Another pioneer in clothing made of animal skins and a coon skin cap rides in on a horse. A dog and white geese play around a wood pile and two pioneers who are sawing wood with a cross-cut saw. The perfection of Mr. Oberteuffer's painting is emphasized when one's attention is drawn to the teeth of the cross-cut saw.

Many favorable comments have been received at the post office by the postmaster and the clerks. McKenzians consider the placement of this mural a rare privilege in our midst as well as the fact that it will remain for years to come as positive evidence of customs and manners of the days gone forever.

Karl Oberteuffer, *Early United States Post Village*

Obertueffer wrote to the Section to suggest creating further decorations for the McKenzie Post Office, but the Section declined given "the small amount of money remaining available." Obertueffer replied,

I received your letter of October 13. I am sorry you do not think it will be possible for me to do an additional decoration in the McKenzie, Tennessee, Post Office. The space now available for further decoration is in effect larger than the panel now completed but if you would consider my decorating one of these larger areas for the sum mentioned, I would be very glad to cooperate. I enjoyed doing the first panel so much that I was already anticipating a confirmation of your first letter to me September 23 about this additional mural. The fact that there is a difference in size between the mural now completed and space remaining available for further decoration, and no funds to compensate for it, is no object to me as I should enjoy doing it. For the next few months, I would have ideal time and opportunity to devote to it.

ABOUT THE ARTIST

Karl Amiard Oberteuffer was born on August 9, 1908, in Le Croisic, France. Both his mother and father were artists in their own right. He is best known for townscapes and marine mural paintings.

Oberteuffer's early education started while in Paris. He moved with his family to the United States and settled in Chicago, where he attended the Art Institute. Upon graduation, Oberteuffer became an art instructor at the Memphis Academy of Art in Tennessee. His works have been exhibited in the Art Institute of Chicago, the Corcoran Gallery of Art, the Whitney Museum of American Art, and the Pennsylvania Academy of Fine Arts.

Karl Oberteuffer was a resident of Memphis, Tennessee, when commissioned for the mural in McKenzie, Tennessee. However, he was living in New York at the time he worked on the McKenzie mural.

Oberteuffer died in January 1958.

SOURCES

Falk, Peter H. *Who Was Who in American Art 1564–1975: 400 Years of Artists in America.* Madison, CT: Sound View Press, 1999.

"Karl Oberteuffer," Ask Art, https://www.askart.com/artist/karl_amiard_oberteuffer/100847/karl_amiard_oberteuffer.aspx?stm=oberteuf

"Karl Oberteuffer," Museums on the Green, http://museumsonthegreen.org/wp-content/uploads/The-Tale-of-Karl-Oberteuffer-and-His-Hopeful-Dawn.pdf

History of McKenzie

McKenzie, Tennessee is located at a junction between Carroll, Henry, and Weakley counties in Tennessee, and as of the 2010 census, the population was 5,310. The city was initially called McKenzie Station after the railroad station that was there and the large McKenzie family.

The town initially had a rivalry between two families, the Sneads and the Gilberts, to the point that the two parts of town that they lived in were named different things. The Sneads lived in a settlement called "Dundas," while the Gilberts founded Marietta. The families owned separate trading posts and founded the two settlements that eventually became McKenzie.

The city organized together in 1867 as a result of the Nashville and Northwestern Railroad being completed and intersecting with the Memphis and Ohio Railroad. The city was incorporated as McKenzie in 1869, and Captain W. H. Hawkins was the first mayor.

The city grew at a decent pace until the Great Depression, and the economy in the area didn't pick back up until just before World War II. The Federal Government decided to build a munitions plant close

to Milan, which caused an influx of 1,300 workers between 1940 and 1950.

The city of McKenzie is also home to historic Bethel University, a Christian university that has satellite campuses in multiple cities in Tennessee, including Memphis, Chattanooga, Nashville, Paris, Jackson, and Clarksville. It was founded in 1842 under the name "Bethel Seminary"; the name was changed to "Bethel College" in 1847 and took on the name Bethel University in 2009.

Sources

"Bethel History," Bethel University, https://www.bethelu.edu/about/bethel-history

"The History of the Town of McKenzie," McKenzie Economic Development Corporation, https://growmckenzie.com/living-here/history

"McKenzie, TN Population," Census Viewer, http://censusviewer.com/city/TN/McKenzie

"Things to Do," Carroll County Chamber of Commerce, https://www.visitcarrolltn.com/things-to-do/

Turner, "History of Carroll County, Tennessee, Volume 1," Turner Publishing Company, Dec 12, 1986, https://books.google.com/books?id=l3oR8-N4UqkC&pg=PA48&lpg=PA48

The Former McKenzie Post Office

640 Main St., McKenzie, Tennessee 38201

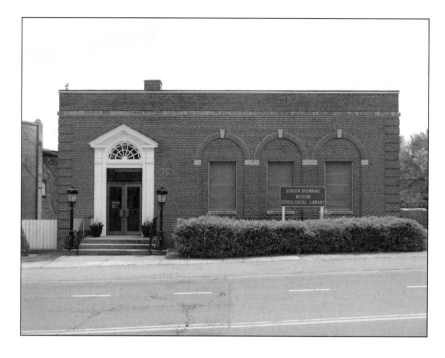

The McKenzie Post Office was constructed by Foley Brothers of McMinnville, Tennessee. The cost was about $41,250.

The McKenzie Post Office was completed in 1935 as indicated on the cornerstone on the lower left corner of the building, which reads, *Henry Morgenthau Jr., Secretary of the Treasury. James A. Farley, Postmaster General. Louis A. Simon, Supervising Architect. Neal A. Melick, Supervising Engineer.*

Early Settlers Entering Mount Pleasant, by Eugene Higgins

The mural *Early Settlers Entering Mount Pleasant* is oil on canvas and measures 11'½" by 5'½". It depicts early settlers traveling by wagon and foot into Mount Pleasant. The mural was installed on October 26, 1942. The commission was $700.

MOUNT PLEASANT

History of the Mural

The Section, when inviting Higgins to submit a design, provided some insight on what the artist might encounter when researching local history and customs:

We are not desirous of antagonizing the public in matters of art and as you are aware there are two schools of thought on this subject. There are those who believe that all art should be terminated for the duration and others who are convinced that the arts should be continued as a stimulus to morale and as a growing evidence of the things for which we are now at war. In case there are serious local objections to a decoration at this time, I will appreciate your notifying me with the understanding that the work will automatically be terminated for the duration.

Ultimately, Higgins did accept the commission:

I will be glad to do the mural if the project goes through. Do you think I should write the Postmaster and try and get a few points on what he thinks would please the inhabitants of that place? Also, the exact dimensions of the wall over his office. I can go to the public library here and read up about Tennessee etc. I could do all the details here in N.Y.C., and when I go to my summer place, do the actual work in my big barn.

After doing some research, Higgins expressed some concern:

I have been waiting for an answer to my letters to the Mount Pleasant Post Office, written right after receiving yours. As I did not want to begin on this mural till I had some idea from the Mt. Pleasant people what they would like on their Post Office wall. I

have looked up the history of Tennessee and outside of Andrew Jackson and slaves did not find anything very interesting. Maybe I'll wait till the postmaster can give me some ideas. Tell them I will wait before sketching anything.

Higgins continued to encounter roadblocks:

It looks like that Postmaster at Mt Pleasant, Tennessee, Post Office does not intend answering my letters.

Maybe you could hustle him a bit. I just had to get going so I am mailing with this letter a sketch. A lady I ran into…from Mt Pleasant, Tennessee, told me this story. I forgot to ask her who the man on horseback was, maybe I can look him up in the library, if we cannot find any better ideas to work with.

Rowan replied,

It is very interesting that you should have met an individual who was born in Mt. Pleasant and who told you this interesting story of the pioneers and their arrival on horseback leading wagons filled with slaves. This is [a] fine subject matter and I am sure will prove especially interesting to the young historians in the public schools.

Rowan then wrote directly to the postmaster:

The mural is to be placed above the Postmaster's door and the bulletin boards on either side. It will be appreciated if you can have one of your assistants measure the exact dimensions of this space from wall to wall and from top of door and top of bulletin boards to ceiling and submit these dimensions to this office. It will also

be appreciated if you can furnish this office with a statement as to whether or not the wall in question has been painted.

Mr. Higgins wishes to undertake a theme of an historical nature showing early settlers with horse drawn wagons filled with slaves and their belongings coming into the valley in accordance with the description furnished Mr. Higgins by a former citizen of Mt. Pleasant. The lady in question was born and raised in Mt. Pleasant and told the artist that her great, great grandfather, McNish, was one of the first local settlers. Looking forward to an early reply.

The artist continued to have difficulties obtaining any information about the post office:

Mt. Pleasant can be a whale of a place as they informed me it only has about 200 inhabitants. The Postmaster of Mt. Pleasant evidently does not intend answering my letter. I cannot fill out information for the contract you sent me till I know what I asked the

Mt. Pleasant Postmaster, maybe if I sent the questions to you and you can mail to him he will give it attention.

Apparently, Rowan was successful in eventually moving the postmaster to supply the needed information for the artist:

It will be appreciated if a report is given to the Section of your consent and advice relative to the architectural fitness of the design.

Higgins updated the Section on his challenges in correctly representing the history of the region:

It's harder to get domestic farm animals right here than in former days. When every farmer had a horse, ox, sheep etc. I need here to check on the drawing. But I think I can do this before the fall sets in. Will send you a photograph of the results of summer work.

Later, Higgins signaled how he determined that the mural was finished:

Thanks for your letter. The mural has reached a point where I am stumped to continue painting—that means it's done and ready to be photographed....

Many here have seen the mural and think it ok. No one criticized it. Maybe they did not like to. I wish you could see it for your approval.

One of the ex-Giants baseball pitchers said he lived in the Mt. Pleasant country and said the landscape with figures is exactly like

Eugene Higgins, *Early Settlers Entering Mount Pleasant*

that country and the mules looked like Tennessee breed instead of the poor specimens who occasionally roam in Lyme.

Higgins ran into problems with the final installation while continuing to have communication difficulties:

Now about getting the paint on the wall off. If I write to the Postmaster, he will probably ignore my letter as he did the last one. If you could drop him a line and tell him to get busy and have the wall in condition when I arrive with the mural. I will pay for the work when I am there.

Finally, the postmaster reported on November 17 that the mural had been satisfactorily installed, though he reported some differences of opinion:

The painting represents a beautiful piece of art and many complimentary remarks have been made regarding its addition to our beautiful new building.
 The only dissenting opinions that I have heard come from those who have not been able to find anything relative to a McNish in the Early History of Mt. Pleasant as portrayed by some lady in New York as being the first settler and used by Mr. Higgins for the mural.

Rowan wrote back:

Thank you for your good letter of November 17 reporting on the satisfactory installation of the mural by Mr. Eugene Higgins in the Mount Pleasant, Tennessee, Post Office. It is gratifying to learn of your favorable reaction and the many compliments which the painting has received.
 The McNish incident is rather baffling as Mr. Higgins was confident in conferring with the lady in New York who came from Mount Pleasant that she was well informed on the early history of your settlement.

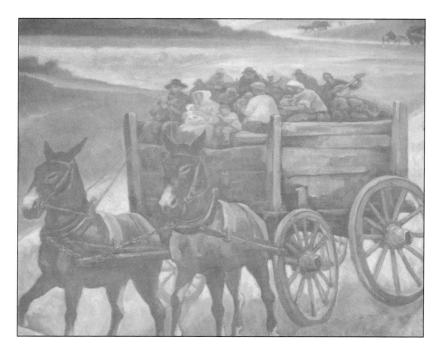

Higgins wrote to Rowan:

I wrote to that lady that suggested the idea for the Mt. Pleasant mural immediately on receiving your letter with Mt. Pleasant Postmaster comments....
 Only yesterday word came from her from her farm in Pennsylvania. Here are the contents of her reply.

I am sorry about the misunderstanding about my great-great grandfather. I thought I made it clear that he settled at Brentwood Tennessee which is a small settlement between Franklin and Nashville. The trek from Virginia in the wagons etc. is absolutely accurate about a great many of Tennessee's early settlers and might easily apply to those of Mt. Pleasant. I do hope this will not cause you any embarrassment. If you need it, I can get you more McNish data from a cousin in Nashville who goes in for genealogy.

ABOUT THE ARTIST

Eugene Higgins was born in 1874 in Kansas City, Missouri. His father was a stonecutter, while his mother died when he was young. He is best known for social realist etchings and landscaping paintings.

Higgins studied at the St. Louis School of Fine Arts. He traveled to Europe and studied at the École des Beaux-Arts and the Académie Julian. While in France, Higgins develop his skills in etching, which was his primary way of earning money at the time.

Higgins had a long career, and his works are housed in various collections including the Los Angeles Museum of Art, the William and Mary Collection, the Museum of Modern Art, the Whitney Museum of American Art, the British Museum of Art, and the New York Public Library. The Library of Congress purchased 240 of his etchings.

In addition to the Mount Pleasant Post Office mural, Higgins also painted *The First Settlers* mural for the Shawano, Wisconsin Post Office and *The Armistice Letter* mural for the Beaver Falls, Pennsylvania Post Office.

He died on February 20, 1958 in New York.

SOURCES

"Eugene Higgins," Ask Art, https://www.askart.com/artist/Eugene_Higgins/2888/Eugene_Higgins.aspx

Falk, Peter H. *Who Was Who in American Art 1564–1975: 400 Years of Artists in America*. Madison, CT: Sound View Press, 1999.

History of Mount Pleasant

Mount Pleasant is in Maury County and was once known as the Phosphate Capital of the World due to the prominence of phosphate rock under the soil and the mining industry that resulted. Its population as of the 2010 census was 4,561.

The city was incorporated in 1824, a full 64 years before William Shirley discovered the high-grade, brown phosphate rock that would produce the greatest industry the town had seen until that point. Phosphate mining went on for nearly 100 years. In just 10 years from 1890 to 1900, the population grew from 466 to 2000. The labor for the mining of the precious brown rock was cheap by today's standards at $0.65 per day, while teams were paid $1.50 a day.

The industry lasted until the mid-1980s when the phosphate reserves in the area had been largely depleted. The Virginia-Carolina phosphate plant in Mt. Pleasant was shut down in 1971.

Today, the Mt. Pleasant Maury Phosphate Museum is dedicated to phosphate and the mining industry, as well as housing the history of the area in general.

The post office in Mt. Pleasant celebrated its 75th anniversary in 2015. It was built in 1940 and has a metal eagle called "Mumford" on top of the front entrance.

The town spans approximately 11 square miles and has many locations on the National Register of Historic Places. U.S. Highway 43 runs through the city, as do Tennessee State Routes 243 and 166.

SOURCES

Duggar, Ashley. "Middle Tennessee Spotlight: Mount Pleasant, TN," Acre of Benchmark Realty, LLC, January 8, 2016, https://www.acrestate.com/blog/middle-tennessee-spotlight-mount-pleasant-tn/

Lightfoot, Marise P. "Maury County," *Tennessee Encyclopedia*, March 1, 2018, https://tennesseeencyclopedia.net/entries/maury-county/

"Mount Pleasant, TN Population," Census Viewer, http://censusviewer.com/city/TN/Mount%20Pleasant

"Museum Ornament Celebrates Local Post Office's 75th Year," *Columbia Daily Herald*, November 8, 2015, https://www.columbiadailyherald.com/article/20151108/NEWS/311089977

The Mount Pleasant Post Office

201 N. Main St., Mount Pleasant, Tennessee 38474

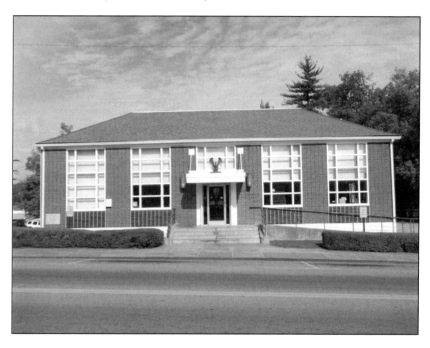

The Mount Pleasant Post Office was constructed by Ray M. Lee Company. The cost was about $65,000.*

The Mount Pleasant Post Office was completed in 1940 as indicated on the cornerstone on the lower right corner of the building, which reads, *James A. Farley, Postmaster General. John M. Carmody, Federal Works Administrator. W. Englebert Reynolds, Commissioner of Public Buildings. Louis A. Simon, Supervising Architect. Neal A. Melick, Supervising Engineer.*

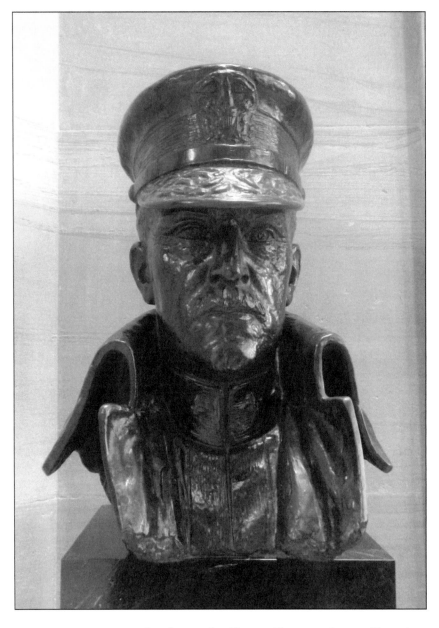

Portrait Bust of Admiral Albert Gleaves, by Belle Kinney

The *Portrait Bust of Admiral Albert Gleaves* depicts Admiral Albert Gleaves, a distinguished Tennessean.

NASHVILLE

History of the Mural

A Senator McKellar wrote about the possible commission:

This will be presented by Miss Belle Kinney of New York who prepared a bust of Admiral Albert Gleaves, a former Tennessean who was head of the Transport and Convoy Service during the World War, which was unveiled at Annapolis last spring.

At that time, I discussed with Miss Kinney the possibility of securing a bust of the Admiral for one of the public buildings at Nashville, as she advised me that she has made certain sketches of him from life which should be an admirable basis for another and different bust.

I am informed that the Federal Government, on occasion, allocates funds for projects of this kind, though I am not at all familiar with the procedure involved. I feel that I can say with assurance that such a project would meet with the enthusiastic approval of the people of the state and I have recently communicated with the Governor about it.

I shall appreciate it if you will go into the matter with Miss Kinney and extend her every possible courtesy.

The Section wrote back,

It just so happens there was a small balance available for the Nashville Post Office. Miss Kinney has, fortunately, complied with our requirements in reference to competitions by having sent in a very good model in the sculptural competition which we held last year for the Federal Trade Commission Building. This makes her available for a commission.

We are drawing up a contract with Miss Kinney for the execution of a bust of Admiral Gleaves. I think her sketch is very handsome and I hope it will turn out to be a great success. It certainly is a thoroughly suitable monument to such a distinguished Naval officer as Admiral Gleaves.

Kinney submitted a separate design for the pedestal, as well as other matters:

Under separate cover, I have forwarded to you for your consideration a drawing of the pedestal for my bust of Admiral Gleaves for Nashville and hope that the design meets with your approval. The design was suggested by Mr. Frederick Kiesler, the well-known modern architect at Columbia University.

I propose to have the bust in dark green bronze, the base polished dark green marble and the pedestal in wood with an ebony finish. The V sunk letters carved into the wooden pedestal to be gilded.

Armistice Day, November 11ᵗʰ, has been selected as the most appropriate and ideal day for the unveiling of the bust, and if it is unveiled on that day, very impressive ceremonies honoring Admiral Gleaves could be arranged.

Generally, the installation and reception went smoothly, as related by a newspaper clipping:

Before massed troops and in the presence of assembled thousands, the bust of Admiral Albert Gleaves, executed by Miss Belle Kinney and presented to the City by the Government, will be unveiled Saturday morning at the reviewing stand on the steps of the War Memorial Building.

In a climax of Armistice Day activities, Congressmen Joe Byrns Jr. will represent the Government in the presentation, and Mayor Thomas L. Cummings will accept the bust on behalf of the city.

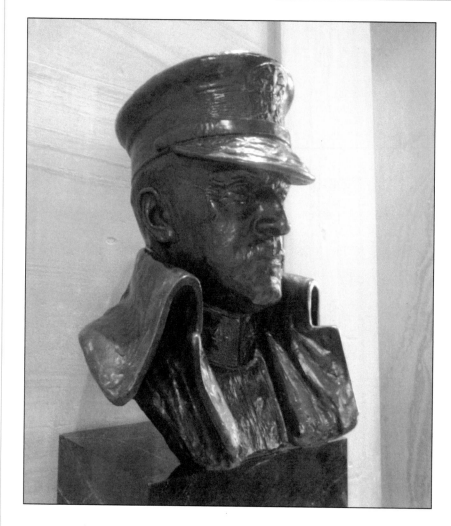

Mrs. John Langham, Miss Corinne Gleaves Anderson, and Miss Helen Anderson, daughters of Dr. and Mrs. E. P. Anderson, will unveil the bust of their great uncle, Admiral Gleaves.

Brig. Gen Frank M. Andrews, Assistant Chief of General Staff, will speak as a representative of the Army and Lieut-Comdr. Frank R. Walker, officer in charge of Navy recruiting in Tennessee, will speak on behalf of the Navy.

But since the bust was to be installed in the Nashville Courthouse, unanticipated problems developed, as recounted by the custodian of the Courthouse:

It seems that the Government, through the Fine Arts Division, gave Mrs. Kinney the contract to do a bust of Admiral Gleaves and presented it to the State of Tennessee. Some two or three months ago, the formal presentation was made and this ceremony was held at the State Capital and the bust presented to the State. I knew nothing about the Federal Government intending for the bust to be placed in this building until the Saturday before the new year, when several men brought the bust and pedestal to this building and wanted to put it up right in front of the elevator on the first floor. I objected to this location for the bust and notified you by telephone as to the disposition I should make of it. Frankly, there is no suitable place in this building for the bust; of course, I can place it in the lobby on the first floor.

I have taken this matter up with Honorable Richard Gleaves, who is the closest relative in Nashville of Admiral Gleaves, and he explained to me that he was taking this matter up with the Fine Arts Division, asking that the bust be returned to the local chapter of the American Legion and that it be placed in the State Memorial Building which, by the way, adjoins the State Capital, along with the picture and bust of other famous Tennesseans.

I had hoped to hear from Mr. Gleaves on this matter and for that reason had neglected writing you. Of course, I do not want to take any position that would embarrass the relatives and friends of Admiral Gleaves and will be covered strictly by your position in this matter.

The eventual resolution ultimately would hinge on Kinney's decision:

After further consideration, it has been decided that it would be preferable to install the sculpture in the Nashville, Tennessee, Court

House located against either the east or west walls of the entrance vestibule, the choice to be made by the sculptor, Miss Belle Kinney, who is being informed of this change in location and asked to communicate directly with the Custodian of the building her choice in the matter. It will be appreciated if you will inform the Custodian to permit installation accordingly.

It will not be possible to install the bust in the State Memorial Building, as the sculptor and the American Legion have been informed, since the work has been contracted for with building funds.

Eventually, the sculpture was installed successfully in the lobby on the east side of the entrance. However, the pedestal manufacturer was unhappy with the lack of payment:

Our part of the work has been completed for a very long time, and upon writing Belle Kinney for payment, she informs us that she must first receive her payment from the government. We are writing you to find out if a settlement has been made with her by now or uncover the reason for the delay.

We are a comparatively small concern, and we count on payment for work that we execute ourselves in a reasonable length of time. Our part of the work in making the pedestal amounted to $50.00, and the drilling, cementing, and erecting amounted to $5.00, which we understand is also to be paid to us.

ABOUT THE ARTIST

Belle Marshall Kinney was born in 1890 in Nashville, Tennessee. She is best known for her sculptures. She married the well-known sculptor Leopold Scholz in 1921. Together they collaborated on several works of art.

Kinney attended the Art Institute of Chicago on a scholarship at the age of 15. A gifted artist, she had a long and distinguished career. Her most well-known work is the pediment figures of the Parthenon in Nashville, which she co-created with her husband. Some of her

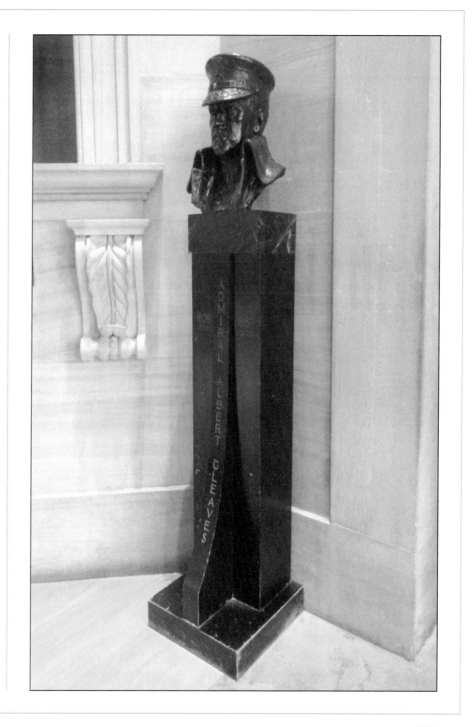

Belle Kinney, *Portrait Bust of Admiral Albert Gleaves*

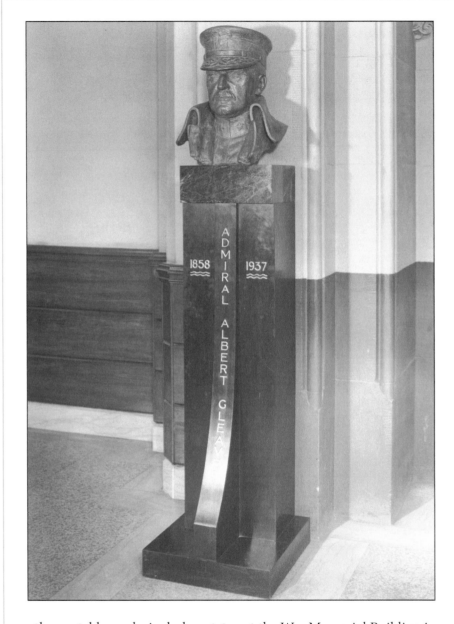

1858 1937

ADMIRAL ALBERT GLEAVES

other notable works include a statue at the War Memorial Building in Nashville, and statues representing Tennessee in the U.S. Capitol.

She died in 1959 in Boiceville, New York, at the age of 69.

Sources

"Belle Kinney," Ask Art. https://www.askart.com/artist/belle_kinney_scholz/123481/belle_kinney_scholz.aspx?stm=belle%20ki

"Belle Kinney," Parthenon, Nashville, https://www.nashville.gov/Parks-and-Recreation/Parthenon/Learn-and-explore.aspx

Falk, Peter H. *Who Was Who in American Art 1564–1975: 400 Years of Artists in America*. Madison, CT: Sound View Press, 1999.

History of Nashville

Nashville is the capital of Tennessee and the county seat of Davidson County. Its population as of the 2010 census was 601,222. Founded by James Robertson in 1779, the original name of the city was Nashborough, named after Francis Nash, who was an American Revolutionary War general. It was renamed Nashville in 1784, and the city was chartered in 1806. It became the permanent capital of Tennessee in 1843.

Its location along the Cumberland River made Nashville a booming area during the early 19th century. The first steamboats arrived in the city in 1819 and resulted in the city becoming a primary distribution point for all types of goods such as tobacco, cotton, corn. Nashville was a mix of many different types of industries at the time, including agriculture, banking, publishing.

During the Civil War, Nashville was an important distribution hub for supplies throughout the Confederacy and the Southeastern United States in general. The Union captured the city in 1862 and did not leave until the end of the Civil War. The Battle of Nashville was fought during December 15 and 16 between the troops of Union General George H. Thomas and Confederate General John Bell Hood. The Union outnumbered the Confederacy almost 4 to 1 (70,000 Union troops versus 21,000 Confederate troops), thus resulting in a Union victory.

Today, Nashville lies at the center of multiple Interstate highways, including Interstate 65, Interstate 40, and Interstate 24. The music and

Belle Kinney, *Portrait Bust of Admiral Albert Gleaves*

entertainment industry in particular contribute to the local economy with manufacturing of many types and healthcare coming in a close second.

Sources

"Battle of Nashville," HistoryNet, https://www.historynet.com/battle-of-nashville

"Nashville, TN Population," Census Viewer, http://censusviewer.com/city/TN/Nashville-Davidson%20(Remainder)

"Nashville: History, Population, & Points of Interest," *Encyclopedia Britannica*, December 5, 2019, https://www.britannica.com/place/Nashville-Tennessee

Paine, Ophelia. "Nashville (Metropolitan Nashville/Davidson County)," *Tennessee Encyclopedia*, March 1, 2018, https://tennesseeencyclopedia.net/entries/nashville-metropolitan-nashville-davidson-county/

WILLIAM H. WOODIN
SECRETARY OF THE TREASURY
JAMES A. FARLEY
POSTMASTER GENERAL
LAWRENCE W. ROBERT JR.
ASSISTANT SECRETARY OF THE TREASURY
JAMES A. WETMORE
ACTING SUPERVISING ARCHITECT
MARR AND HOLMAN
ARCHITECTS
1933

The Nashville Post Office

901 Broadway, Nashville, Tennessee 37202

The Nashville Post Office was constructed by Frank Messer and Sons of Cincinnati, Ohio. The cost of the building when new was about $1,565,000.

The Nashville Post Office was completed in 1933 as indicated on the cornerstone on the lower right corner of the building, which reads, *William H. Woodin, Secretary of the Treasury. James A. Farley, Postmaster General. Lawrence W. Robert Jr., Assistant Secretary of the Treasury. James A. Wetmore, Acting Supervising Architect. Marr and Holman, Architects.*

TVA Power, by Minna Citron

The mural *TVA Power* is oil on canvas; one panel of the mural measures 12' by 5'9", and the other measures 34'6" by 6'9". It depicts several scenes from the Tennessee countryside, including elements from the Tennessee Valley Authority. The commission was $1,650.

NEWPORT

History of the Murals

The Section of Fine Arts originally invited Hamilton Parks Jr. for the Newport mural commission. However, Hamilton was working for the National Parks Service, thus disqualifying him from accepting the Newport mural opportunity.

Minna Citron was then invited for the Newport mural commission. While corresponding with the Section, the amount of the commission was increased an additional $1,000 from $650 as a result of an increase in the wall space allocated for decoration.

After disqualifying Parks, the Section invited Citron to submit a mural design, though the payment amount initially was still $650.

The Section acknowledged the skill shown in the preliminary sketch:

The scope of the design has a fine sweep and very neatly solves the architectural problems of the door, the grilles, windows and the transition from one wall to another. The subject matter you propose has much interest. I suggest that you proceed with the scale color sketch. Your pencil sketch is being photographed and returned to you.

In later letter, the Section notes the increased payment:

The increase of $1000 was obtained for the mural decoration in the Newport, Tennessee Post Office. The total fee which you will receive will be $1,650.

But when the Section received color sketches, there were problems:

The designs have been considered by the members of the Section, and I regret to tell you that in the estimation of this office the color sketches do not bear out the promise of the preliminary black and whites. The arbitrary use of the scale between the figures of the foreground and ends and center of the long panel and the elements in between those three foreground groups proves distressing to us.

Possibly the most obvious weakness in your design is due to the fact that you have not accepted the grilles as part of the pattern. It is our feeling that the elements of the painting should be related to these architectural features, for by not doing so, the artist passes up the possibilities for wall painting offered by the wall and in a way ignores the wall problem.

The most acceptable area in the entire design is that which appears between the enfacement and the grilles on the extreme left of the long panel. It is suggested that the rest of the design be brought up to this. The small-scale figures in the spaces between the grilles and the architecture containing these figures are in need of a more convincing solution. There was a feeling that too much heaviness exists in the horizontals below the grilles. This could be countered by raising the architecture of this area; you will also be able to eliminate some part of the high-tension towers which can be interestingly treated but which in our estimation would not have been so treated in your sketch. It would be my personal suggestion to relegate these somewhat to the background as the individuals living in Newport who have to see them in their landscape from day to day must find them somewhat monotonous as pure subject matter.

In the small panel, it is suggested that the tower be entirely eliminated and that at least one of the cows be painted in profile or full front in view of the fact that the cows in the barn, which area is one of the most interesting from the standpoint of the painting, are all looked at from the same position.

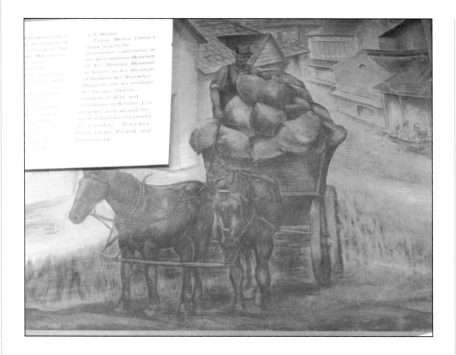

The diagonal hill of the landscape is not convincing as it seems too static and forced, particularly in view of the fact that the line coincides with the left upper corner of the door. It is also suggested, in order to create a little more interest in this panel, that some figures or object be introduced on the summit immediately over the door providing the summit is retained.

The form of the stadium was regarded as unsuccessful. We feel the heavy diagonal form impedes the man operating the tractor on the extreme right in the long panel. More attention is needed to the painting of the smoke coming from the stacks as it is in no way convincing as it appears in the long panel.

Your designs are being photographed and will be returned to you under separate cover for the necessary revisions before they can be formerly approved by the Director of Procurement. I am quite aware that this action must prove a great disappointment to you but there seems no other procedure open to us.

Citron assured the Section that she would incorporate their suggestions into the designs, which subsequently were approved with a final suggestion: "The one suggestion offered is that the silo, center of the long panel, be moved slightly left and the small booth-like building on its left be entirely removed."

The Section had some reservations about the linen selected, however:

The sample is somewhat light for a mural as large as the one you are undertaking and you may find that the person who installs the work will encounter some difficulties due to its lightness.

Experience has led us to believe that a heavier grade of canvas presents fewer difficulties in installation. If, however, you are satisfied you may proceed using the canvas of which you submitted a sample.

Citron submitted a new sample: In "the opinion of this office … you are acting wisely in procuring a heavier grade of linen canvas as this will facilitate the installation." But the Section wrote again that

This office objects to the canvas which you have submitted on the basis of its loose weaving. Note how thin the threads are in one direction and the large spaces between the threads. A closer woven canvas would guarantee your work greater permanency and is requested on this account.

Relative to the cost of the canvas, this office offers no comment on that but suggest that you confer with some of your artist friends relative to information on this point.

After Citron submitted yet another sample, the Section wrote that

This sample is not satisfactory and is not recommended for your use in connection with the Newport, Tennessee, mural.

The objection raised to this canvas is that it is not high-grade linen and the weaving is so loose that the filler has to perform work which should be carried by the threads. It gives no guarantee of the permanence which you might wish in connection with your work.

Finally, she was able to satisfy the Section with canvas that "appears to be an excellent quality of linen."

Citron asked for and received an extension on her contract because of "unavoidable delays." She "also had the experts fine comb my mural and were shown several inaccuracies which I am correcting in the finishing."

Citron wrote about the impending mural reception in New York City:

Another success story! Mrs. Roosevelt is coming to the opening reception of the T.V.A. murals at the Art Students League Oct 8 at

6 o'clock. Of course, I am expecting you to come up and help receive her. Why not, you are the godfather of the mural. I'd like you and Mrs. Rowan to come up and count on having dinner with me after the show. But entertaining royalty raises a few questions.

I'm assuming you are acquainted with Mrs. Roosevelt and can greet her. If you can't come, will someone else from the Section?…

Rowan replied,

I am sure you will experience no uneasiness in introducing Mrs. Roosevelt as she is so innately gracious that everyone immediately feels at ease with her and as though she were a friend of long standing.

Citron wrote back about the finished installation:

The enclosed letter from the Mayor of Newport is offered with the greatest pride and pleasure. The fine days I spent in the PO up

Minna Citron, now a world renowned artist, was born in October, 1896, in Newark, New Jersey. Her father died when she was eight. After an unsuccessful marriage in the 1920's - "He kept the money and I kept the children" (two sons), she said after the divorce in 1934 - Minna Citron concentrated all her energies on her art. She became friends with outstanding artists and has spent the rest of her life in New York City.

The murals depict life in East Tenn as influenced by TVA: including the Great Smoky Mountains, Norris Lake, local Newport buildings, planting and planting methods, cultivating, and grazing cattle.

To become familiar with these scenes the artist spent time and attention discovering the unique aspects of this region. During the several months she spent in Newport she made her home with Dr. and Mrs.

L.S. Nease.

Today Minna Citron's work graces the permanent collections of the Metropolitan Museum of Art, Whitney Museum of American Art, Museum of Modern Art, Brooklyn Museum, the Art Institute of Chicago, Detroit Institute of Arts, and museums in Boston, Los Angeles, and abroad her work is found in museums in London, Dresden, Paris, Israel, Poland, and Switzerland.

and down the ladders gave me a fine opportunity of making observations. My choice of light, lunar, somewhat oriental arabesques seems a very happy one. The space before the murals is very confined but the spaciousness of the design and the light which comes through the grilles from the workroom give an impression of opening up and airy rather than confining and over-powering which would have been the case with a compact lightly organized design.

I found David Martin's mural at Lenoir City successful for the same reason. The content and particularly the local scenes made a great hit . . . with one woman exclaiming "Lord a mercy if it isn't the high school."

We talk so much of strengthening our democracy but what better way then bringing together regional points of view and simplifying them.

Minna Citron, *TVA Power*

The enclosed letter from the mayor read as follows:

I want you to know how very much we, the people of Newport, like the murals you have painted for our Post Office walls. While the work has been finished only a day, the whole town is loud in its praise of the manner in which you have shown the many activities of this section of the country. The TVA background is excellent, but what we like best is the way you have shown our industries and buildings of Newport. We feel that we are extremely fortunate in having our Post Office chosen for these paintings, and that they will serve as an attractive drawing card for the many tourists and visitors who come to our town.

And two, I do not know when any "furriner" (as the mountain people would say) has captured our hearts as you have. You have made many friends while here, and your interest in the people of this section and the friendships made will further endear the murals to us. We shan't forget your kindness and patience in explaining your work to all of us who asked so many questions.

ABOUT THE ARTIST

[See About the Artist, Manchester, Tennessee, for further details.] Minna Citron had solo exhibitions in New York; Newark, New Jersey; Lynchburg, Virginia; Norris, Tennessee; and Chicago, Illinois. She is represented in the Whitney Museum of Art, and most major art museums in America, and the Library of Congress.

SOURCES

Citron, Christiane Hyde. Granddaughter of the artist Minna Wright Citron.

Falk, Peter H. *Who Was Who in American Art 1564–1975: 400 Years of Artists in America.*

"Minna Citron," Ask Art, https://www.askart.com/artist/minna_wright_citron/73930/minna_wright_citron.aspx?stm=minna%20ci

History of Newport

Newport is the county seat of Cocke County, and its population when the 2010 U.S. census was taken was 6,945. The city is located in eastern Tennessee close to the North Carolina state line and was originally known as Clifton. Clifton was renamed Newport when Newport moved the county courthouse there.

The first settler to the area was John Gilliland, an American Revolutionary War veteran who had come from Virginia. To secure his ownership of the land near the Pigeon River's mouth, he planted corn. He donated 50 acres of his land for what would become known as Newport. He was also known for assisting in establishing the lesser-known State of Franklin, which included many Tennessee counties close to the border of North Carolina in 1785.

A large portion of the reason that Newport became the county seat was the ferry that was operated by Peter Fine on the river near the site, called Fine's Ferry. If the ferry had not been there, transportation to the town and its economic activity would have been significantly reduced.

During the Civil War, the town tried to remain neutral and as a result was a target of raids from both sides of the conflict.

Newport made an attempt to annex Clifton, but was sued by Clifton in court because they did not want to be annexed. In 1884, the court case was decided in favor of Clifton, and the courthouse was constructed there and completed in 1886. Clifton was later renamed Newport, and Newport was renamed "Oldport" or "Oldtown."

Today, Newport is surrounded by historical sites in Cocke County, including the Great Smoky Mountains National Park, Cherokee National Forest, and Pigeon River, among others.

SOURCES

"Cocke County Heritage Development Report," MTSU Center for Historic Preservation, https://www.mtsuhistpres.org/wp-content/uploads/2014/08/A-Legacy-to-Be-Preserved-and-CelebratedAfrican-American-Heritage-Resources-in-Cocke-County-TN-12.081.pdf

"Goodspeed's History of Cocke County," TNGenWed, https://www.tngenweb.org/cocke/goodspeedshistory.htm

"History of Newport and Cocke County," The City of Newport, Tennessee, https://www.cityofnewport-tn.com/?SEC=4279909A-6A80-4248-A1F1-3AA2AD879FFC

"History: Cocke County Partnership," Cocke County Chamber of Commerce, https://www.newportcockecountychamber.com/our-community/history/

"Newport, TN Population," Census Viewer, http://censusviewer.com/city/TN/Newport

O'Neil, Duay, "Remembering John Gilliland: Founder of Newport," *Newport Plain Talk*, April 29, 2016, http://www.newportplaintalk.com/community/as_it_was_give_to_me/article_bd42aba2-0e61-11e6-9428-a3ebfc2e9148.html

Soule, Thomas, and Winsor, "Reported Cases Argued and Determined in the Supreme Court of Tennessee, Volume 67," 1880, p. 143, https://books.google.com/books?id=4dczAQAAMAAJ&pg=PA143&lpg=PA143

The Former Newport Post Office

219 E. Broadway Street, Newport, Tennessee 37821

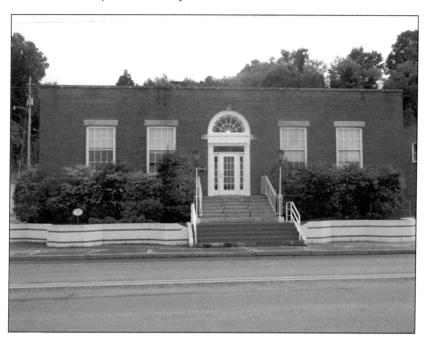

The Newport Post Office was constructed by Blauner Construction Company of Chicago, Illinois. The cost when new was about $62,433.

The Newport Post Office was completed in 1937 as indicated on the cornerstone on the lower left corner of the building, which reads, *Henry Morgenthau Jr., Secretary of the Treasury. James A. Farley, Postmaster General. Louis A. Simon, Supervising Architect. Neal A. Melick, Supervising Engineer.*

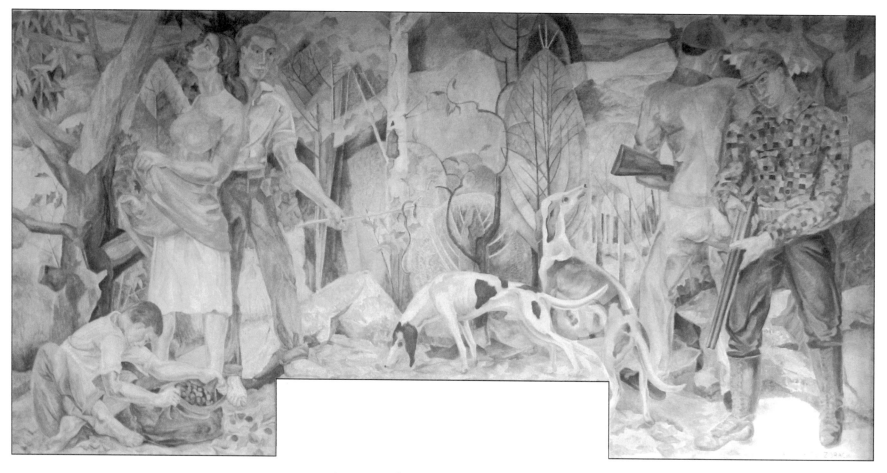

Autumn, by Marguerite Zorach

The mural _Autumn_ is oil on canvas and measures 12' by 4'6" inches and was installed on December 12, 1939. It depicts a typical autumn scene in Ripley. The commission was $700.

RIPLEY

History of the Mural

After being invited to submit a mural design, Zorach wrote to the Section:

The idea of a mural for the P.O. in Ripley, Tennessee is a complete surprise to me. I will be very happy to submit designs for the same as soon as I have worked some in my mind which I consider appropriate.

I doubt if I will be able to visit Ripley at this time due to the distance but I have friends near there that will be glad to describe the building to me and give me general information as to the county and the town.

In a second letter, the artist wrote,

Bill and I came down to Washington this spring when alas you were not there. Ned P. and Inslee Hopper looked over my sketches and selected one which they had photographed which answers half your question. The color sketch I sent the other day which answers the other half. I hope you like them both. The particular subject was used because of a young man's description that comes from that part of Tennessee. Dahlov's mural is coming along swell. She paints like I do, embodying not the result but the method which interests me to discover.

Zorach later wrote about possible difficulties:

A lot of the complication is just my water color technique. If I sound apologetic, it is mainly that the sketch is exactly the sort of thing I need to work from, and I hope you will approve of it as such.

Another Zorach letter explains her technique in more detail:

I was afraid my water color technique would make the mural a bit difficult for you all to see, but I thought you would be able to see it as a working sketch....

I used a composition balanced at both ends principally because then people could enjoy it in spite of the map obscuring the middle which I consider pretty important for which the hanging lamp problem....

I think if you can accept that part of the sketch you can depend upon me to make it a convincing and integral part of the whole. I hate to change it in the small sketch because to me it is the key on which I have the entire background of woods...[I] can do a much finer mural than if I destroy it by making something to please you or rather to get by, yet I don't blame you for not seeing how I mean to develop this sketch. I just wish you could trust me to do it.

The other part the scale of the figures is well raised. I had it in mind myself with a question. In the sketch it is not very obvious that the children gathering nuts are children and even if it is may be difficult to balance them against two men. If I find on enlarging that there is a discrepancy of scale, I will have to use one grown person in place of one of the children on the other side. I consider it very important that this should look right in every respect.

Rowan wrote back:

I have read your letter with great interest and accept your logic relative to the treatment of the center of your design. I would like to inform you that this office intends to have the hanging lighting fixture raised so that there will be no obstruction to the view of the finished mural by such fixtures.

I concur with you heartily that there is grave danger of lost enthusiasm by coerced repetition, and certainly I do not wish to be guilty of this. If you are confident that more clarity in the central portion of the composition can be achieved as the work develops, you may proceed with the full size cartoon, a photograph of which should be forwarded to this office for our further consideration.

I am gratified that you concur in this suggestion relative to the scale of the figures and am confident that this will be taken care of according to your best judgement as the work progresses. I feel that I did not stress how much I personally liked the design. I thought it was in every way charming and gay and that it would prove a note of real pleasure to the citizens of Ripley.

The artistic challenges obviously were overcome, even though the artist chose to complete the whole mural:

I am sending you a photograph of the mural for Tennessee; it's finished! And I sincerely hope you will all like it. If you don't I will just be out of luck and all I can do is paint you another one. I know I took a chance doing it this way but it's the way I work best and I don't mind taking chances. I only hope you will all approve the results now that it is finished.

In the print I am sending you the left hand side comes out a little too dark in value owing to its having to be taken with an excess of light on one side. I think that can be remedied in another printing and it can be brought nearer the original. Hoping for the best.

The Section wrote back,

Thank you for your letter of September 28 and permit me to acknowledge the receipt in this office of a photograph, not of the cartoon which was expected, but of the completed mural for the Ripley, Tennessee Post Office. I am very pleased to tell you that the

photograph indicates that the work has been carried out satisfactorily and it seems alive with a shimmering quality which I presume is the exquisite color you refer to.

I wish to invite you to exhibit the work in the Corcoran show to be opened November 2 and lasting until November 21. The work can then be shipped from here at your request to Ripley.

Since you did not send the photograph of the cartoon it will be necessary to await the official authorization being requested from the Post Office Department before you may undertake the installation.

Unfortunately, this office has no funds with which to pay the transportation of your mural to Washington.

The artist did send the mural to the Corcoran, where, according to the Section, it was "very well received by the public. The fine quality of design and charming color of the mural excited many favorable comments." The artist asked for suggestions concerning whom to correspond with in Ripley for the eventual installation. In the meantime, the Section officially approved the mural.

Rowan wrote about the artist's concern that lights were obscuring portions of the mural after its installation:

Thank you for your letter of recent date stating that you have been notified that your mural is installed in the Ripley, Tennessee, Post Office. This office is addressing a letter to the Postmaster asking for a statement relative to the satisfactory installation, on receipt of which it will be possible to prepare your letter of final settlement....

In a typical letter mentioning the economic circumstances that nearly all of the mural artists faced, Zorach asked about payment:

This is just a note to ask if it is possible to hurry up the last payment on the mural. It just happens to be one of those moments when finances are low and that would be a help, and I know my Ripley postmaster is not timely when it comes to responding to letters!

Eventually, the local postmaster wrote about the mural:

The mural painted by Mrs. Marguerite Zorach for the Ripley, Tennessee, Post Office has been received and was satisfactorily installed December 12. It has caused many favorable comments from the patrons who have seen it, and I think it is a real addition to the decoration of the building.

About the Artist

Marguerite Thompson Zorach was born on September 25, 1887, in Santa Rosa, California. She is best known for modernist landscapes, textile art, and figural and genre paintings. Zorach was raised and educated in California. She was admitted to Stanford in 1908 and later traveled to Europe to study under several noted artists. She traveled with her aunt who was influential in her early career and life.

Upon returning to the United States, Thompson married the well-known artist William Zorach, and the couple settled in New York and

Georgetown, Maine. They had two children, Tessim and Dahlov—Dahlov became a well-known artist who painted the mural in the La Follette, Tennessee Post Office.

In addition to the Ripley, Tennessee Post Office mural, Zorach also painted the post office murals in Peterborough, New Hampshire, and Monticello, Indiana.

She died June 27, 1968 in Brooklyn, New York.

Sources

"Marguerite Thompson Zorach," Ask Art, https://www.askart.com/artist/marguerite_thompson_zorach/9465/marguerite_thompson_zorach.aspx?stm=marguerite%20th

Falk, Peter H. *Who Was Who in American Art 1564–1975: 400 Years of Artists in America*. Madison, CT: Sound View Press, 1999.

History of Ripley

Ripley is the seat of Lauderdale County, and at the 2010 Census had a population of 8,445. It was named after General E. W. Ripley, a veteran of the War of 1812.

The first store was opened in a log cabin, resulting in the community becoming a trade center between the communities of Dyersburg and Covington. The first wooden framed house in Ripley still stands as Sugar Hill Library on Jefferson Street.

During the Civil War, the county fell back and forth between Union and Confederate occupation after the Fort Pillow Massacre in 1864, which was a reaction from Confederate soldiers concerning the Union's use of black soldiers. Approximately 300 African American soldiers (half the garrison) were killed by Confederate troops led by Nathan Bedford Forrest. Ripley was a frequent camping location for both Union and Confederate troops.

The post office in Ripley was built in 1938, and today is listed on the National Register of Historical Places. Designed by Louis A. Simon and Neal A. Melick, it was added to the register in 1988.

Ripley is home to one of a few Choctaw communities in western Tennessee today. The community has its origins in migrants from a reservation in Philadelphia, Mississippi. They were sharecroppers at the time, and the U.S. Government's Bureau of Indian Affairs recognizes the community as an independent tribe. Approximately 300 Choctaw people live in the area of Ripley, Henning, Gates, Halls, and Memphis.

Sources

"Asset Detail," National Park Service, https://npgallery.nps.gov/NRHP/AssetDetail?assetID=fb56f54f-8193-4d07-a758-e4d7a9da3322

Dye, David H. "Choctaws," *Tennessee Encyclopedia*, March 1, 2018, https://tennesseeencyclopedia.net/entries/choctaws/

"Joyce Ann Robinson Bell," Tennessee Arts Commission, https://tnartscommission.org/permanentcollection/joyce-ann-robinson-bell/

"Ripley, TN Population," Census Viewer, http://censusviewer.com/city/TN/Ripley

Toplovich, Ann. "Lauderdale County," *Tennessee Encyclopedia*, March 1, 2018, https://tennesseeencyclopedia.net/entries/lauderdale-county/

"35 Reasons To Visit Lauderdale County," The Lauderdale County Homepage, December 15, 1999, http://www.lctn.com/chamber/35reasons.html

HENRY MORGENTHAU JR
SECRETARY OF THE TREASURY
JAMES A FARLEY
POSTMASTER GENERAL
LOUIS A SIMON
SUPERVISING ARCHITECT
NEAL A MELICK
SUPERVISING ENGINEER
1937

The Ripley Post Office

117 E. Jackson Ave., Ripley, Tennessee 38063

The Ripley Post Office was constructed by Algernon Blair of Montgomery, Alabama. The cost of the building when new was about $45,700.

The Ripley Post Office was completed in 1937 as indicated on the cornerstone on the lower right corner of the building, which reads, *Henry Morgenthau Jr., Secretary of the Treasury. James A. Farley, Postmaster General. Louis A. Simon, Supervising Architect. Neal A. Melick, Supervising Engineer.*

Wild Life, by Christian Heinrich

The terra cotta relief *Wild Life* is 7' by 3' and was installed on October 5, 1939. It depicts wild deer in their natural habitat. The commission was $760.

ROCKWOOD

History of the Mural

The artist asked for and was granted an extension for the project since he was working on a project for the New York World's Fair. He submitted three designs:

Sketch No. 1 represents "Early Trading." As you can see, this design would cover the whole wall above the door and windows and would be about the size of 12 feet by 3 1/2 feet. The reason why I did this design in this large size is to overcome the form of a panel which breaks off the background into many small square panels. I have in mind to use the entire wall as background to eliminate the form of a square panel, so that the doors and windows would not compete with it. This design would be suitable only in plaster.

Design No. 2 represents "Farming." This panel could be done in wood or some other material; the size is 2 1/2 by 7 feet as indicated in the blue prints.

Design No. 3 represents "Wild Life." There is also an ornament of the "State Flower" and "State Bird" on the sides. This should be very well executed in terra cotta.

I personally prefer the design of the "Wild Life." I am very anxious to have your opinion about the designs. In order to find the right subject matter for this town I read and heard so many interesting things about the State of Tennessee, that I would like to make a trip to Rockwood and execute the panel there.

The Section selected the third choice and made some suggestions:

We have several suggestions, however, which we believe should be considered in developing the design. First is that the motifs of the State bird and State flower seem extraneous to the panel and would be very difficult to relate in scale to the central theme. It was thought that if they could not be incorporated into the central motif as decorative adjuncts, it would be best to eliminate them from the theme. It was also thought that the central motif might be increased in height by approximately six inches. The most satisfactory way of avoiding the rectangular form which we agree with you is unfortunate in relation to the other architectural features would be to eliminate the background of the relief above backs and heads of the figures and apply the design to the wall. By a certain amount of redesigning of the figures so that they would be a compact mass, I believe this could be very satisfactorily achieved, keeping the lower line of the relief as you have indicated it and letting the top of the relief conform to the outline of the three deer.

The artist agreed with the suggestions:

I am glad you liked the design "Wild Life." Your suggestion to make the design in a more compact mass and letting the top of the relief conform to the outline of the three deer to eliminate the background of the relief about the animals is, I think, a very good idea to overcome the rectangle form in relation to the other architectural features. Also, I believe it will be very good to drop the ornaments on the sides entirely. This will help to simplify the decoration.

After the panel was installed, the artist wrote to the Section with some concerns:

The installation of the terra cotta panel "Wild Life" for the Rockwood, Tennessee Post Office was completed on October 5th. The sculpture is fastened on nine toggle bolts....

The lighting fixtures are not very satisfactory; they are about four feet from the sculpture. The glass ball of the light is too close to

the panel and interferes. I would like to suggest to install the lighting on both sides between the windows or have an indirect light from the ceiling above the panel.... In case this cannot be done, the lighting fixture should be raised up to the ceiling.

The local postmaster wrote to the Section about the successful installation and reception of the work:

Please be advised that the relief of Mr. Christian W. Heinrich has been satisfactorily installed in this office, and we have received many favorable comments from the patrons of the office on this panel Wild Life which adds greatly to the lobby of our office and is very appropriate for this section of the county.

About the Artist

Christian W. Heinrich was born in Germany in 1893. He is best known for architectural sculptures in bronze, wood, and terra cotta.

Heinrich studied at the Darmstadt Art School and the Academy of Arts in Munich, and eventually immigrated to the United States, settling in New York.

Sources

"Christian Heinrich," Ask Art, https://www.askart.com/index.aspx

Falk, Peter H. *Who Was Who in American Art 1564–1975: 400 Years of Artists in America.* Madison, CT: Sound View Press, 1999.

Hull, Howard, *Tennessee Post Office Murals.* Johnson City, TN: Overmountain Press, 1996.

History of Rockwood

Rockwood is located in Roane County; when the 2010 Census was taken, its population was 5,562. It was named after William O. Rockwood, who was the president of Roane Iron Company at the time.

The city was constructed after the Civil War when Captain Hiram S. Chamberlain partnered with Union General John Wilder and bought 728 acres of land that was rich in iron deposits in 1865. Roane Iron Company was formed, and the surrounding town was built to house workers who had come from as far away as England. In 1868, the materials for the furnace arrived, and it took another 8 months for the

first cast to be made. The furnace was the first of its kind south of Ohio for the production of iron from mineral coal.

The town was known as a company town for a long time due to its origins, and the population of the town was linked directly to how well the iron industry was doing. The Roane Iron Company was known for paying white and black people the same wages, whether in cash or scrip. The population of Rockwood grew from 698 people in 1870 to 2,305 in 1890.

Today, Rockwood is a community that sits just off of Interstate 40, while U.S. Highways 70 and 27 intersect through the downtown area.

SOURCES

"Roane County, TN: Walton Road Scenic Byway, Tennessee," http://waltonroad.com/historic-context-2

"Rockwood, TN Population," Census Viewer, http://censusviewer. com/city/TN/Rockwood

"Rockwood 2000," https://www.rockwood2000.com/history-of-rockwood.html

HENRY MORGENTHAU JR.
SECRETARY OF THE TREASURY
JAMES A. FARLEY
POSTMASTER GENERAL
LOUIS A. SIMON
SUPERVISING ARCHITECT
NEAL A. MELICK
SUPERVISING ENGINEER
1937

The Rockwood Post Office

340 W. Rockwood St., Rockwood, Tennessee 37854

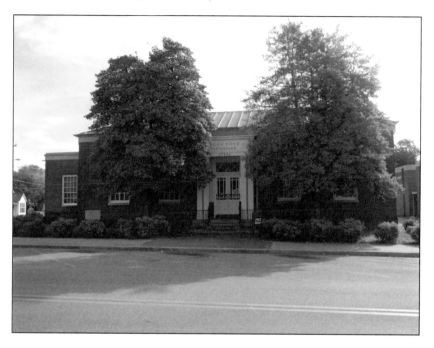

The Rockwood Post Office was constructed by Algernon Blair of Montgomery, Alabama. The cost was about $44,934.

The Rockwood Post Office was completed in 1937 as indicated on the cornerstone on the lower left corner of the building, which reads, *Henry Morgenthau Jr., Secretary of the Treasury. James A. Farley, Postmaster General. Louis A. Simon, Supervising Architect. Neal A. Melick, Supervising Engineer.*

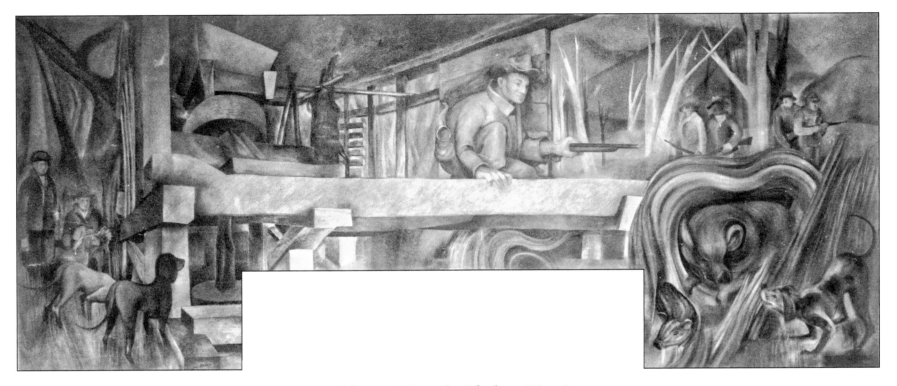

***Wild Boar Hunt*, by Thelma Martin**

The mural *Wild Boar Hunt* is egg tempera on canvas and measures 11' by 4'5". It depicts locals hunting wild boar. The commission was $750.

SWEETWATER

History of the Mural

The artist wrote to the Section about her decision in selecting the subject matter:

I chose the subject of a boar hunt because the region in which Sweetwater is located is the principle spot in America where real wild boar is hunted. The East Tennessee boar are descendants of East European animals which were imported by early gentlemen farmers and let loose in the Cherokee Forest to provide seasonal sport.

They thrive in the favorable habitat and are now quite plentiful. At the present time, each November, the hunting is done under the sponsorship of the National Park Service. A great deal of local pride is connected with this sport and many people of the region are expert boar hunters.

You may notice that the boar hanging in the old mill has an indication of stripes. This simply shows that he is young. The very young animals have very distinct stripes but lose them when they are fully matured.

The old grist mill (spindle type) is typical of small mountain mills which dot the region of the boar hunt. Most are abandoned and used mainly as shelters for hikers and hunters.

I realize this is quite a finished sketch to submit without having sent preliminary rough ones, but after finishing the drawing I couldn't leave it because I felt that much of the character depended upon the painting and color.

The Section was complimentary:

Your design has been reviewed by the members of the Section and is charming and, of course, is approved. The only suggestion is that . . . it would be very nice if you could introduce one of the little striped animals along with the larger one at bay.

The artist wrote back about the full-size cartoon:

Enclosed is a negative and print of the completed full size cartoon for the Sweetwater, Tennessee, Post Office as required. You will notice that the cartoon includes two little striped pigs which you suggested I include. I think the one in the foreground corner is a particularly fortunate addition since it helps nail the composition around the door. The photographer has increased the contrasting values somewhat more than I had intended but the work itself will have more analogous transitions.

Thelma Martin, *Wild Boar Hunt*

The Section wrote after installation to the postmaster:

Thanks for your letter of December, 1942, reporting on the satisfactory installation of the mural by Mrs. Thelma Martin in the Sweetwater, Tennessee, Post Office.

It is gratifying to learn that you feel the mural adds considerably to the decoration of the building.

ABOUT THE ARTIST

Thelma Martin is best known for her early paintings, though later she had a successful career as a photographer. Martin studied at the Art Institute of Chicago. She was the wife of David Stone Martin, the artist of the Lenoir City Post Office mural.

Martin died in Lambertville, New Jersey, in 1969.

SOURCES

Hull, Howard, *Tennessee Post Office Murals*. Johnson City, TN: Overmountain Press, 1996.

History of Sweetwater

The city of Sweetwater is located in both Monroe and McMinn counties in Tennessee. The population, the highest in Monroe County, was 5,586 in the Census of 2010. It was founded sometime in the 1850s through the sale of lots that were owned by Isaac Lenoir. The city was officially incorporated in 1875.

The origin of the city's name has been a subject of debate for a long time, but it is known today that an original story was made up by W. B. Lenoir and a friend, who claimed that John Howard Payne had dinner with a Cherokee chief, and that "Swatee Watee" were supposedly Cherokee words that meant "happy home." The whole story was invented due to the city not really having any traditions of its own.

The truth about the name is that the area has many springs that have good water that tastes sweet. Just a few miles from the city is a famous underground lake, the Lost Sea, which is listed in the *Guinness Book of World Records* officially as the world's largest underground lake, part of a cave system known as Craighead Caverns, and is a popular tourist attraction. It was used by Native Americans and early white settlers for food storage due to the cave's constant temperature of 58°F.

Cannon Spring provides water to Sweetwater today and has since 1908 when it was purchased from the Cannon family. It still provides as much as 300,000 gallons of water a day for the city's use.

Sources

"History of the Lost Sea," The Lost Sea, https://thelostsea.com/history/

"Sweetwater," Monroe County Chamber of Commerce, http://www.monroecountychamber.org/sweetwater/

"TN Population," Census Viewer, http://censusviewer.com/city/TN/Sweetwater

"Why Do They Call It That?" August 2, 2010, http://www.vanshaver.com/why_do_they_call_it_that1.htm

The Sweetwater Post Office

701 N. Main St., Sweetwater, Tennessee 37874

The Sweetwater Post Office construction when new was about $75,000.*

The Sweetwater Post Office was completed in 1940 as indicated on the cornerstone on the lower left corner of the building, which reads, *James A. Farley, Postmaster General. John M. Carmody, Federal Works Administrator. W. Englebert Reynolds, Commissioner of Public Buildings. Louis A. Simon, Supervising Architect. Neal A. Melick, Supervising Engineer.*

JAMES A FARLEY
POSTMASTER GENERAL
JOHN M CARMODY
FEDERAL WORKS ADMINISTRATOR
W ENGLEBERT REYNOLDS
COMMISSIONER OF PUBLIC BUILDINGS
LOUIS A SIMON
SUPERVISING ARCHITECT
NEAL A MELICK
SUPERVISING ENGINEER
1940

TENNESSEE POST OFFICE MURAL LIST

Bolivar: Carl Nyquist, *Picking Cotton*

Camden: John H. Fyfe, *Mail Delivery to Tranquility—The First Post Office in Benton County*

Chattanooga (#1): Hilton Leech, *Allegory of Chattanooga*

Chattanooga (#2): Leopold Scholz, *The Mail Carrier*

Clarksville: F. Luis Mora, *Abundance of Today* and *Arrival of Colonel John Donaldson*

Clinton: Horace Day, *Farm and Factory*

Columbia (#1): Henry Billings, *Maury County Landscape*

Columbia (#2): Sidney Waugh, *American Eagle*

Crossville: Marion Greenwood, *The Partnership of Man and Nature*

Dayton: Bertram Hartman, *View from Johnson's Bluff*

Decherd: Enea Biafora, *News on the Job*

Dickson: Edwin Boyd Johnson, *People of the Soil*

Dresden: Minetta Good, *Retrospection*

Gleason: Anne Poor, *Gleason Agriculture*

Greeneville: William Zorach, *Man Power* and *Natural Resources*

Jefferson City: Charles Child, *Great Smokies and Tennessee Farms*

Johnson City: Wendell Jones, *Farmer Family*

La Follette: Dahlov Ipcar, *On the Shores of the Lake*

Lenior City: David Stone Martin, *Electrification*

Lewisburg: John H. R. Pickett, *Coming 'Round the Mountain*

Lexington: Grace Greenwood, *Progress of Power*

Livingston: Margaret Covey Chisholm, *The Newcomers*

Manchester: Minna Citron, *Horse Swapping Day*

McKenzie: Karl Oberteuffer, *Early United States Post Village*

Mount Pleasant, Eugene Higgins, *Early Settlers Entering Mount Pleasant*

Nashville: Belle Kinney, *Portrait Bust of Admiral Albert Gleaves*

Newport: Minna Citron, *TVA Power*

Ripley: Marguerite Zorach, *Autumn*

Rockford: Christian Heinrich, *Wild Life*

Sweetwater: Thelma Martin, *Wild Boar Hunt*

BIBLIOGRAPHY

Archival Sources

The bulk of research performed for this book was conducted at the National Archives and Records Administration in College Park, Maryland. The Section of Fine Arts kept records as they corresponded with the artists during the development of the murals. These records are stored in Case Files Concerning Embellishments of Federal Buildings, record group 121 entry 133. The records are stored alphabetically in boxes, and each state has its own number. Each box contains individual folders for each town. The folders contain various handwritten letters, original black-and-white photographs, press releases, newspaper clippings from the period, and various other documents created while corresponding with the artists and other government agencies during the development and eventual installation of the artwork. The bulk of the material for the development of this book was pulled from these records.

The National Archives and Records Administration also houses building records for each town and building. These are stored in record group 121 Public Buildings Service, General Correspondence and related records. The records for the Lenoir City Post Office, for example, is in box 7048. The estimated cost of the building when new and the contractor who won the bid was taken from these records. Sadly, not all the documents are complete; some of this is missing from several of the towns. Since each building physically has a cornerstone, the author was able to cross-verify the year the building was constructed with the documents from the General Correspondence records. Unfortunately, the author was not able to determine the contractor or validate the approximate cost for several buildings but nonetheless felt it was important to proceed with the information that was uncovered.

As part of the contract with the artist, the government required the artist to send a photograph of the finished mural to the Section upon completion of installing the mural in the post office. The National Archives and Records Administration also houses these records. They are stored in record group 121-CMS, Records of the Public Building Service, Completed Murals and Sculptures. The black-and-white photographs for the Clarksville and Dickson, Tennessee murals were pulled from these records. Clarksville had two murals commissioned, but the author only found one photograph in the records.

The artists' biographies at the archives are limited, but some do exist. They are stored in record group 121 in the Records of the Public Buildings Service, entry 136—Biographical Data File Concerning Artists.

In addition to the scholarly research performed for this book, the author personally visited each town and photographed each building and mural. During these visits, there often are various documents, period photos, and descriptions regarding the murals and buildings in the enclosed bulletin boards. The author also consulted with numerous postal employees, postmasters, and other authors regarding the buildings and art.

Sources Consulted

Bridewell Beckham, Sue. *Depression Post Office Murals and Southern Culture: A Gentle Reconstruction.* Baton Rouge: Louisiana State University Press, 1989.

Bruce, Edward & Watson, Forbes: *Art in Federal Buildings Volume 1* "Mural Designs."

Byrne, Peter. *Going Postal: U.S. Senator Dianne Feinstein's Husband Sells Post Offices to His Friends, Cheap.* Peter Byrne, 2013.

Carlisle, John C. *A Simple and Vital Design: The Story of the Indiana Post Office Murals.* Indianapolis: Indiana Historical Society, 1995.

Fahlman, Betsy. *New Deal Art in Arizona.* The University of Arizona Press, 2009.

Falk, Peter Hastings. *Who Was Who in American Art 1564–1975: 400 Years of Artists in America*: Sound View Press, 1999.

Frist Center for the Visual Arts. *From Post Office to Art Center: A Nashville Landmark in Transition. Nashville*: Frist Center for the Visual Arts, 2001.

Gallagher, Winifred. *How the Post Office Created America*. Penguin Random House, 2016.

Gates, David W., Jr. *Tennessee Post Office Mural Guidebook*. Crystal Lake, Illinois: Post Office Fans, 2020.

Gates, David W., Jr. *Wisconsin Post Office Murals*. Crystal Lake, Illinois: Post Office Fans, 2019.

Gates, David W., Jr. *Wisconsin Post Office Mural Guidebook*. Crystal Lake, Illinois: Post Office Fans, 2019.

Hallsten McGarry, Susan. *The Art of Charles W. Thwaites: Freedom of Expression*. Albuquerque, New Mexico: Fresco Fine Art Publications, 2008.

Hull, Howard. *Tennessee Post Office Murals*. Johnson City, Tennessee: The Overmountain Press, 1996.

Kalfatovic, Martin R. *The New Deal Fine Arts Projects: A Bibliography, 1933–1992*. The Scarecrow Press, 1994.

Leonard, Devin. *Neither Snow Nor Rain: A History of the United States Postal Service*: New York, New York, Grove Press, 2016.

Marling, Karal Ann. *Wall-to-Wall America: A Cultural History of Post-Office Murals in the Great Depression*. Minneapolis: University of Minnesota Press, 1992.

McIntosh, Toby. *Apple Picking, Tobacco Harvesting and General Lee: Arlington's New Deal Murals and Muralist*. BookBaby, 2016.

McKinzie, Richard D. *The New Deal for Artists*. Princeton University Press, 1973.

Michael Scragg's Postal Museum, Marshall, Michigan.

O'Connor, Francis V. *The New Deal Art Projects: An Anthology of Memoirs*. Washington, D.C.: Smithsonian Institution Press, 1972.

Parisi, Philip. *The Texas Post Office Murals: Art for the People*. Texas: Texas A&M University Press, 2004.

Park, Marlene, and Gerald E. Markowitz. *Democratic Vistas: Post Office Murals and Public Art in the New Deal*. Philadelphia: Temple University Press, 1984.

Price Davis, Anita. *New Deal Art in North Carolina: The Murals, Sculptures, Reliefs, Paintings, Oils and Frescos and Their Creators*. North Carolina: McFarland & Company, 2009.

Puschendorf, Robert L. *Nebraska's Post Office Murals: Born of the Depression, Fostered by the New Deal*. Lincoln, Nebraska: State Historical Society Books, 2012.

"Speaking of Pictures... This is Mural America for Rural Americans...," *Life Magazine*, December 4, 1939.

Smithsonian American Art Institute.

Thomas, Bernice L. *The Stamp of FDR*. Purple Mountain Press, 2002.

The U.S. Postal Service. *An American Postal Portrait: A Photographic Legacy*. Harper Collins, 2000.

OTHER TITLES BY THE PUBLISHER

WISCONSIN POST OFFICE MURALS

Author: David W. Gates Jr.

ISBN (Softcover): 978-1-970088-00-7

ISBN (eBook): 978-1-970088-01-4

ISBN (PDF): 978-1-970088-02-1

WISCONSIN POST OFFICE MURAL GUIDEBOOK

Author: David W. Gates Jr.

ISBN: 978-1-970088-09-0 (Paperback)

ISBN: 978-1-970088-10-6 (EPUB)

ISBN: 978-1-970088-11-3 (PDF)

ABOUT THE AUTHOR

DAVID W. GATES JR. is a post office enthusiast and author who has traveled thousands of miles nationwide in search of historic post office buildings and art.

He blogs about his work at www.postofficefans.com.

Although the murals have been around for more than 86 years, David discovered how often these works of art are overlooked. Join David in his quest to visit them all.

He lives in Crystal Lake, Illinois, with his wife and son. When not photographing and documenting post offices, he can be found cooking, baking, hiking, or involved in do-it-yourself projects at home, not necessarily all at once and not necessarily in that order.

For more of David's work please visit www.davidwgatesjr.net.

TENNESSEE POST OFFICE MURAL GUIDEBOOK

Tennessee Post Office Mural Guidebook is the companion to *Tennessee Post Office Murals*

We hope you have enjoyed this book of ***Tennessee Post Office Murals***. If you are planning on visiting or traveling to view these magnificent works of art in person, you will find the ***Tennessee Post Office Mural Guidebook*** a valuable addition.

While the book you are holding now contains the history and images, the guidebook provides the location and status of the artwork. In some cases, the mural could be miles from the building where it was initially installed.

Tennessee Post Office Mural Guidebook is available from your favorite retailer or can also be ordered directly from the publisher at www.postofficefans.com.

CPSIA information can be obtained
at www.ICGtesting.com
Printed in the USA
LVRC082154120721
692516LV00002B/19

9 781970 088038